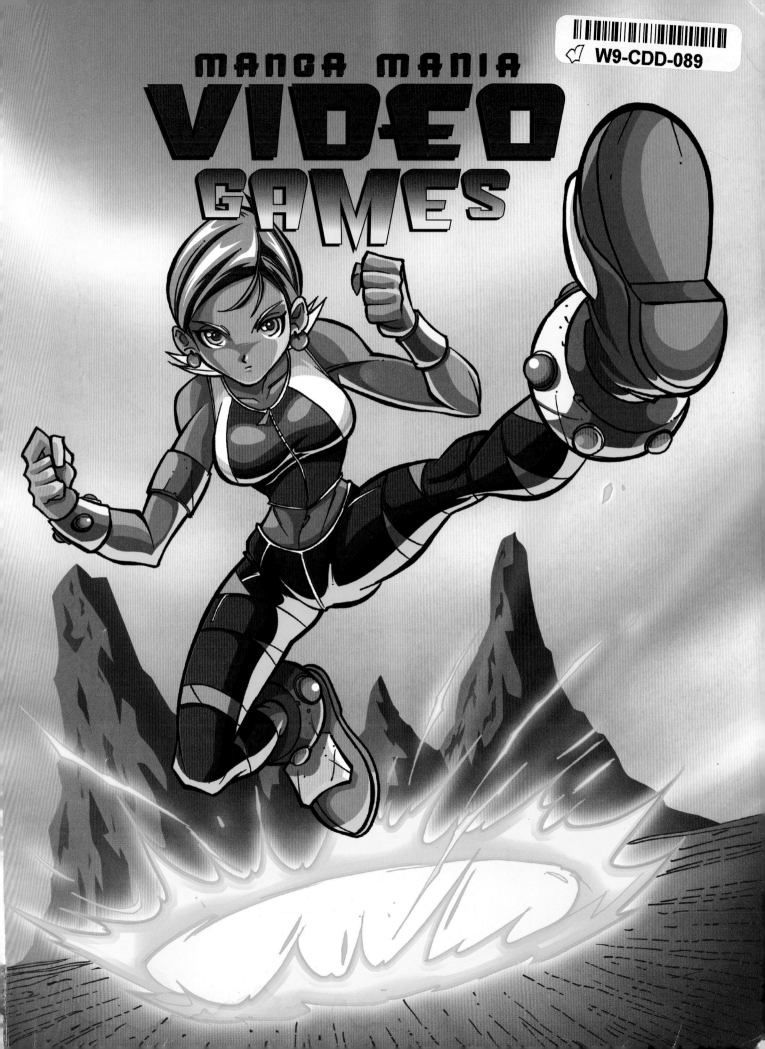

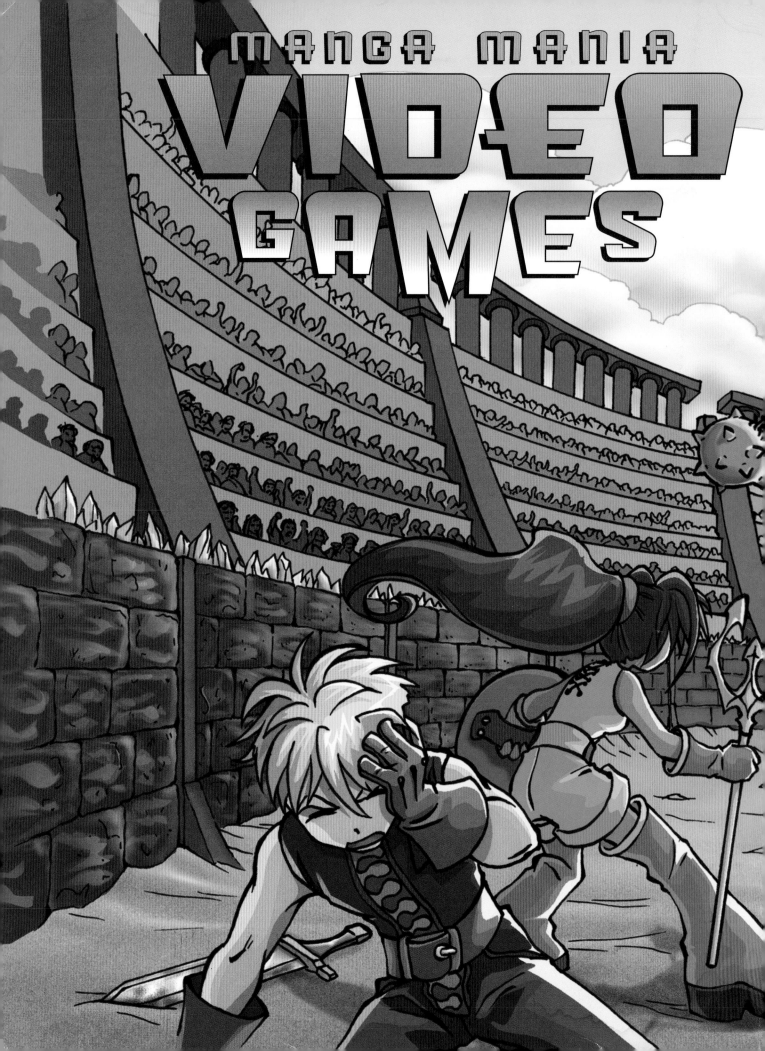

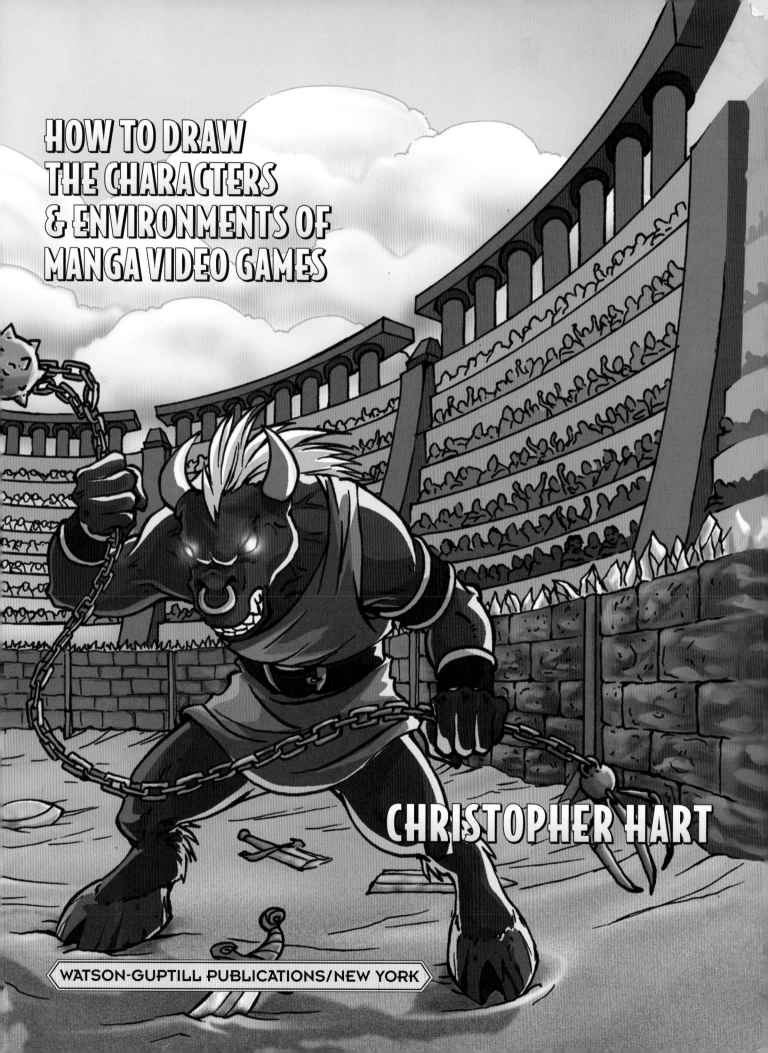

HOW TO DRAW THE CHARACTERS & ENVIRONMENTS OF MANGA VIDEO GAMES

CHRISTOPHER HART

WATSON-GUPTILL PUBLICATIONS/NEW YORK

This book is dedicated to all the people who have kept playing video games long after their eyes have gone blurry

Special thanks go to Isabella Hart for her video game expertise.

My thanks also go to all of the people at Watson-Guptill. Or, at least, most of the people there. Okay, okay, all of the people.

CONTRIBUTING ARTISTS:
Denise Akemi: 82–95
Svetlana Chmakova: 2–3, 104–117
Christopher Hart: 56–57
Park Hee Jin: 62–81
Makiko Kanada: 4, 28–45, 53–55
Mike Leeke: 96–103
Ruben Martinez: 1, 6, 46–52, 58–61
John Staton: 8–27
Dave White: 5, 118–140

Color by MADA Design, Inc. with the exception of pages 4, 28–45, and 53–55 (color comps by Makiko Kanada; final color by Vaughn Ross)

Executive Editor: Candace Raney
Senior Development Editor: Alisa Palazzo
Designer: Bob Fillie, Graphiti Design, Inc.
Production Manager: Hector Campbell

Published in 2004
by Watson-Guptill Publications
a division of VNU Business Media, Inc.
770 Broadway, New York, NY 10003
www.wgpub.com

Library of Congress Cataloging-in-Publication Data
Hart, Christopher.
 Manga mania video games : how to draw the characters
& environments of Manga video games /
Christopher Hart.
 p. cm.
Includes index.
 ISBN 0-8230-2974-3 (pbk.)
 1. Computer graphics. 2. Drawing—Technique.
3. Video games. I. Title.
 T385.H3472 2004
 741.5--dc22
 2004014805

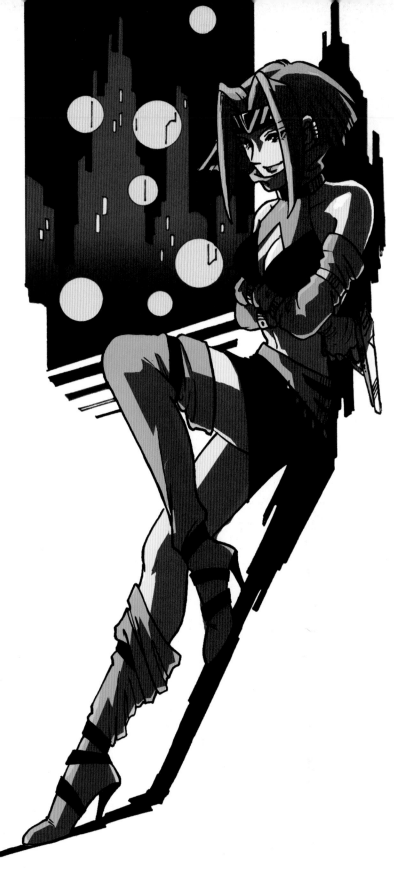

VISIT US AT
www.artstudiollc.com

CONTENTS

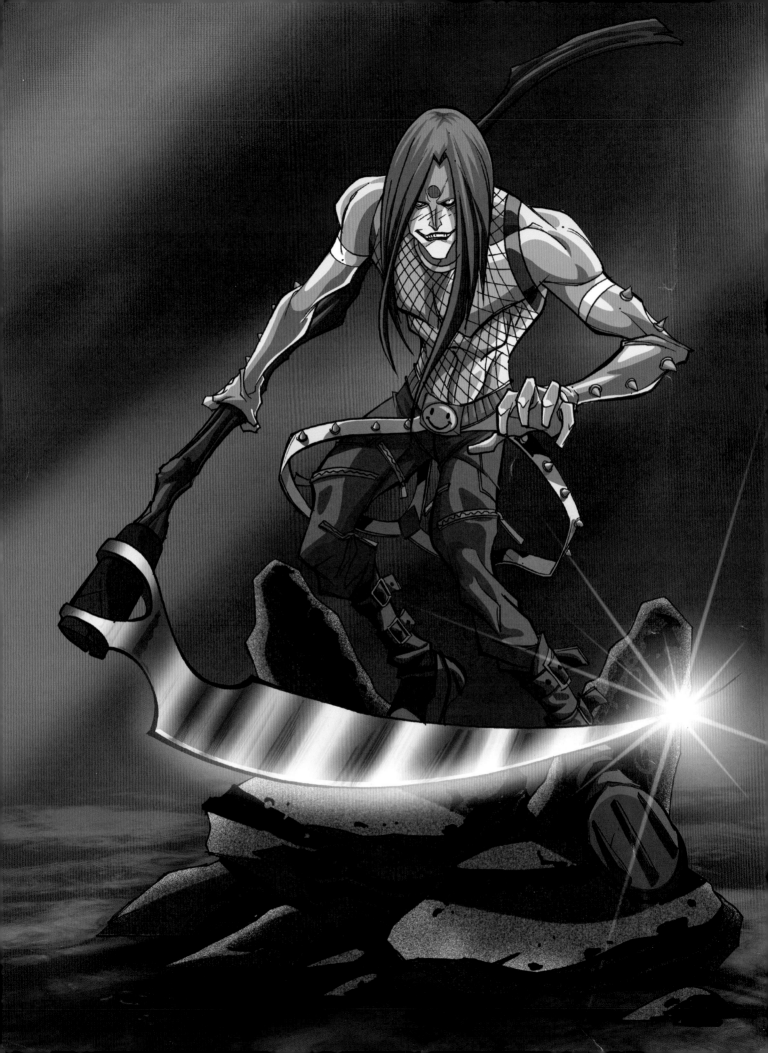

INTRODUCTION

This is a comprehensive book that will not only show you how to draw video game characters, but also how to improve your manga and make it more cutting edge, exciting, and action packed.

Manga and video games go together. Popular manga styles are represented among many of the top-selling video games of all time. Whether you want to be a video game artist, invent your own video game (how cool is that?), or just want to know the latest drawing techniques, you can benefit from this book. Every video game starts with a pencil sketch. The cool characters and the strange worlds they inhabit must be handdrawn before they can be transposed digitally. Artists who can draw well are always needed in the growing video game industry.

You'll learn how to draw basic anatomy and dynamic action poses. You'll get step-by-step instruction on how to draw a huge variety of the most popular types of video game characters. And, since you'll want to do something with your characters, this book will show you how to create thrilling fight scenes using all the martial arts moves you'll

ever need. Then we'll move on to martial arts weapons, like throwing stars and samurai swords. Gunfights are standard fare in action-oriented video games, but how do you stage one so that it keeps viewers on the edge of their seats? I'll show you all the tricks.

And that's not all! Your characters also need locations—called video *environments* or *worlds*—for their adventures. You'll learn how to create these amazing environments in all different genres—from fantasy worlds to medieval to futuristic to horror. And then—and this is something you won't want to miss—you'll learn how drawings are turned into digital, computer-generated images.

And finally, an interview with Dave White, a senior game artist at the famous Cyberlore Studios, Inc., tops it all off. In the interview, White gives you the inside track on how to break into the video game business. It's a virtual road map designed to place you ahead of the pack.

So, whether you use this book to create your own ideas for video games or to ratchet up your manga drawing skills to the next level, there's something in here for you.

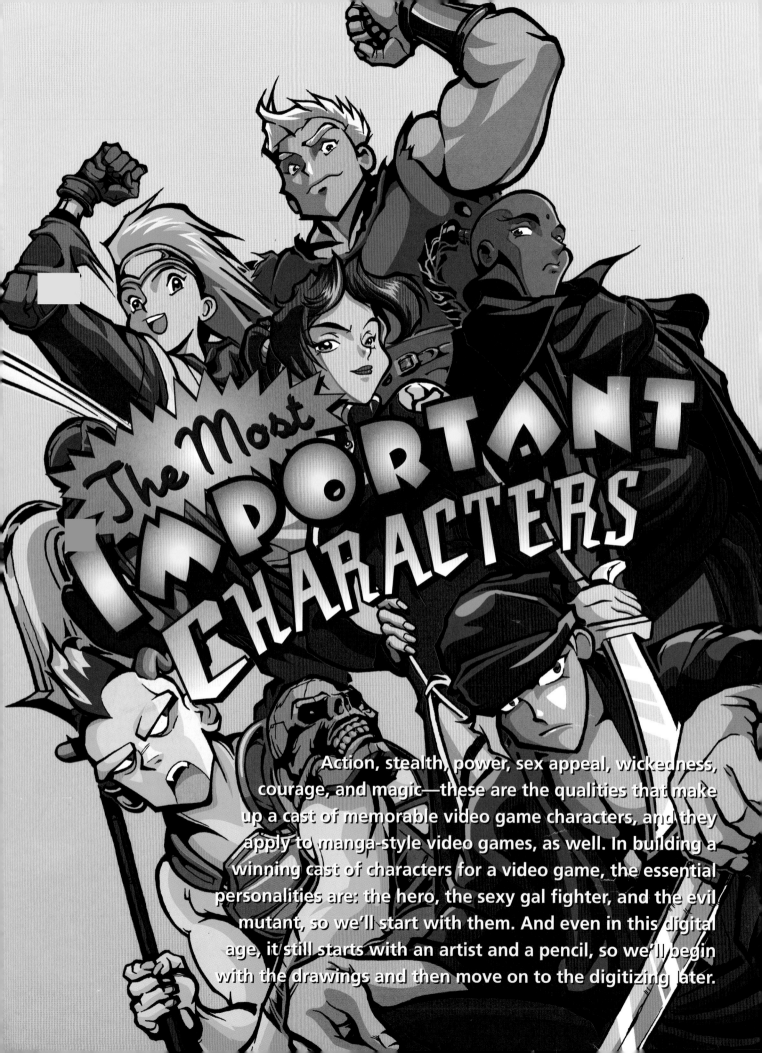

The Most IMPORTANT CHARACTERS

Action, stealth, power, sex appeal, wickedness, courage, and magic—these are the qualities that make up a cast of memorable video game characters, and they apply to manga-style video games, as well. In building a winning cast of characters for a video game, the essential personalities are: the hero, the sexy gal fighter, and the evil mutant, so we'll start with them. And even in this digital age, it still starts with an artist and a pencil, so we'll begin with the drawings and then move on to the digitizing later.

THE HERO

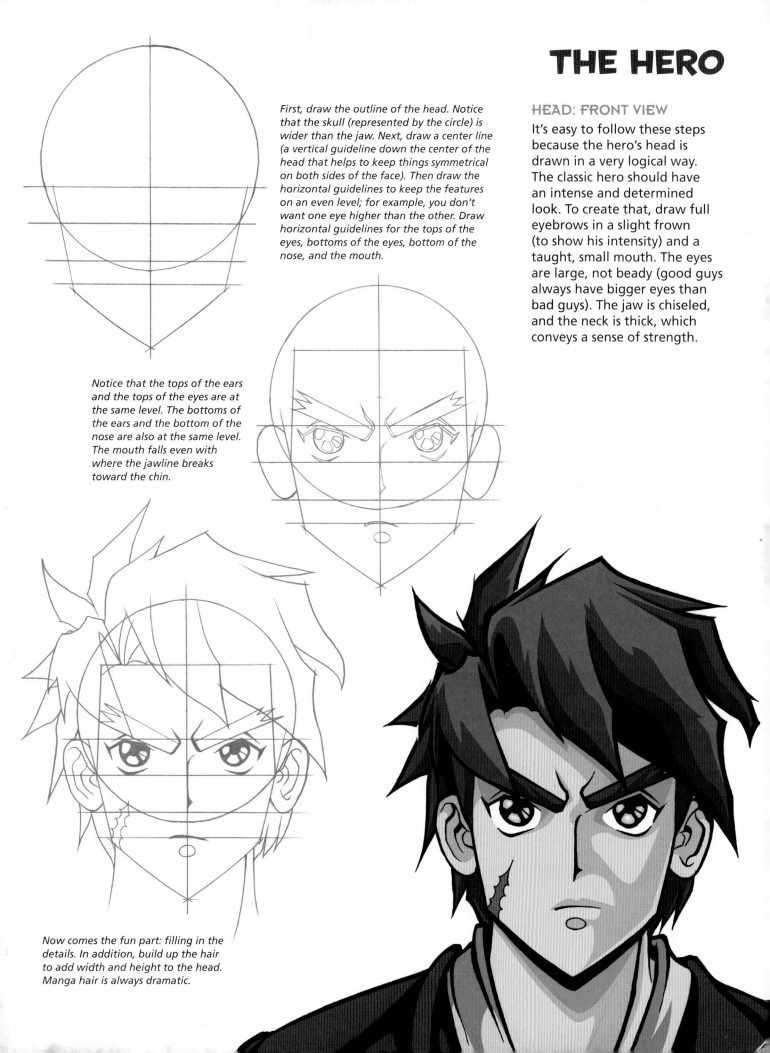

First, draw the outline of the head. Notice that the skull (represented by the circle) is wider than the jaw. Next, draw a center line (a vertical guideline down the center of the head that helps to keep things symmetrical on both sides of the face). Then draw the horizontal guidelines to keep the features on an even level; for example, you don't want one eye higher than the other. Draw horizontal guidelines for the tops of the eyes, bottoms of the eyes, bottom of the nose, and the mouth.

HEAD: FRONT VIEW

It's easy to follow these steps because the hero's head is drawn in a very logical way. The classic hero should have an intense and determined look. To create that, draw full eyebrows in a slight frown (to show his intensity) and a taught, small mouth. The eyes are large, not beady (good guys always have bigger eyes than bad guys). The jaw is chiseled, and the neck is thick, which conveys a sense of strength.

Notice that the tops of the ears and the tops of the eyes are at the same level. The bottoms of the ears and the bottom of the nose are also at the same level. The mouth falls even with where the jawline breaks toward the chin.

Now comes the fun part: filling in the details. In addition, build up the hair to add width and height to the head. Manga hair is always dramatic.

PROFILE

When you begin with a simplified shape, everything falls into place. Don't be tempted to skip the first step. You'll only make your life harder! The hero's profile has a pleasing, sweeping curve to the forehead. The nose, lips, and chin fall along one diagonal line, which makes for easy placement.

SWEEPING FOREHEAD

Nose, lips, and chin fall on the same diagonal line.

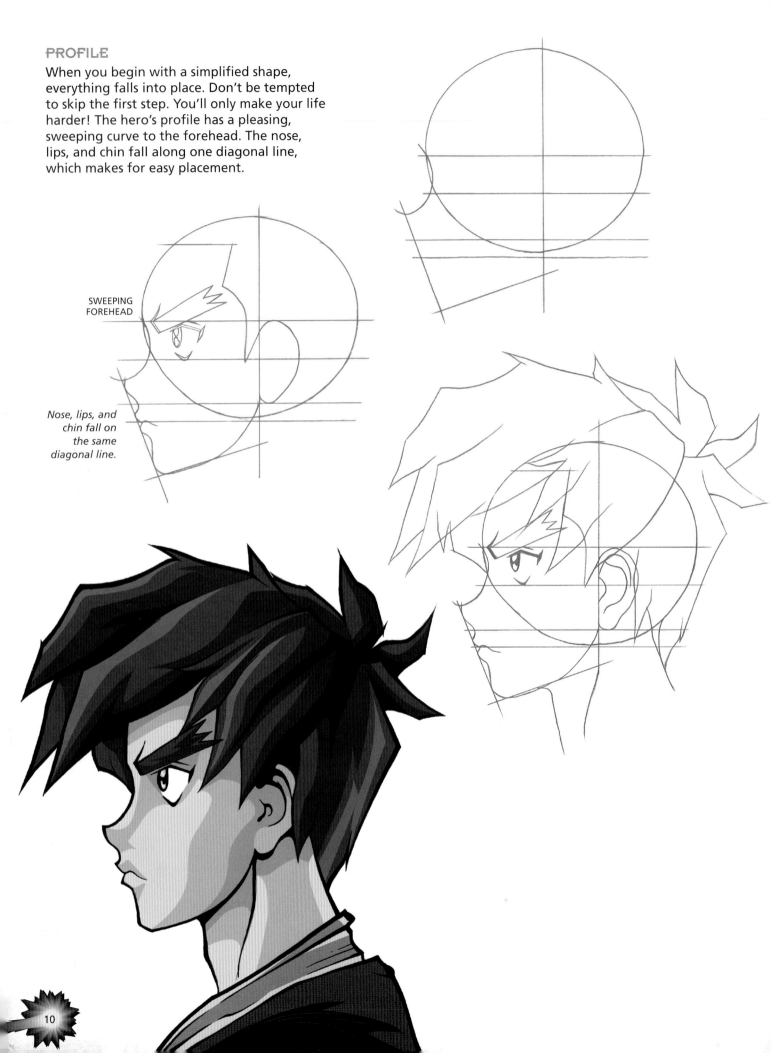

3/4 VIEW

In the 3/4 view of the head, the head is turned between a front view and a profile. As a result of the face turning, the far eye recedes back around the curve of the head and must be drawn more narrowly than the near eye. Also, more of the mouth should appear on the near side of the center line (the vertical line down the middle of the face). Leave the far ear out entirely. Notice that the neck begins at the base of the ear.

NECK
BEGINS
AT BASE
OF EAR

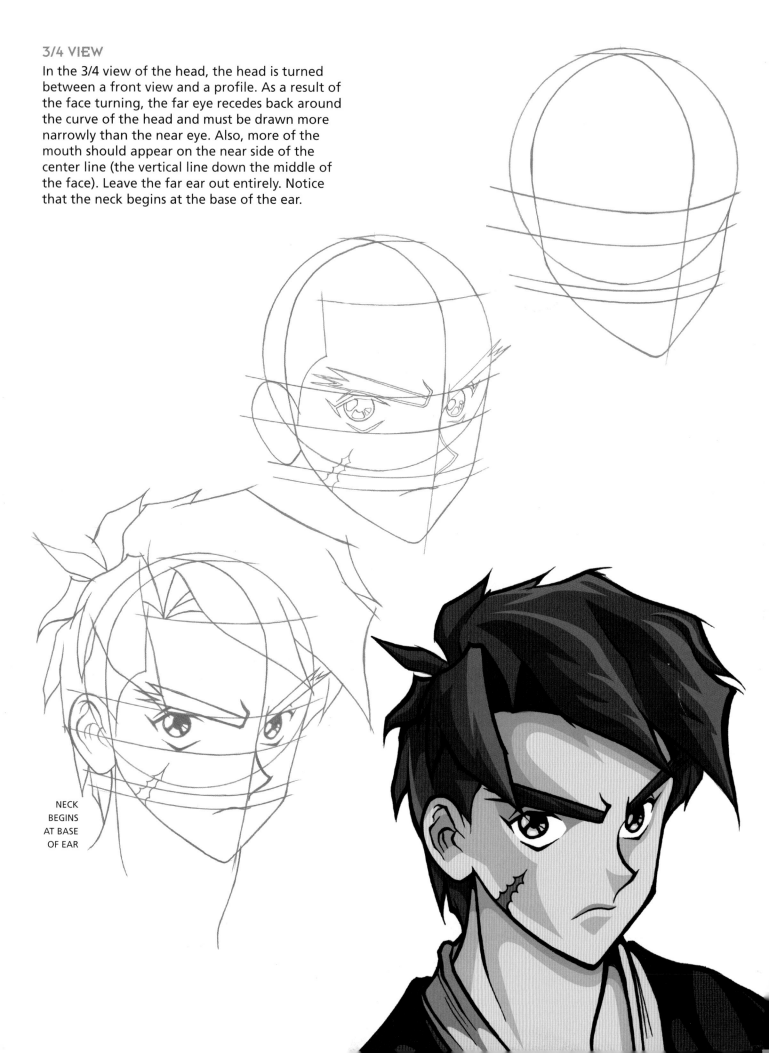

BODY: FRONT VIEW

Do you often have trouble drawing the human body? For beginning artists, the task looks very complicated—almost undoable. We need to find a way to take out the *un* and add more *doable*. Most beginners start with the head and work their way down to the feet, drawing in great detail as they go. But that's the hard way. It's easier to block out the major sections of the body first.

The first step is to block out the body in the most general way. Don't go into detail at this point. All you're trying to do is get the proportions correct. Erase and adjust as needed.

Now add the features to the face. Draw the face early in the process in order to give yourself the feeling of the character. Sculpt the body, indicating the chest muscles, shoulder muscles, and rib cage. Then add curves to the arms and legs. At this stage, the character is all in place. The only things left are the hair and the costume.

Costumes are much easier to create over a correctly proportioned figure. Once you've added the costume, erase the underlying body, or trace over your drawing, leaving out any lines and eraser marks that you don't want in the final picture.

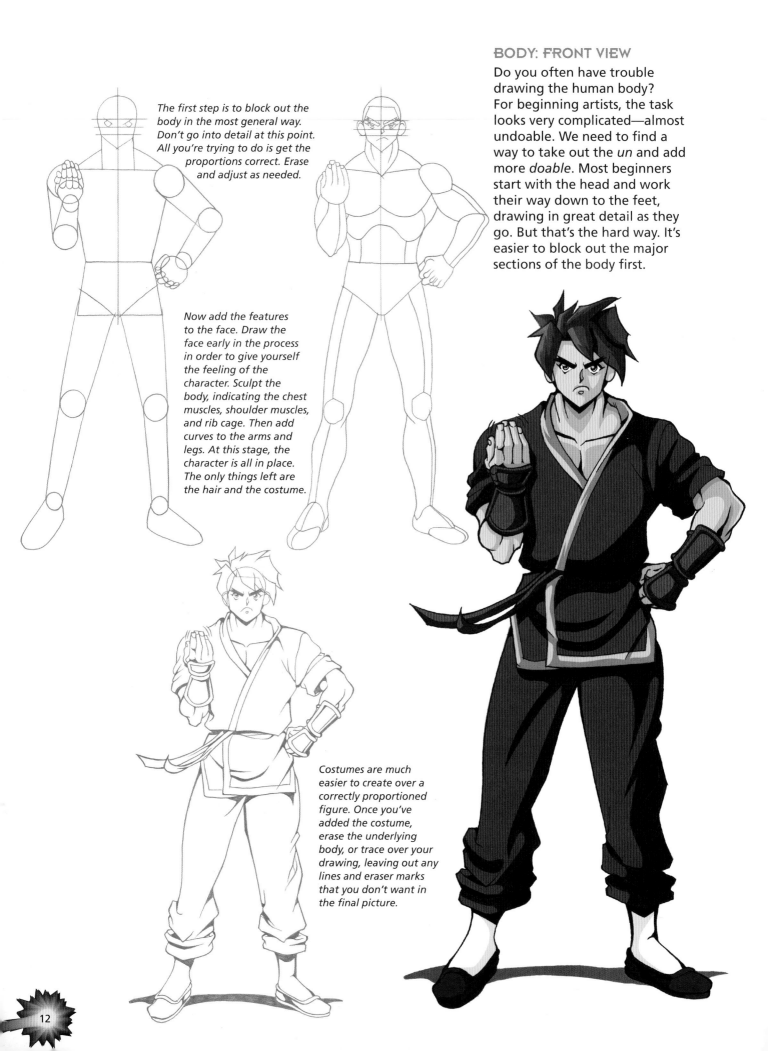

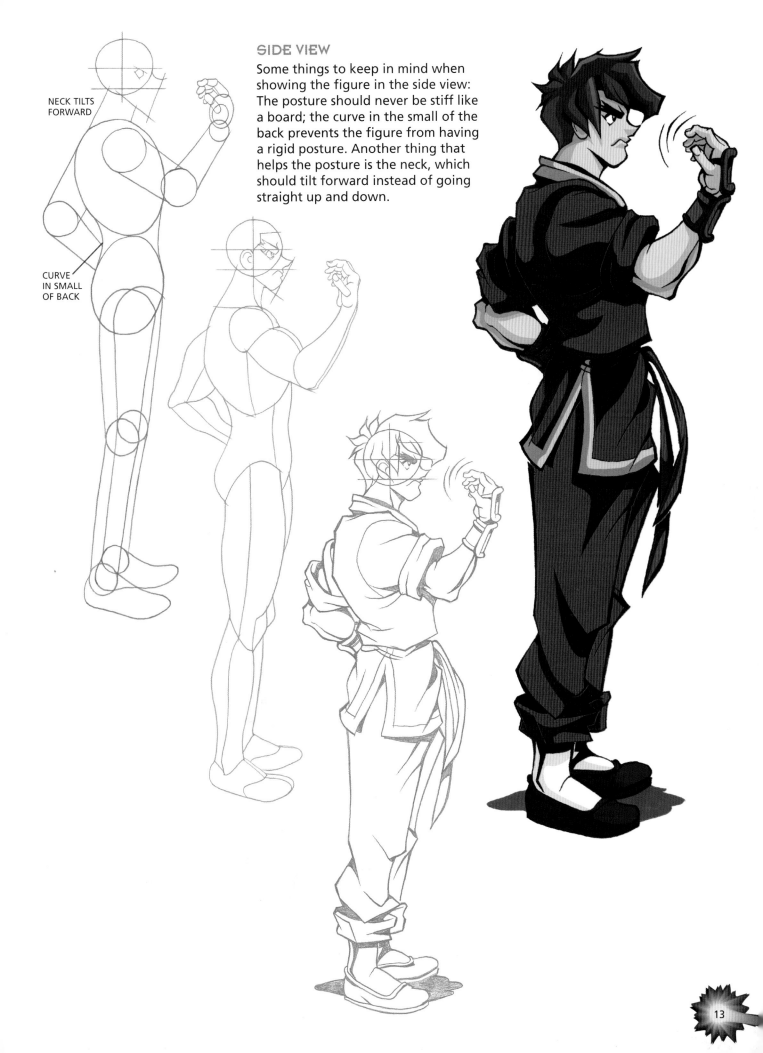

NECK TILTS
FORWARD

CURVE
IN SMALL
OF BACK

SIDE VIEW

Some things to keep in mind when showing the figure in the side view: The posture should never be stiff like a board; the curve in the small of the back prevents the figure from having a rigid posture. Another thing that helps the posture is the neck, which should tilt forward instead of going straight up and down.

THE SEXY GAL

HEAD: FRONT VIEW

The basic proportions for the female head are the same as those for a man, but the outline of the face is softened and the features are different: The eyes are almond shaped, with long lashes, and they rise up at the ends. The eyebrows are thin and curved. The nose is more delicate and has tiny nostrils. The lips are small but full, whereas male lips are drawn as a simple line. And she requires a well-constructed hairstyle, whereas male hair can be messy and carefree.

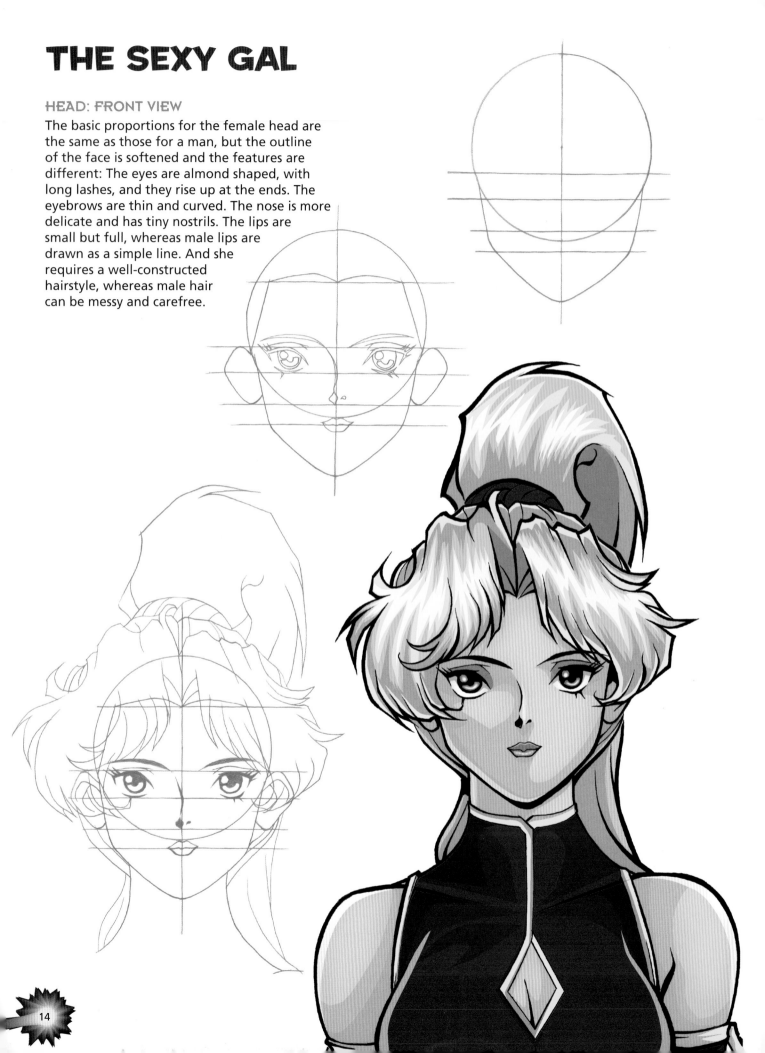

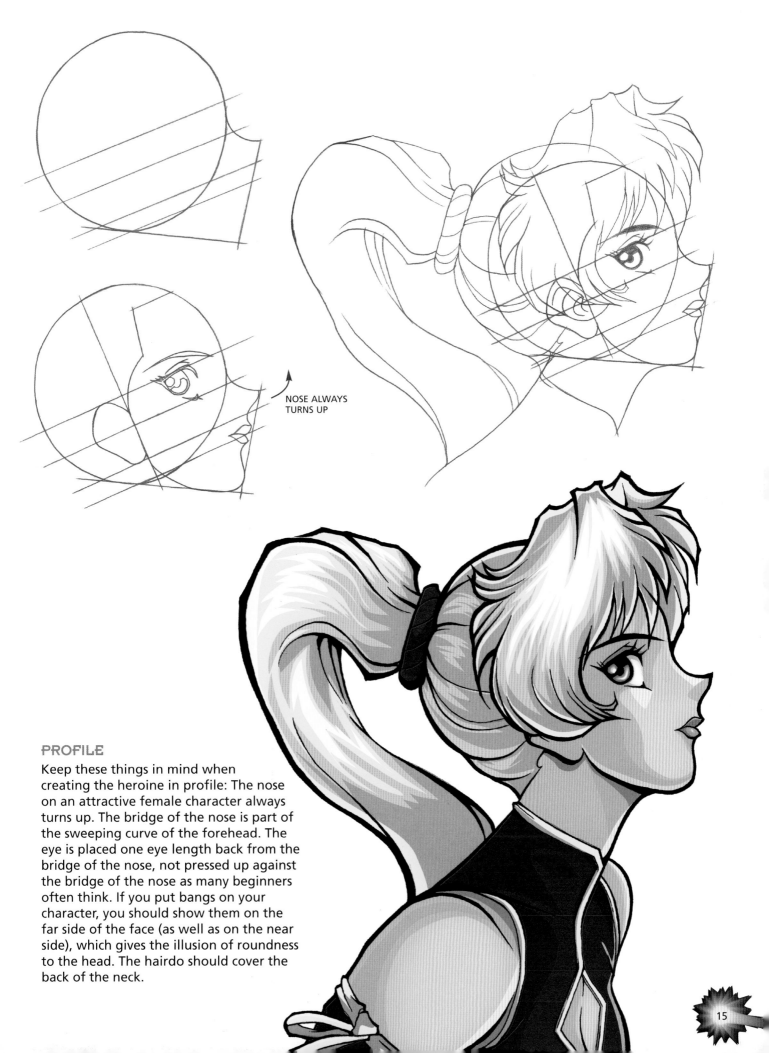

NOSE ALWAYS
TURNS UP

PROFILE

Keep these things in mind when creating the heroine in profile: The nose on an attractive female character always turns up. The bridge of the nose is part of the sweeping curve of the forehead. The eye is placed one eye length back from the bridge of the nose, not pressed up against the bridge of the nose as many beginners often think. If you put bangs on your character, you should show them on the far side of the face (as well as on the near side), which gives the illusion of roundness to the head. The hairdo should cover the back of the neck.

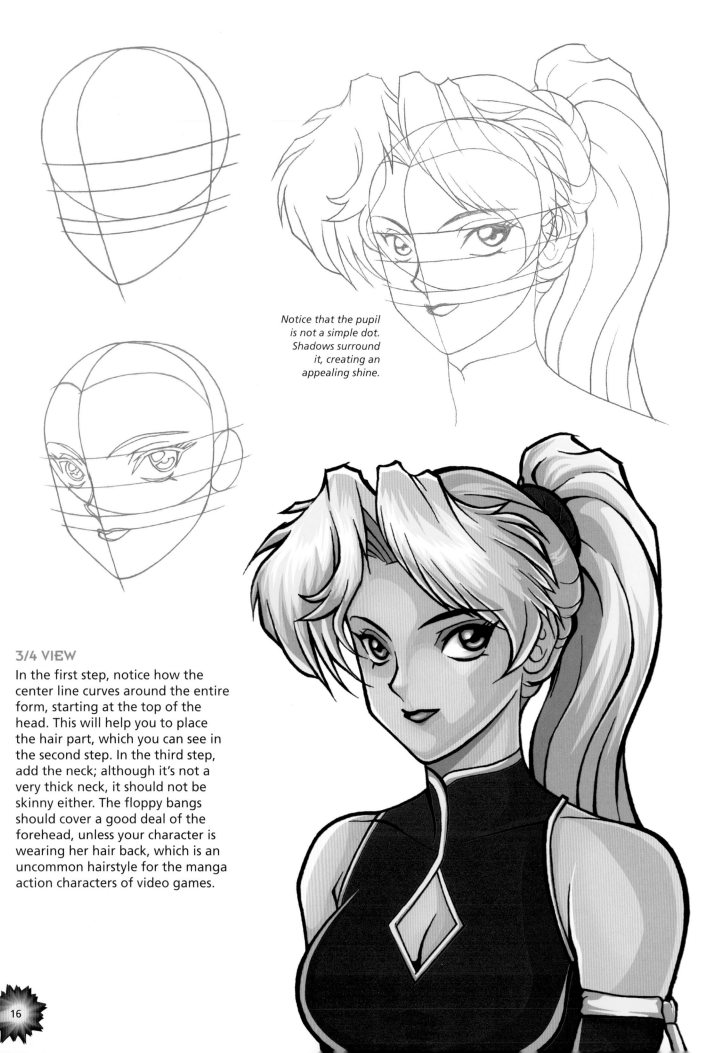

Notice that the pupil is not a simple dot. Shadows surround it, creating an appealing shine.

3/4 VIEW

In the first step, notice how the center line curves around the entire form, starting at the top of the head. This will help you to place the hair part, which you can see in the second step. In the third step, add the neck; although it's not a very thick neck, it should not be skinny either. The floppy bangs should cover a good deal of the forehead, unless your character is wearing her hair back, which is an uncommon hairstyle for the manga action characters of video games.

BODY: FRONT VIEW

On a woman's body, the narrowest part of the waist occurs higher up than it does on a man. The collarbone provides a straight level for the shoulders; therefore, the shoulders never slouch. They should also be somewhat muscular. The hips are wide, but only at the lowest point, near the thighs. Some beginning artists draw female arms as narrow, straight lines. However, female video characters should have athletically muscular arms. The difference is that a woman's muscles don't bunch or bulge like those of a man; women's muscles are long and sinewy. Draw full thighs, not skinny ones like the kind you see on anorexic fashion models.

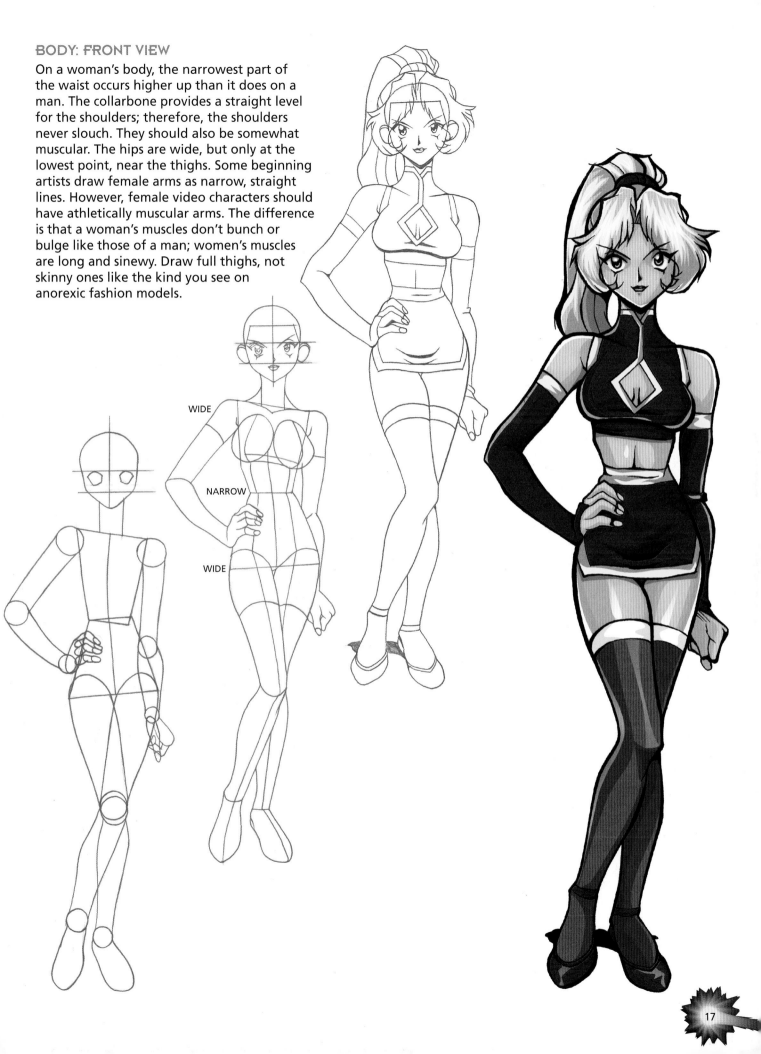

WIDE

NARROW

WIDE

SIDE VIEW

In this pose, the rib cage is quite articulated. If you look at the front of the torso in the final drawing, you'll see that the stomach goes in where the rib cage leaves off. The more severe the curve of the back, the more sexual the pose will be since the curve pushes the chest up while lifting the glutes (the gluteus muscles in the buttocks). In addition, a slight downward tilt of the head gives a female character an alluring look. (You can see that the head is tilting forward by looking at the angle of the center line in the first construction drawing.)

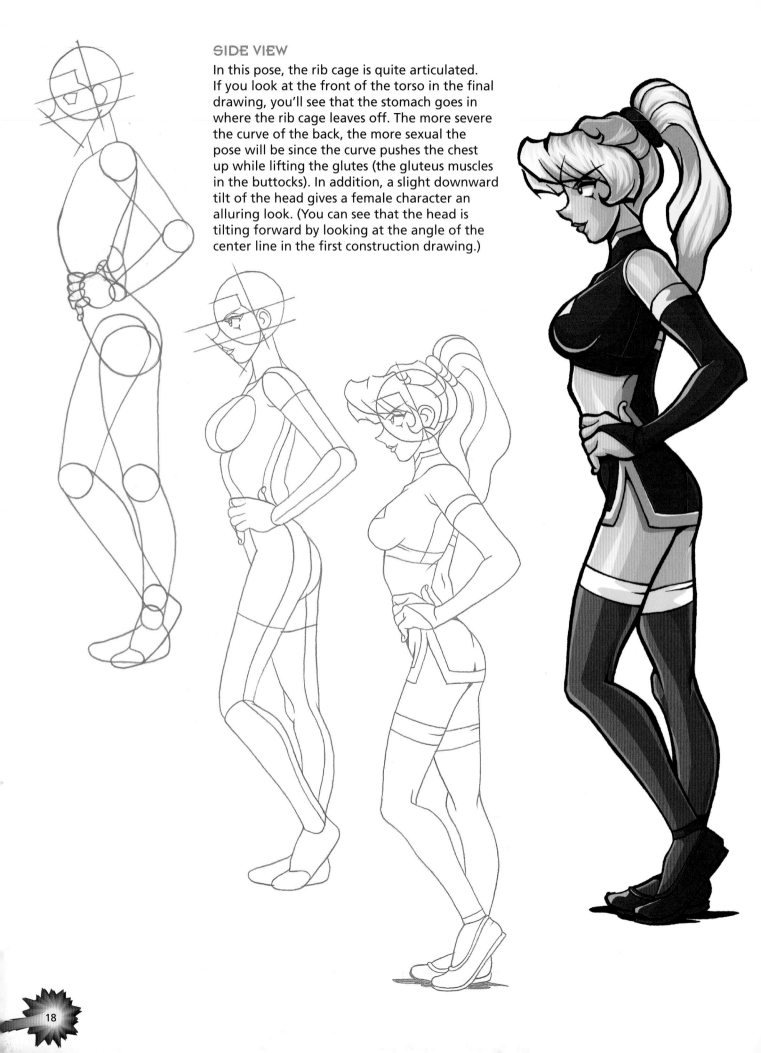

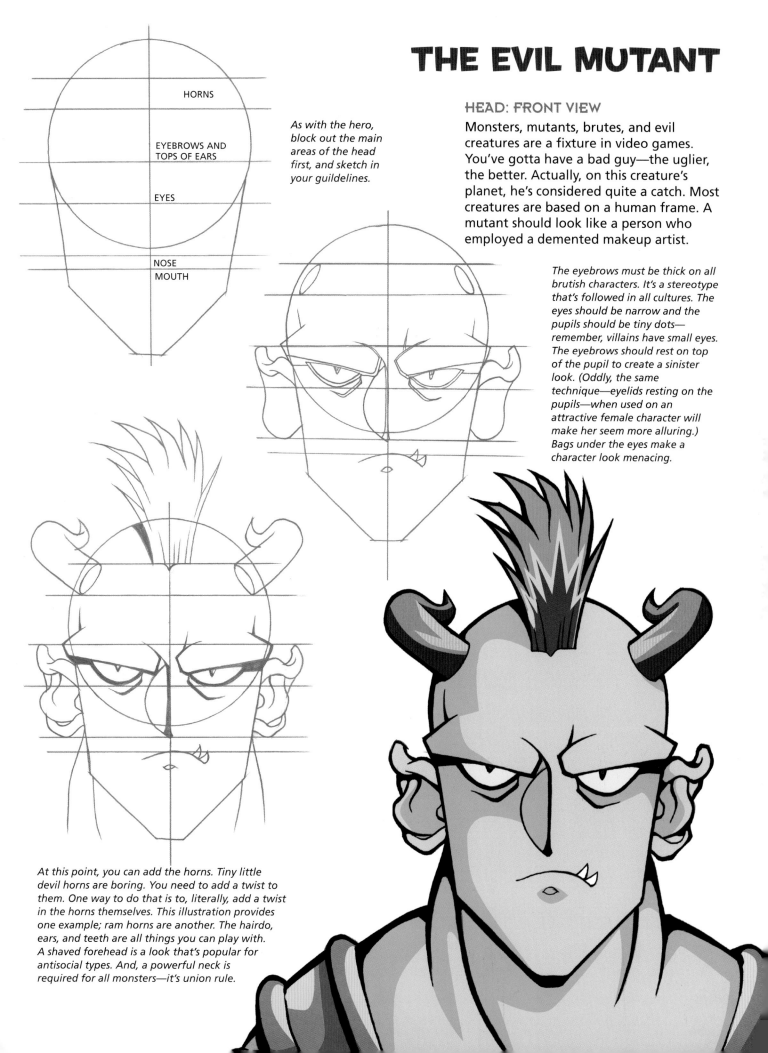

THE EVIL MUTANT

HEAD: FRONT VIEW

Monsters, mutants, brutes, and evil creatures are a fixture in video games. You've gotta have a bad guy—the uglier, the better. Actually, on this creature's planet, he's considered quite a catch. Most creatures are based on a human frame. A mutant should look like a person who employed a demented makeup artist.

The eyebrows must be thick on all brutish characters. It's a stereotype that's followed in all cultures. The eyes should be narrow and the pupils should be tiny dots—remember, villains have small eyes. The eyebrows should rest on top of the pupil to create a sinister look. (Oddly, the same technique—eyelids resting on the pupils—when used on an attractive female character will make her seem more alluring.) Bags under the eyes make a character look menacing.

HORNS

EYEBROWS AND TOPS OF EARS

EYES

NOSE

MOUTH

As with the hero, block out the main areas of the head first, and sketch in your guildelines.

At this point, you can add the horns. Tiny little devil horns are boring. You need to add a twist to them. One way to do that is to, literally, add a twist in the horns themselves. This illustration provides one example; ram horns are another. The hairdo, ears, and teeth are all things you can play with. A shaved forehead is a look that's popular for antisocial types. And, a powerful neck is required for all monsters—it's union rule.

PROFILE

Since this evil mutant's eyes are so beady and narrow, you should place them close to the bridge of the nose in the profile view; on characters with large eyes, the eye is placed further back in the profile (see page 15). The nose is pointy and narrow. From this angle, you can really see the thickness of the neck.

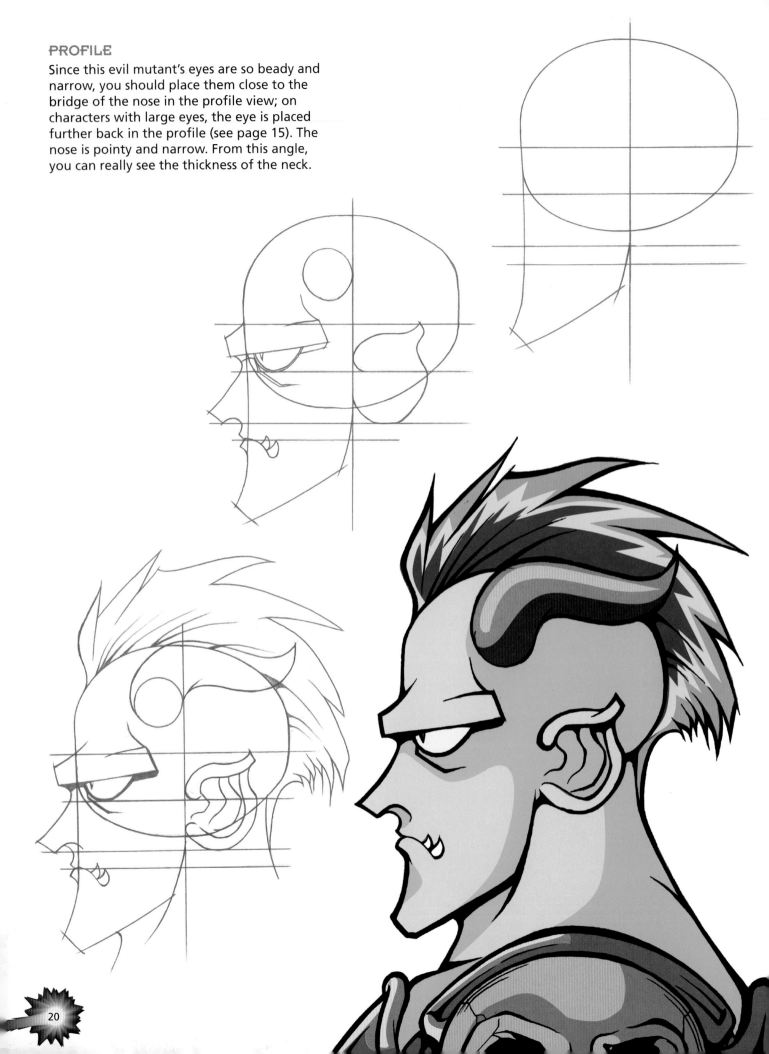

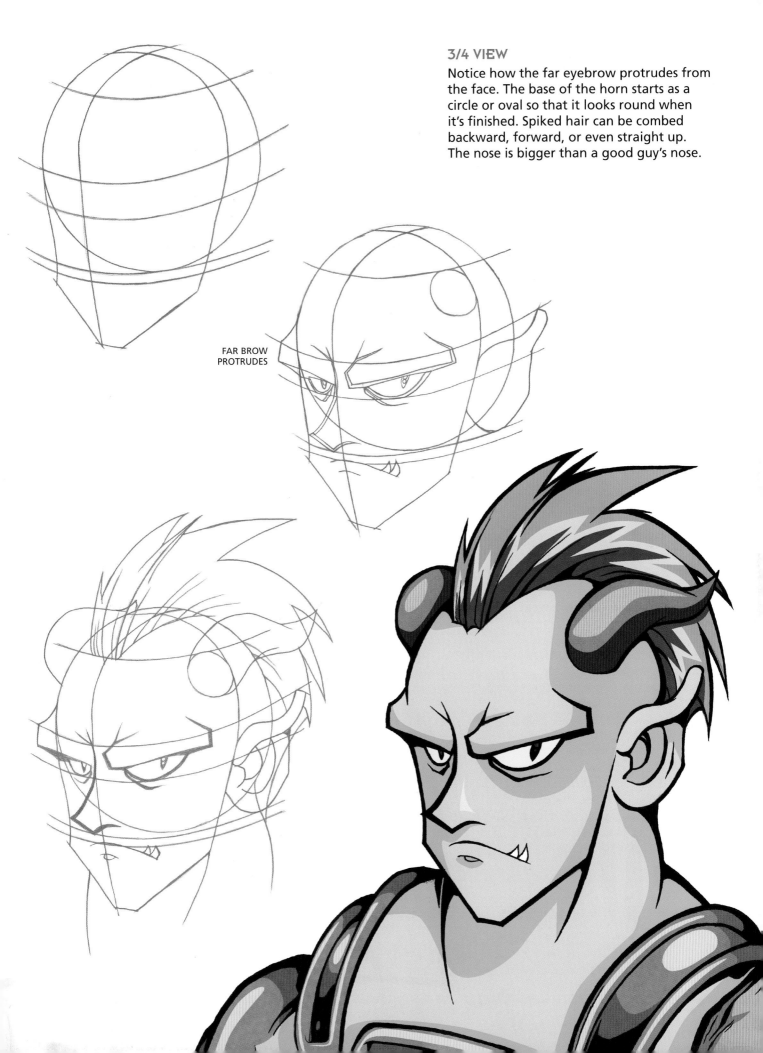

3/4 VIEW

Notice how the far eyebrow protrudes from the face. The base of the horn starts as a circle or oval so that it looks round when it's finished. Spiked hair can be combed backward, forward, or even straight up. The nose is bigger than a good guy's nose.

FAR BROW
PROTRUDES

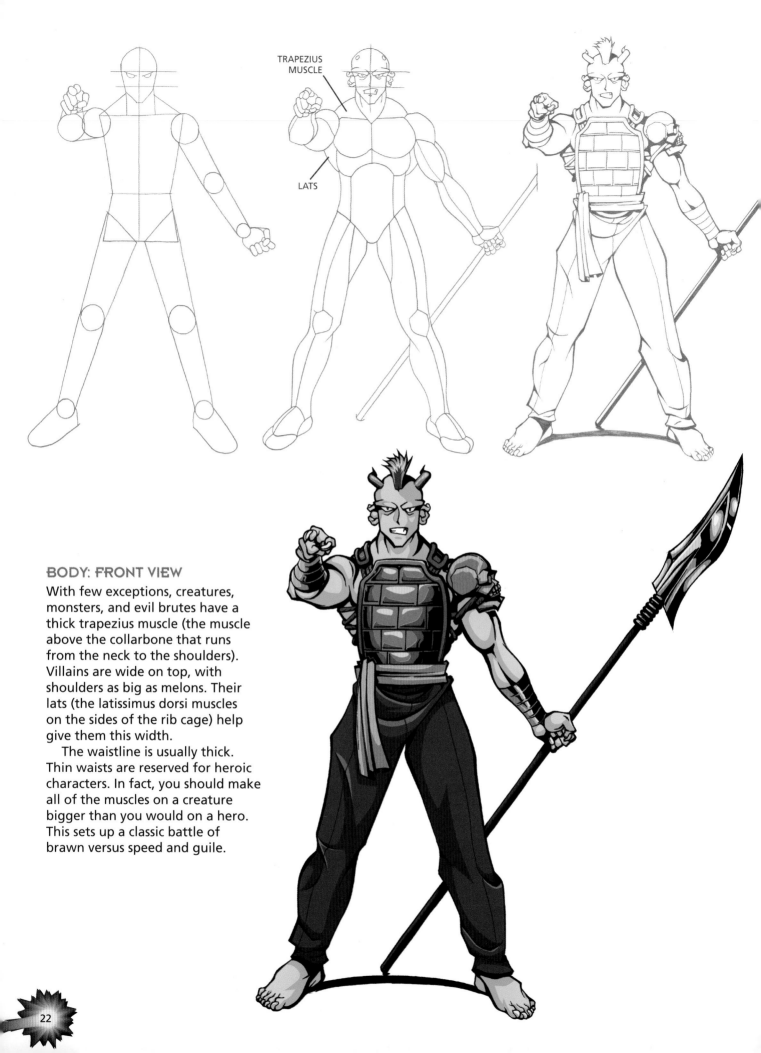

TRAPEZIUS MUSCLE

LATS

BODY: FRONT VIEW

With few exceptions, creatures, monsters, and evil brutes have a thick trapezius muscle (the muscle above the collarbone that runs from the neck to the shoulders). Villains are wide on top, with shoulders as big as melons. Their lats (the latissimus dorsi muscles on the sides of the rib cage) help give them this width.

The waistline is usually thick. Thin waists are reserved for heroic characters. In fact, you should make all of the muscles on a creature bigger than you would on a hero. This sets up a classic battle of brawn versus speed and guile.

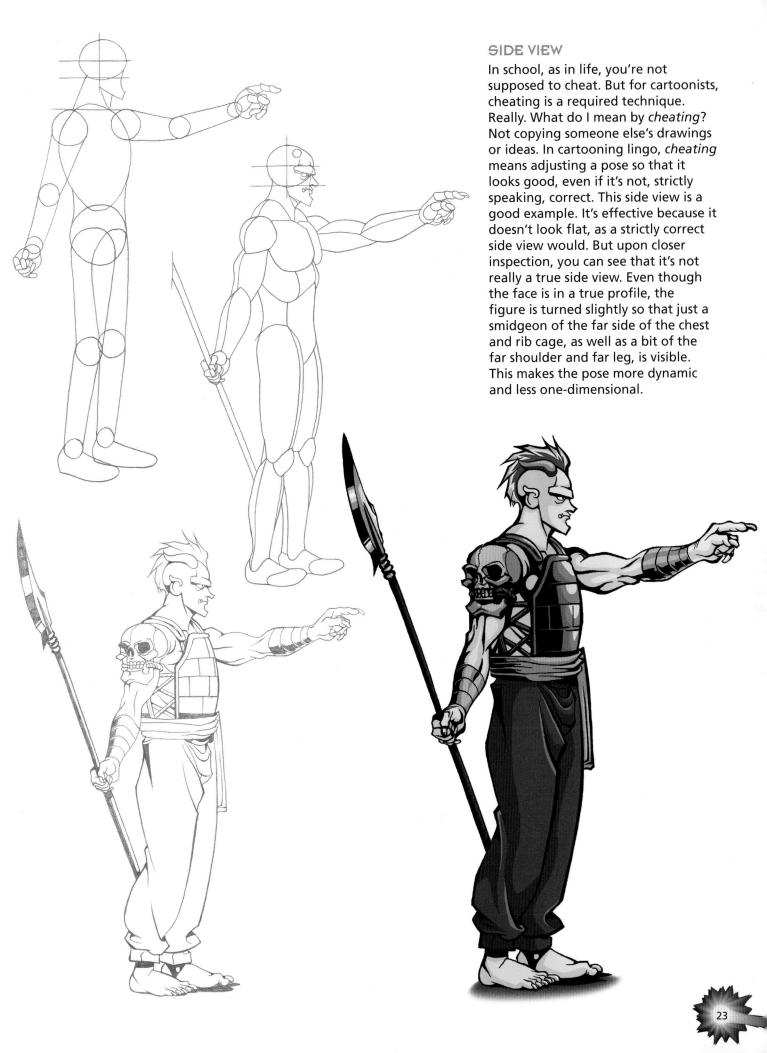

SIDE VIEW

In school, as in life, you're not supposed to cheat. But for cartoonists, cheating is a required technique. Really. What do I mean by *cheating*? Not copying someone else's drawings or ideas. In cartooning lingo, *cheating* means adjusting a pose so that it looks good, even if it's not, strictly speaking, correct. This side view is a good example. It's effective because it doesn't look flat, as a strictly correct side view would. But upon closer inspection, you can see that it's not really a true side view. Even though the face is in a true profile, the figure is turned slightly so that just a smidgeon of the far side of the chest and rib cage, as well as a bit of the far shoulder and far leg, is visible. This makes the pose more dynamic and less one-dimensional.

23

A BRIEF ANATOMY LESSON

Showy muscles are a must for video game characters. It's also important to be familiar with the placement and shape of the muscles, for basic drawing. Even when characters have costumes covering them, sleeves will bunch up in action poses, for example, or will be omitted entirely, revealing the arms. Costumes often reveal the legs. So, knowing how to draw the muscles will help in all of these circumstances.

There are literally hundreds of different muscles in the human body, but we're only interested in the showy muscles, the big muscles, and the muscles that contribute to the shapes of the body parts.

HERO MUSCLE CHART: FRONT AND BACK

1. trapezius
2. deltoids
3. serratus anterior
4. obliquus externus (fam. external oblique)
5. rectus abdominis
6. pectoralis major
7. teres major
8. infraspinatus
9. latissimus dorsi
10. trapezius
11. triceps
12. biceps
13. brachioradialis
14. flexor digitorum

MUTANT MUSCLE CHART: FRONT AND BACK

1. sternocleidomastoideus
2. rectus femoris
3. sartorius
4. vastus lateralis
5. vastus medialis
6. gastrocnemius
7. peroneus longus
8. semitendinosus
9. biceps femoris

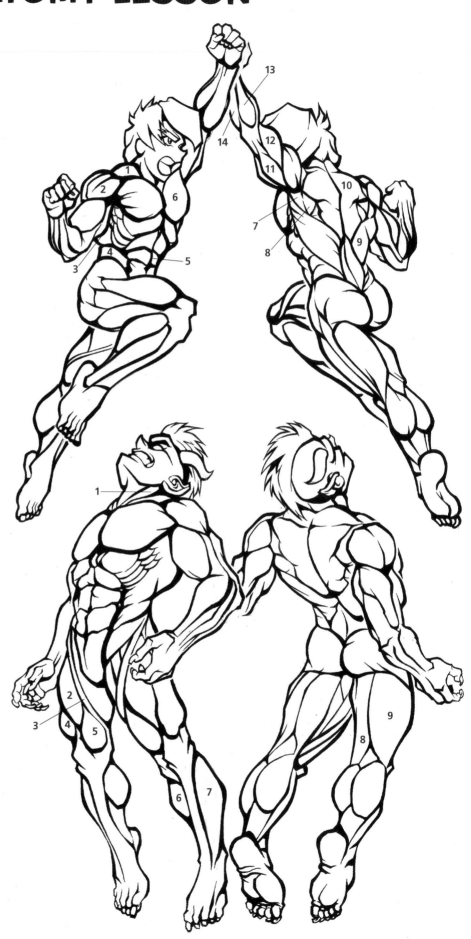

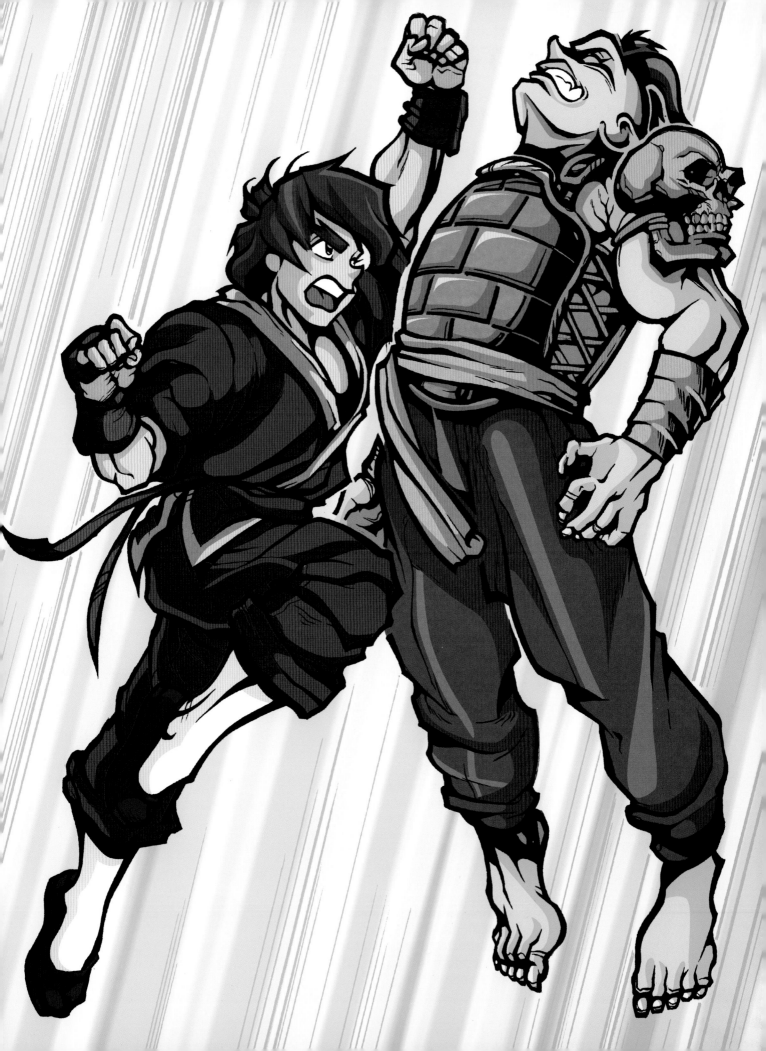

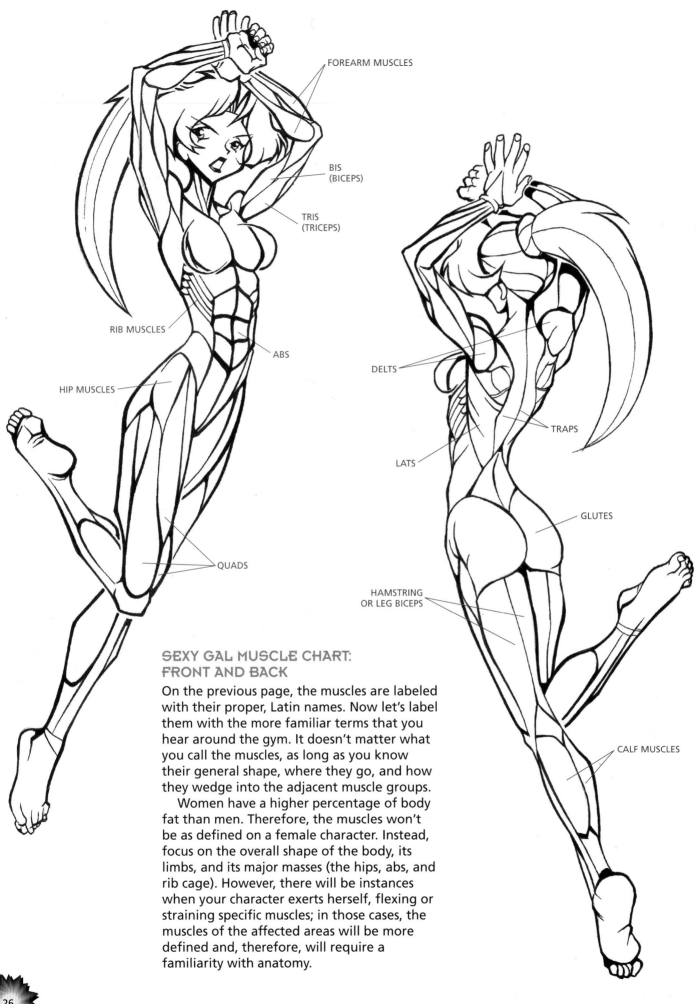

FOREARM MUSCLES

BIS
(BICEPS)

TRIS
(TRICEPS)

RIB MUSCLES

ABS

HIP MUSCLES

QUADS

DELTS

TRAPS

LATS

GLUTES

HAMSTRING
OR LEG BICEPS

CALF MUSCLES

SEXY GAL MUSCLE CHART: FRONT AND BACK

On the previous page, the muscles are labeled with their proper, Latin names. Now let's label them with the more familiar terms that you hear around the gym. It doesn't matter what you call the muscles, as long as you know their general shape, where they go, and how they wedge into the adjacent muscle groups.

Women have a higher percentage of body fat than men. Therefore, the muscles won't be as defined on a female character. Instead, focus on the overall shape of the body, its limbs, and its major masses (the hips, abs, and rib cage). However, there will be instances when your character exerts herself, flexing or straining specific muscles; in those cases, the muscles of the affected areas will be more defined and, therefore, will require a familiarity with anatomy.

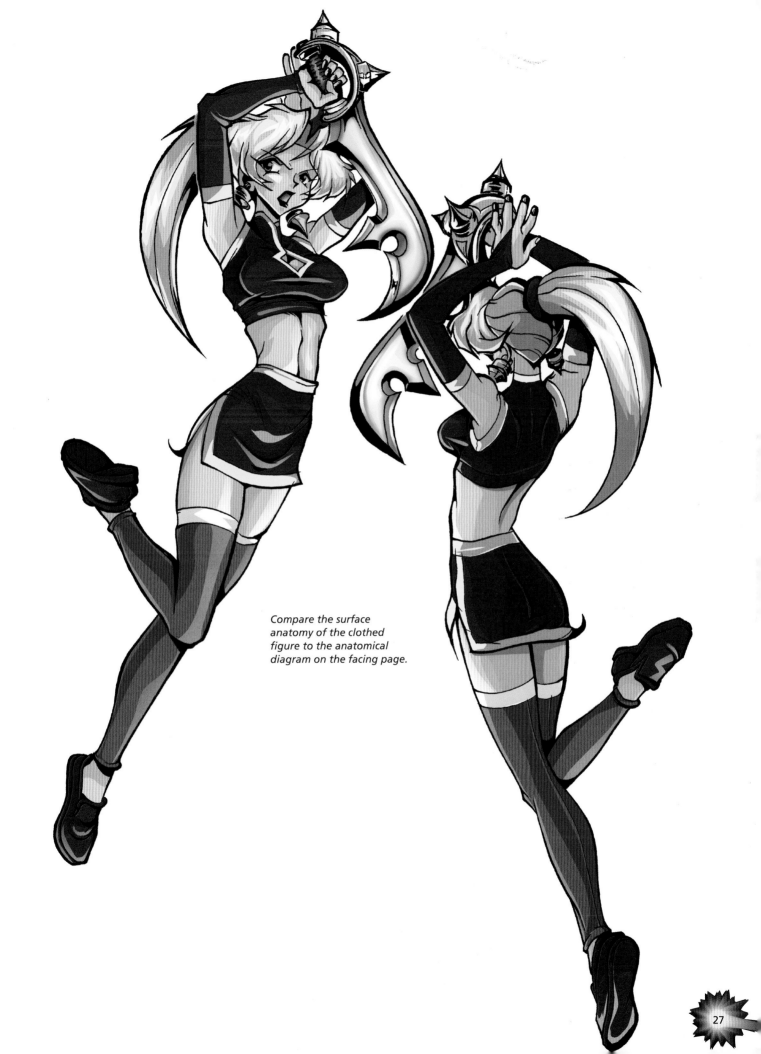

Compare the surface anatomy of the clothed figure to the anatomical diagram on the facing page.

Other POPULAR VIDEO GAME CHARACTERS

Only the coolest characters get to star in video games. They can't be ordinary, otherwise who would want to assume their identities and control their moves? And since characters are often placed in visually stimulating environments, they have to stand out. We've covered the three basic character types already, but there are many more supporting players. And despite their differences, they all have the following two traits in common: charisma and a cool costume. Characters with charisma have good expressions along with body language that communicates their personality. Successful costumes are ones that convey the role and personality of the character.

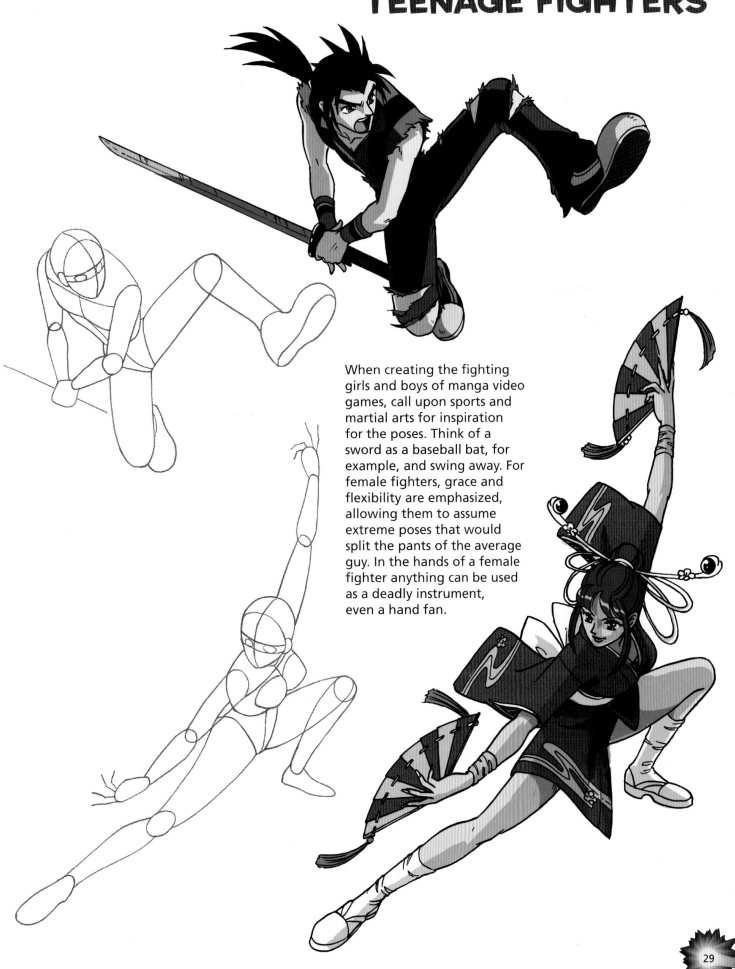

When creating the fighting girls and boys of manga video games, call upon sports and martial arts for inspiration for the poses. Think of a sword as a baseball bat, for example, and swing away. For female fighters, grace and flexibility are emphasized, allowing them to assume extreme poses that would split the pants of the average guy. In the hands of a female fighter anything can be used as a deadly instrument, even a hand fan.

PUNK

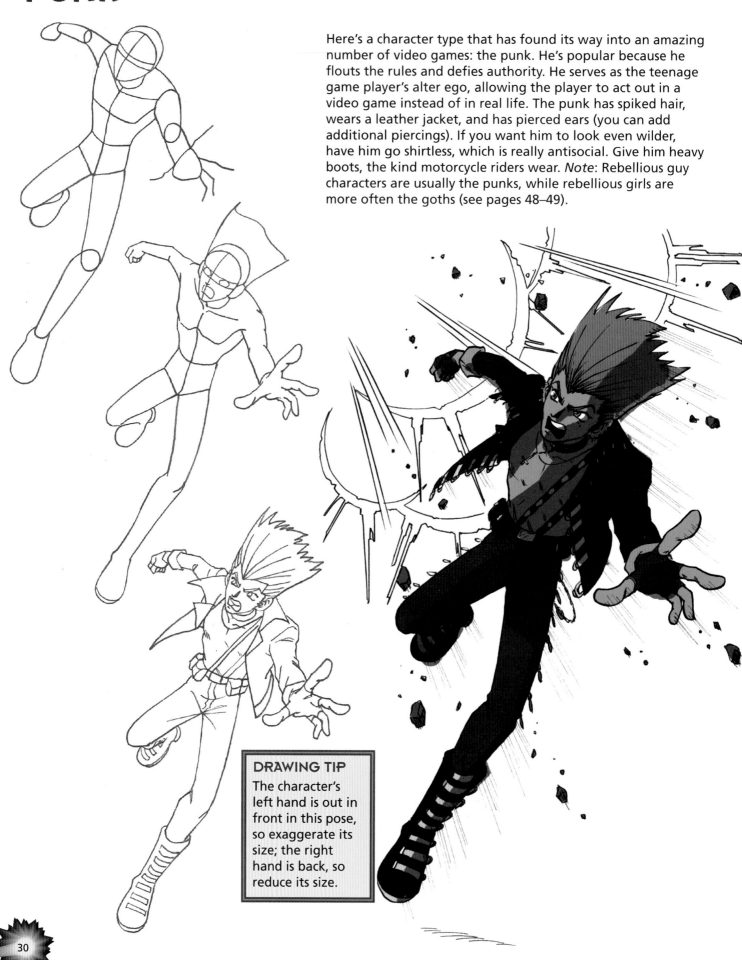

Here's a character type that has found its way into an amazing number of video games: the punk. He's popular because he flouts the rules and defies authority. He serves as the teenage game player's alter ego, allowing the player to act out in a video game instead of in real life. The punk has spiked hair, wears a leather jacket, and has pierced ears (you can add additional piercings). If you want him to look even wilder, have him go shirtless, which is really antisocial. Give him heavy boots, the kind motorcycle riders wear. *Note*: Rebellious guy characters are usually the punks, while rebellious girls are more often the goths (see pages 48–49).

DRAWING TIP
The character's left hand is out in front in this pose, so exaggerate its size; the right hand is back, so reduce its size.

SEXY SPY

Don't let yourself be mesmerized by her beauty—that could be a deadly mistake. With looks that could kill, and often do, this spy is an expert at tracking and vanquishing her enemies. She must be attractive, her body designed with appealing curves. She needs to be designed with a highly athletic build so that she can turn at a moment's notice and counterfire at her opponents, who will continually surprise her during the course of a video game. She sports a cool hairstyle and only the trendiest of clothes (read: futuristic). The outfit is typical for an edgy, sexy character: a miniskirt and a top that's cut to show off the torso. She could also wear a full bodysuit that would be so tight it would look painted on. She doesn't require lots of firepower; she can usually hit her mark with the first shot.

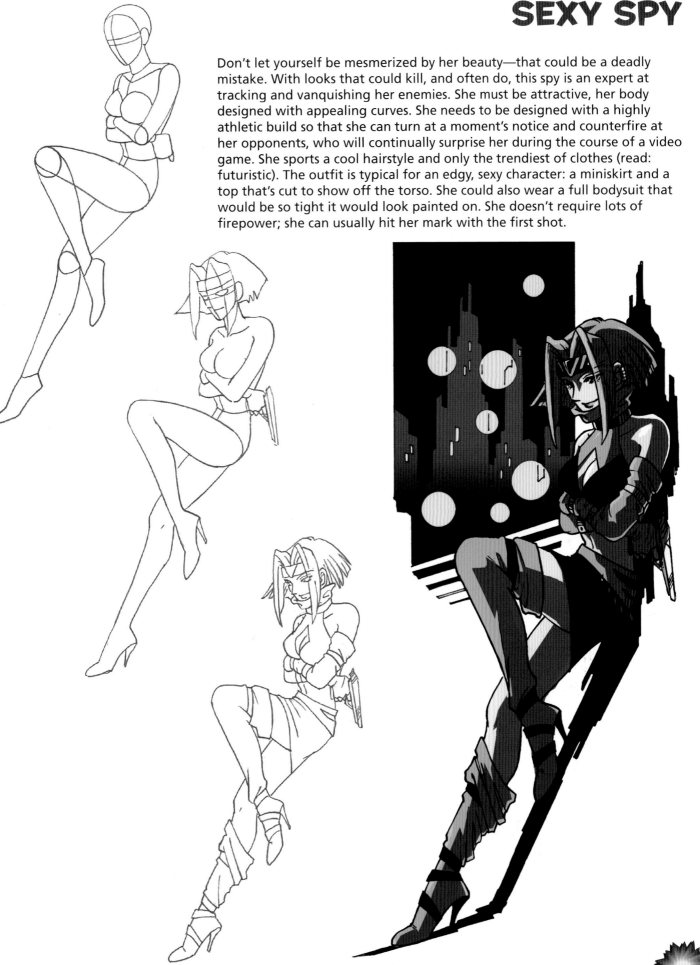

FREAK

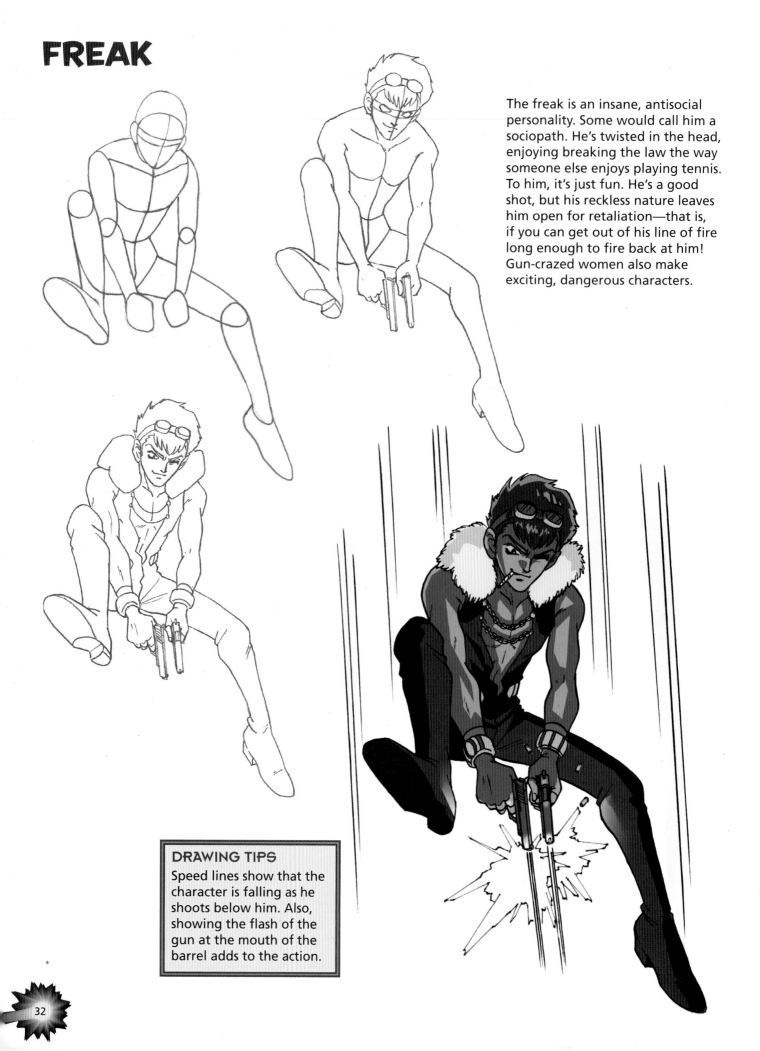

The freak is an insane, antisocial personality. Some would call him a sociopath. He's twisted in the head, enjoying breaking the law the way someone else enjoys playing tennis. To him, it's just fun. He's a good shot, but his reckless nature leaves him open for retaliation—that is, if you can get out of his line of fire long enough to fire back at him! Gun-crazed women also make exciting, dangerous characters.

DRAWING TIPS
Speed lines show that the character is falling as he shoots below him. Also, showing the flash of the gun at the mouth of the barrel adds to the action.

MAGICAL GIRL

The magical girl is an extremely popular character type. Her mere presence in a video game turns the story into one of fantasy and adventure. She's usually around fourteen years of age, pretty, with long, flowing hair and a short, pleated skirt (as part of her school uniform). The face is young, and the eyes are large. She possesses magical powers to transform herself into someone else. Often, she'll have a cute mascot as a companion/helper; make the mascot cute and furry.

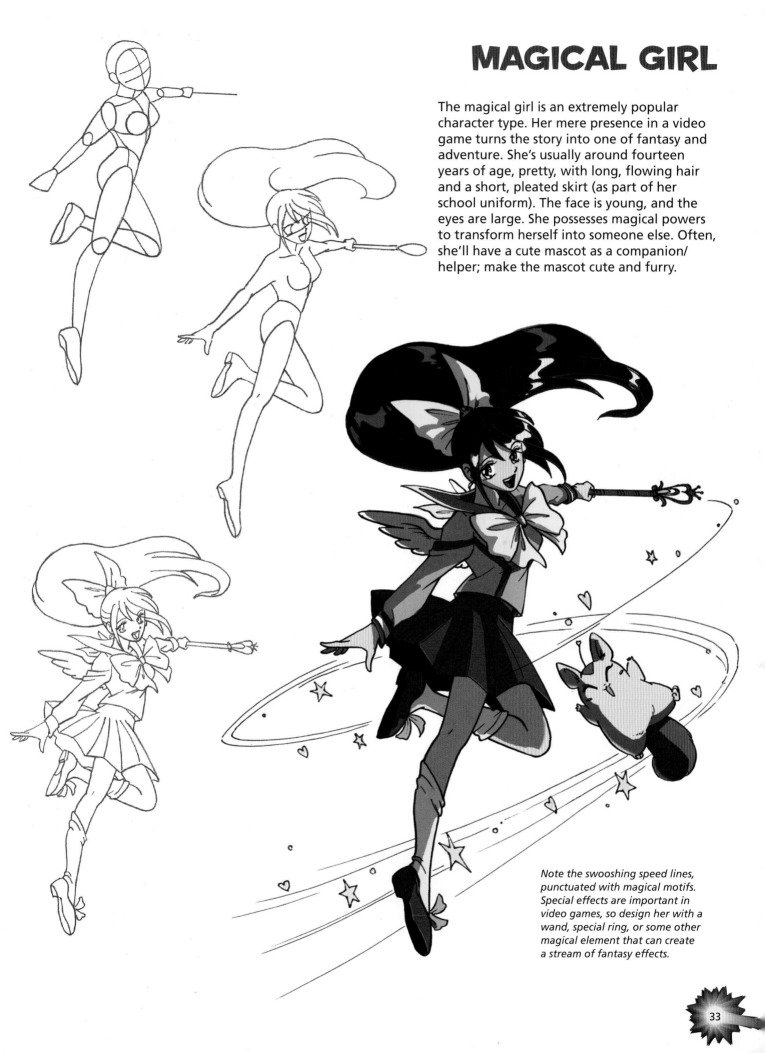

Note the swooshing speed lines, punctuated with magical motifs. Special effects are important in video games, so design her with a wand, special ring, or some other magical element that can create a stream of fantasy effects.

33

EVIL SAMURAI

His blade is his weapon. And he's fast, plenty fast. In video games, this type of character can twirl his sword like a baton as he advances on his opponent.

Historically, samurai trace their roots back to feudal Japan, and they are popular characters, like their European equivalents, knights in armor. Samurai worked for the emperor and were on the side of good. However, when samurai lost their masters, they would function independently and were then known as *ronin*. They had the same devastating fighting abilities as they did when they were operating as good samurai but no moral creed to follow, making them dangerous, skilled warriors.

To create an evil samurai, give him a bony appearance and long fingernails. He should also have sinister, bushy eyebrows as well as stringy hair and a stringy goatee.

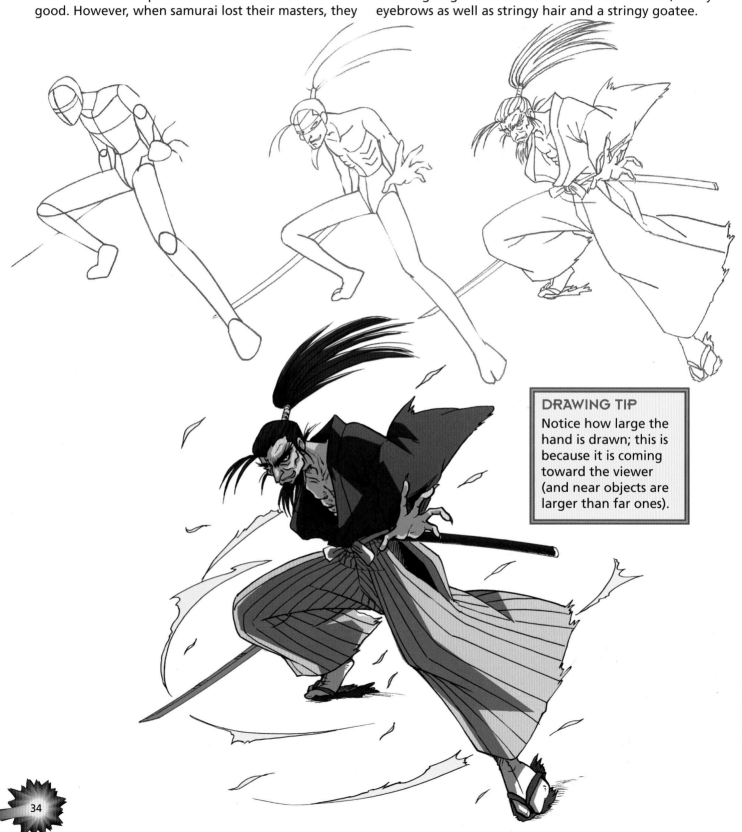

> **DRAWING TIP**
> Notice how large the hand is drawn; this is because it is coming toward the viewer (and near objects are larger than far ones).

BRAWNY CHARACTER

You always need someone to play the heavy. Big, brawny strongmen are popular types. If your hero can whip the biggest, baddest guy, then he must be pretty good. The brawny character is powerful but slow; that's his one weakness. You can't beat brawny characters with strength, but you can outmaneuver them, which is still easier said than done. Smaller characters have to use even more aggressive fighting tactics, such as throwing three punches for every one punch thrown by the bigger man. Also use leaps and jumps to confuse brawny characters, then attack them from the rear.

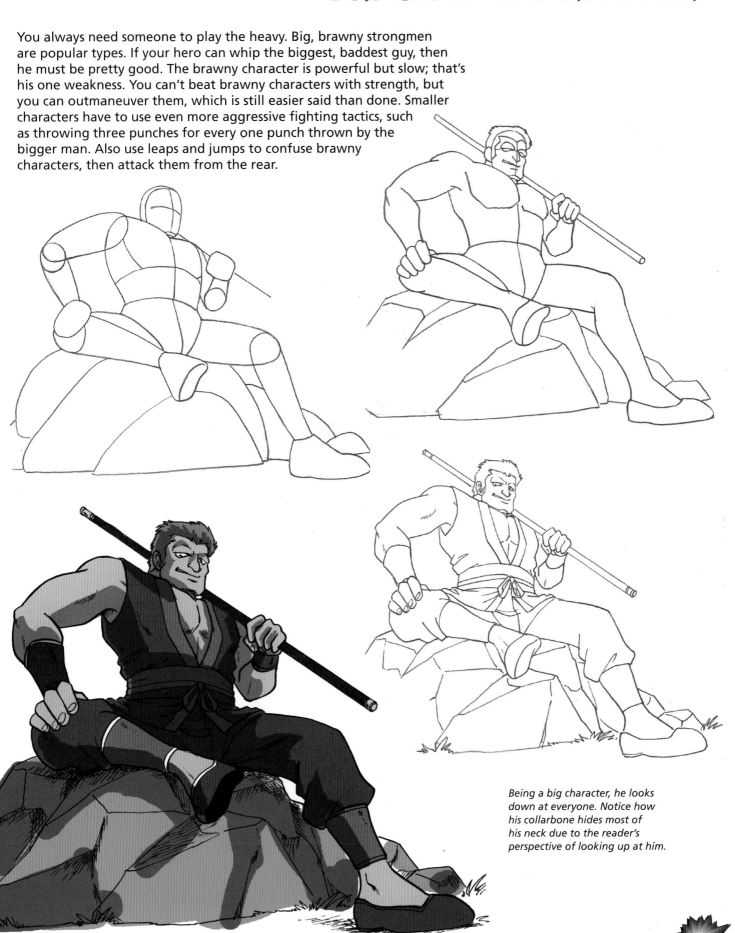

Being a big character, he looks down at everyone. Notice how his collarbone hides most of his neck due to the reader's perspective of looking up at him.

35

INDEPENDENT TEEN FIGHTER

This character's a real classic—a teenager with an average build who is sent to fight a huge, intimidating opponent. His ragtag costume shows that he's not part of an organized fighting force; he's on his own. He makes up for his slight stature by assuming athletic, action-packed poses. His facial expression is usually fierce and determined; he has the courage of men twice his size!

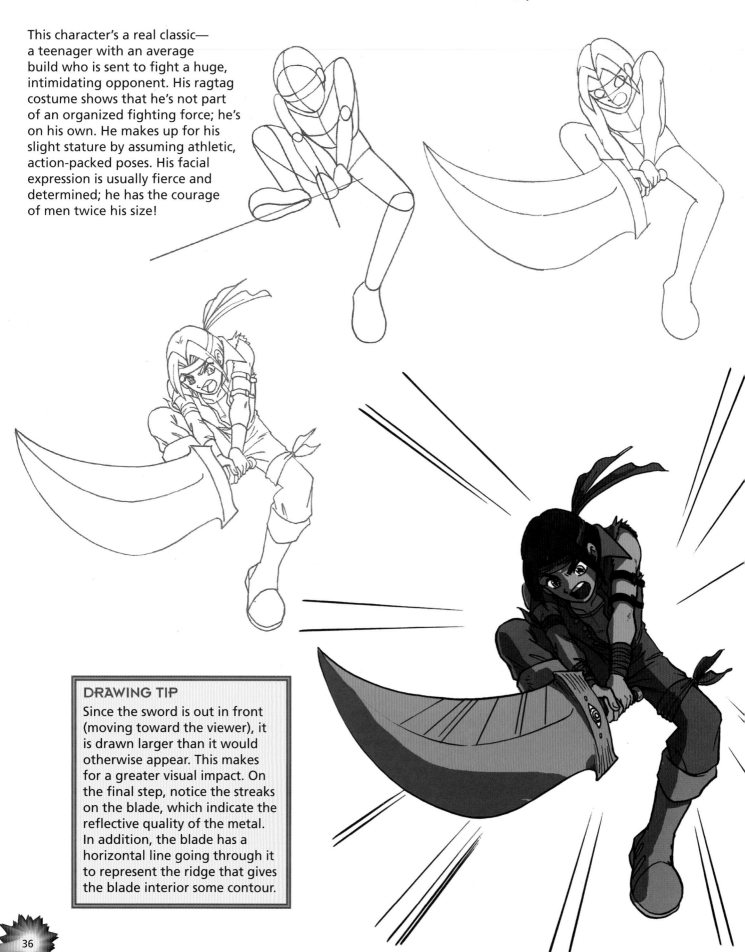

DRAWING TIP
Since the sword is out in front (moving toward the viewer), it is drawn larger than it would otherwise appear. This makes for a greater visual impact. On the final step, notice the streaks on the blade, which indicate the reflective quality of the metal. In addition, the blade has a horizontal line going through it to represent the ridge that gives the blade interior some contour.

MECHA-CLAD FIGHTER

This character is drawn in the shounen style. *Shounen* is a Japanese term that refers to the action-packed adventure comics that boys like. Often, these take place in a militaristic future, set in space and on Earth, where forces from another world are trying to overtake our planet. Don't let them do it!

When drawing mecha outfits, always rough out the underlying figure first to establish the pose. Then build the armor onto it. Divide the armor into sections, with smaller, but bulkier, guards covering the moveable joints—such as shoulder, forearm, and elbow guards, and ankle and chest protectors. Good-guy characters, such as this one, are clean-cut with shorter hair.

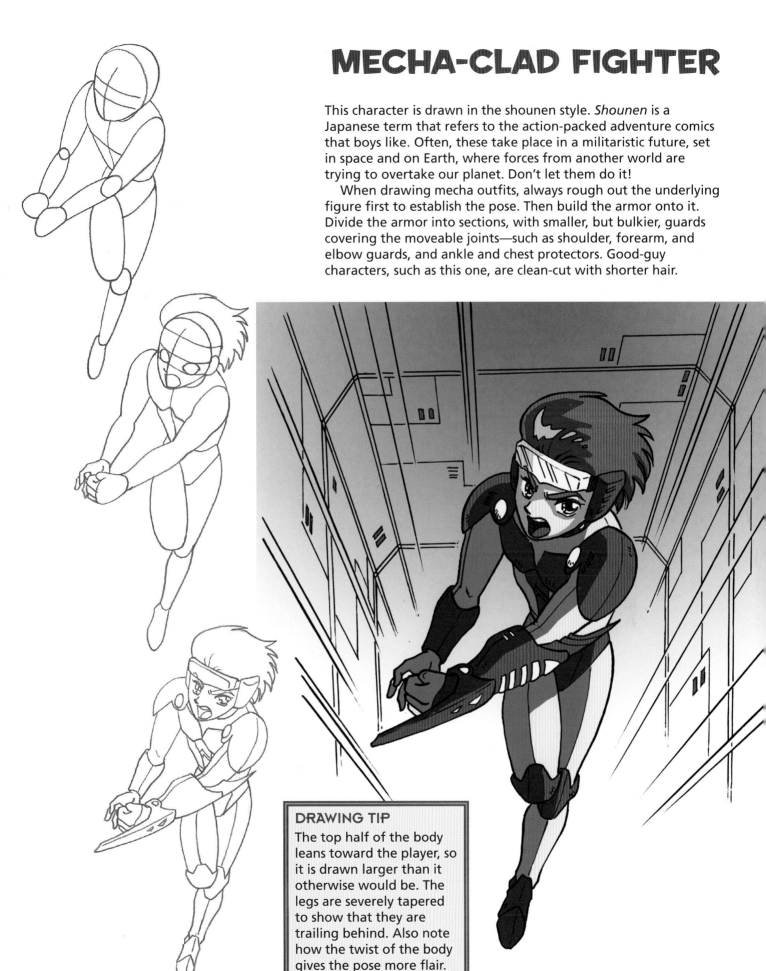

DRAWING TIP

The top half of the body leans toward the player, so it is drawn larger than it otherwise would be. The legs are severely tapered to show that they are trailing behind. Also note how the twist of the body gives the pose more flair.

ANGEL WARRIOR

This type of character is very popular in anime as well as in video games. She has an ethereal quality and is often seen levitating above the ground. She is often surrounded by magical effects. Although she has a serene look, she can be a merciless fighter. And, not all angel warriors are good; some are cruel.

The angel warrior should have extra-long hair that blows in the wind. Give her large, swanlike wings—the larger, the better. Her body is feminine, without heavily defined muscles.

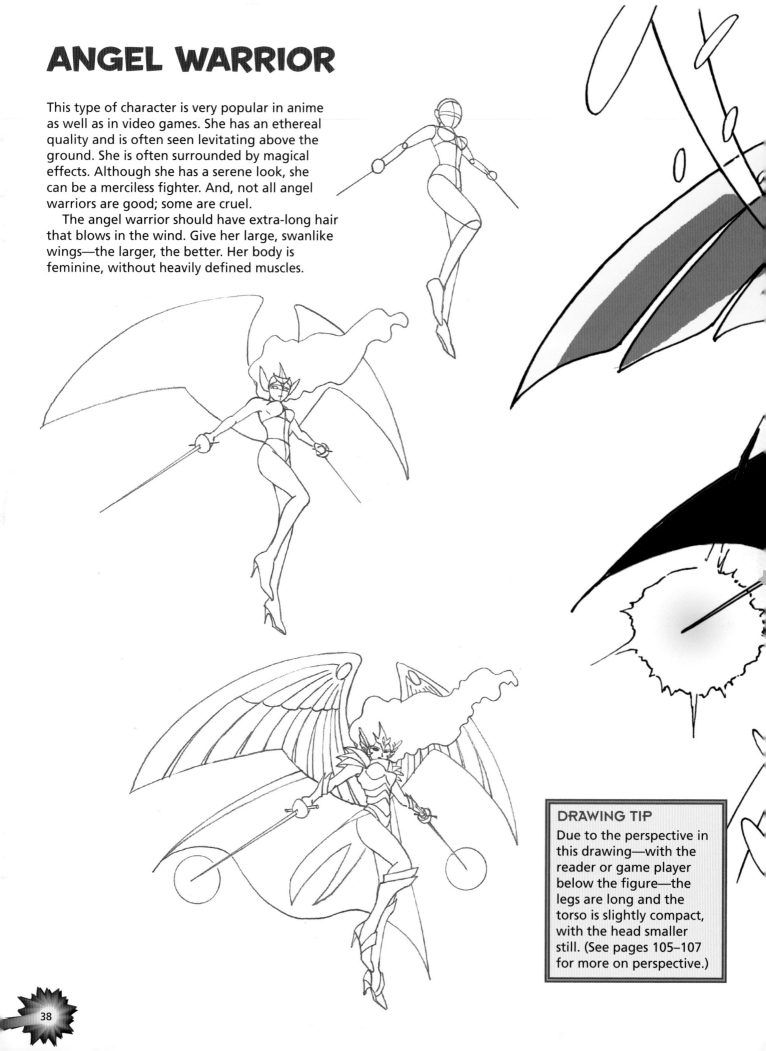

DRAWING TIP
Due to the perspective in this drawing—with the reader or game player below the figure—the legs are long and the torso is slightly compact, with the head smaller still. (See pages 105–107 for more on perspective.)

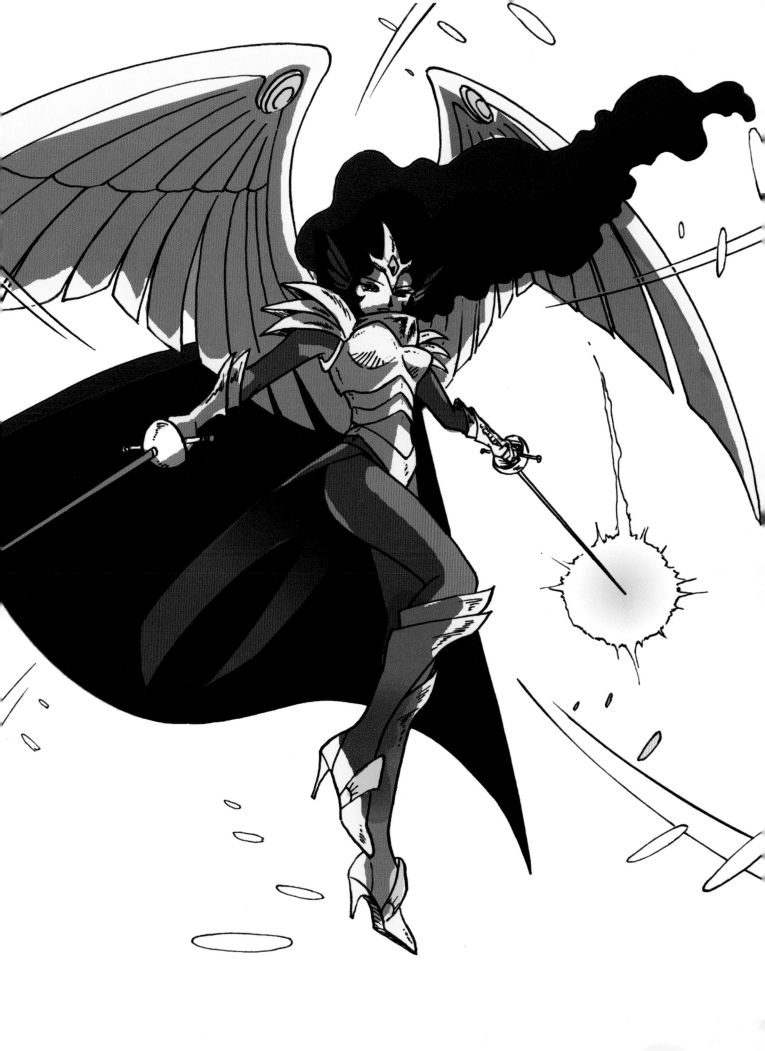

FANTASY FAERIE

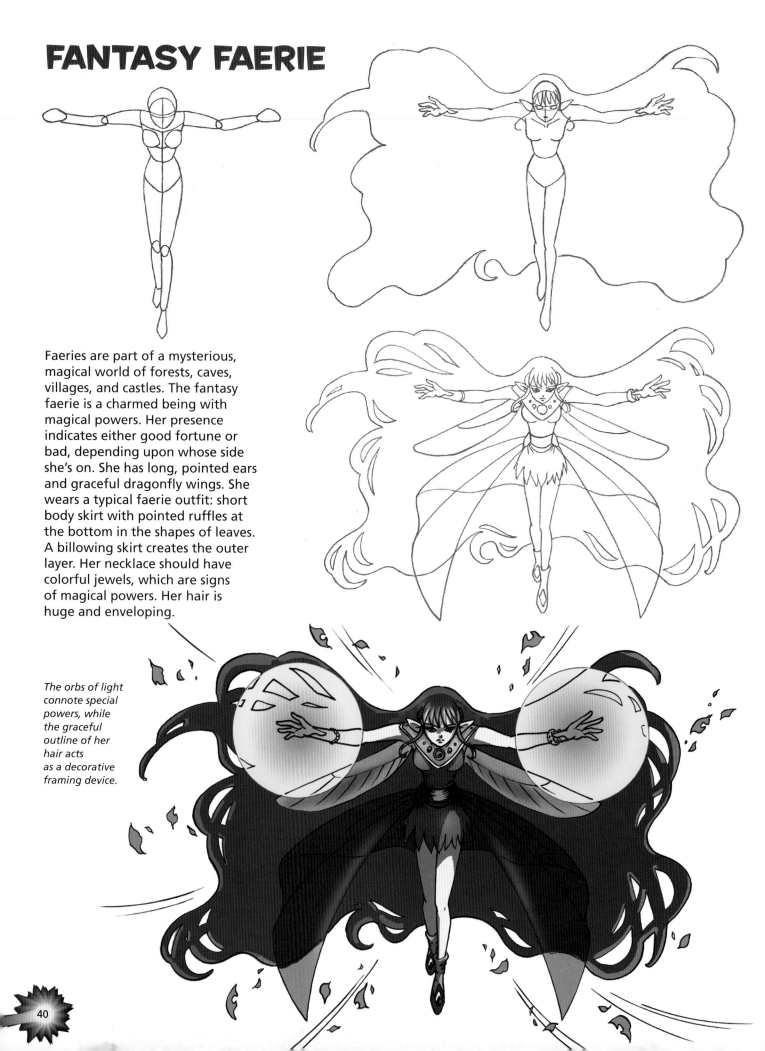

Faeries are part of a mysterious, magical world of forests, caves, villages, and castles. The fantasy faerie is a charmed being with magical powers. Her presence indicates either good fortune or bad, depending upon whose side she's on. She has long, pointed ears and graceful dragonfly wings. She wears a typical faerie outfit: short body skirt with pointed ruffles at the bottom in the shapes of leaves. A billowing skirt creates the outer layer. Her necklace should have colorful jewels, which are signs of magical powers. Her hair is huge and enveloping.

The orbs of light connote special powers, while the graceful outline of her hair acts as a decorative framing device.

SPACE FIGHTER

Base the space fighter costume on the futuristic styling of the high boots and arm-length gloves, which can be armor to protect her during intense video game battle scenes. The rest of the costume is body-hugging spandex. There's often a visor, goggles, an ear piece, or a helmet. Space adventures aren't relegated to space alone. Space fighters often fight in the skies, oceans, or streets of various worlds.

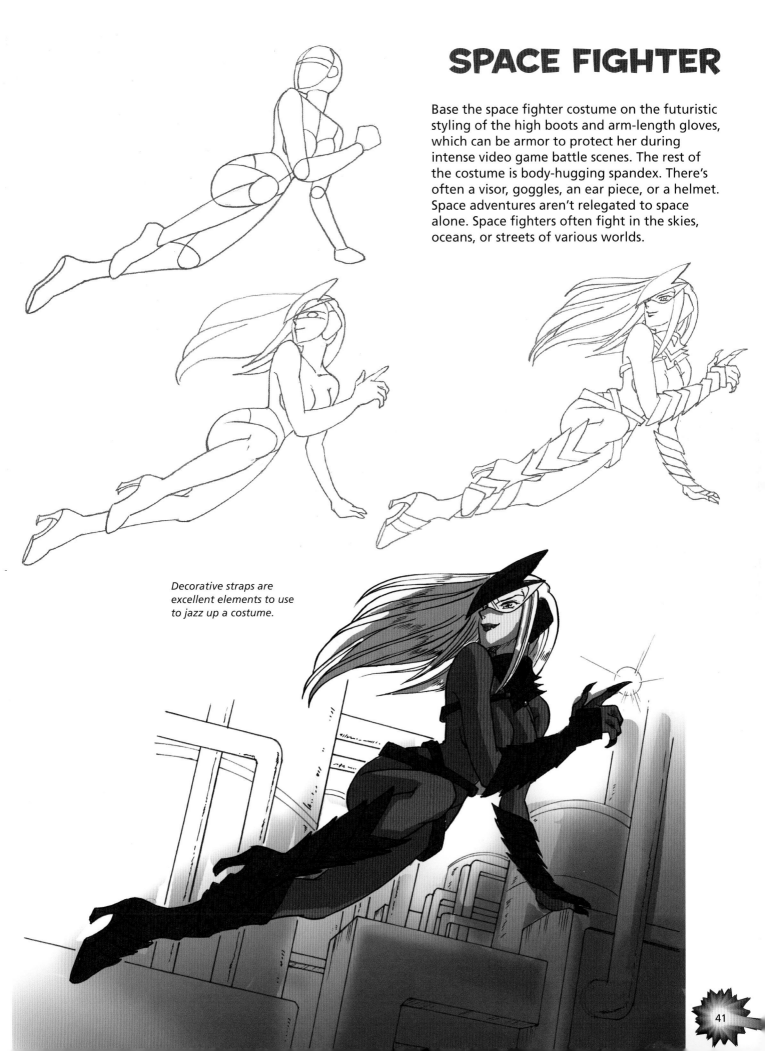

Decorative straps are excellent elements to use to jazz up a costume.

MANGA MUTANT

In American-style comics, mutants are usually gigantic, muscle-bound, partially humanoid creatures. But in manga, quasihuman characters are more often based on animals. For this catlike specimen, even though the body has human anatomy, the entire creature should be furry. It should even retain its claws and tail.

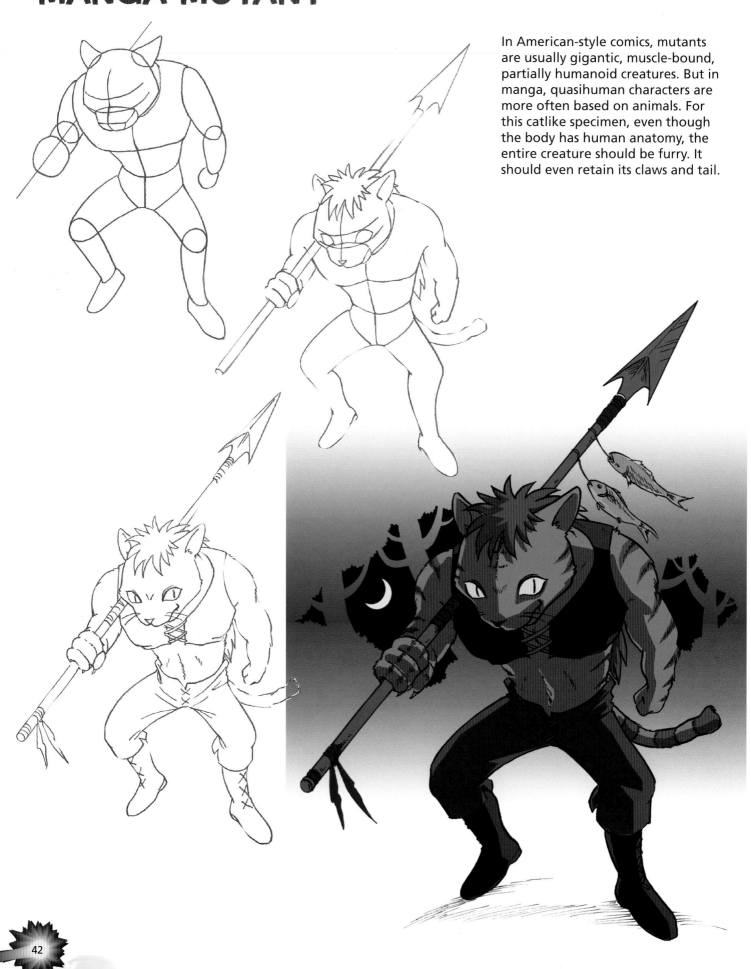

Chibis are favorites in video games and anime. They're curious, fun, and mischievous. They're regular fighting characters, shrunk down to miniature size. But to make them accurate, you have to change their proportions; they don't retain the same proportions as full-sized characters. They also become chubbier and chunkier.

CHIBI PROPORTIONS

The chibi body can be divided into three sections: the head takes up most of the length of the character, followed by the legs, with the torso being the shortest section. Chibis have huge heads compared to the size of the body.

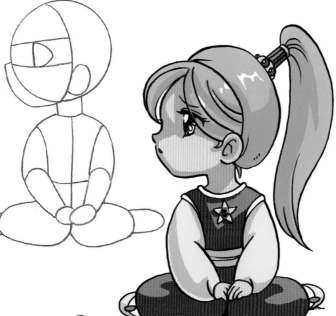

RUNNING CHIBI

Always simplify chibi characters, even their costumes. The arms and legs should look short for the body.

SITTING CHIBI

Cute, sweet chibi characters always have big eyes; this gives them a young look. They also have cute, small hands and feet, whereas the fighting chibi characters tend to have clumsier, bigger hands and feet.

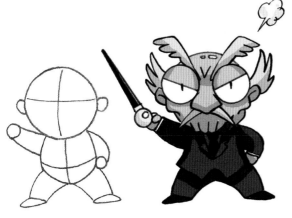

OLD CHIBI

In order to avoid having the head on an older chibi look like a normal head that has been shrunk down to miniature size, you should exaggerate the facial features, such as the eyes, eyebrows, and nose of this old man.

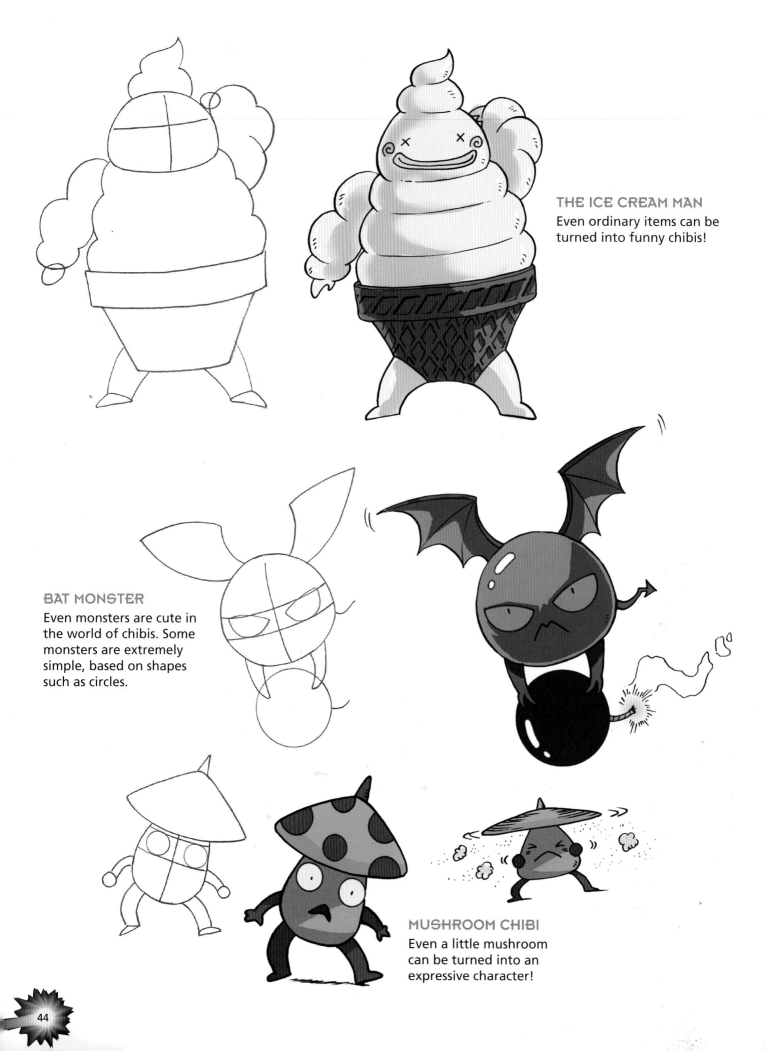

THE ICE CREAM MAN
Even ordinary items can be turned into funny chibis!

BAT MONSTER
Even monsters are cute in the world of chibis. Some monsters are extremely simple, based on shapes such as circles.

MUSHROOM CHIBI
Even a little mushroom can be turned into an expressive character!

Fantasy animals are also very cool. Think of them as plush toys that have been zapped with a magic wand. To create a fantasy animal, simplify the animal that you're using as your main inspiration and add fantasy elements, such as wings, horns, and elongated ears.

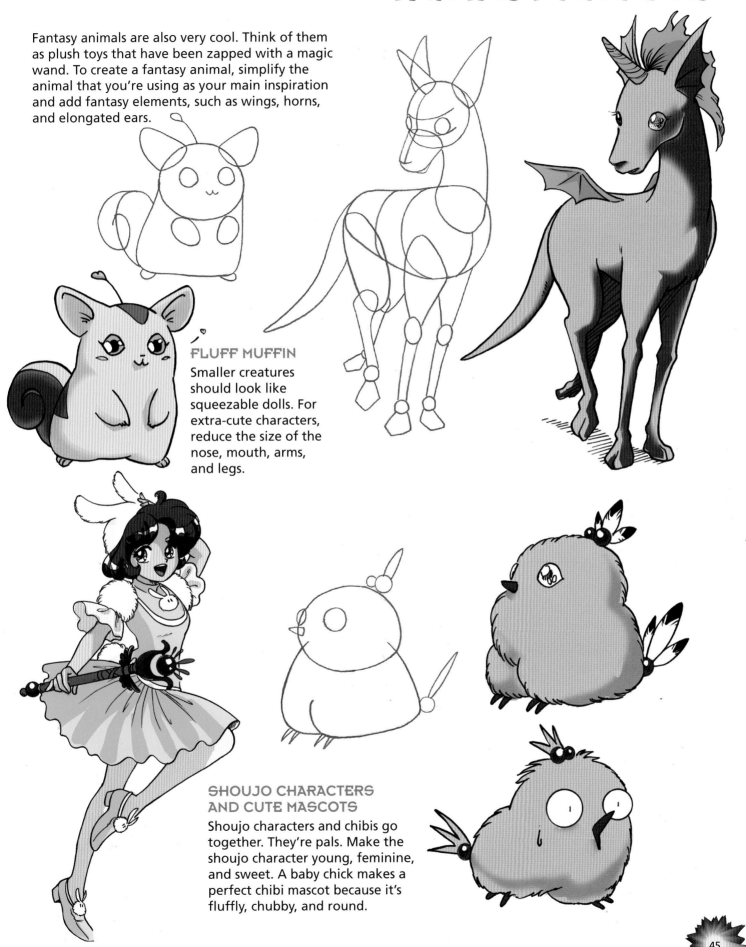

FLUFF MUFFIN

Smaller creatures should look like squeezable dolls. For extra-cute characters, reduce the size of the nose, mouth, arms, and legs.

SHOUJO CHARACTERS AND CUTE MASCOTS

Shoujo characters and chibis go together. They're pals. Make the shoujo character young, feminine, and sweet. A baby chick makes a perfect chibi mascot because it's fluffly, chubby, and round.

45

GOTHS

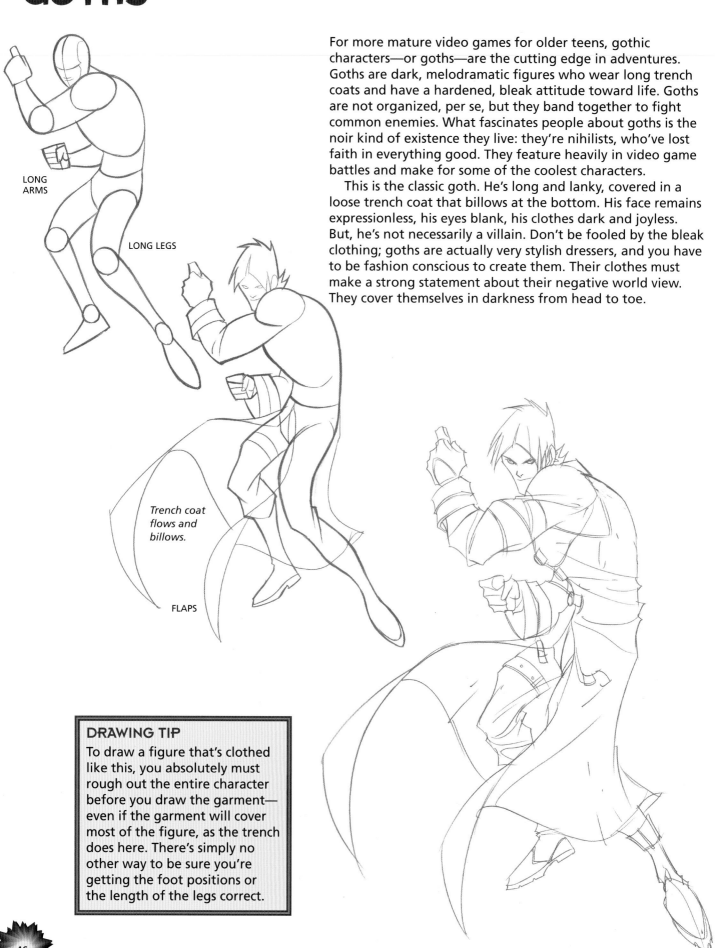

LONG ARMS

LONG LEGS

Trench coat flows and billows.

FLAPS

For more mature video games for older teens, gothic characters—or goths—are the cutting edge in adventures. Goths are dark, melodramatic figures who wear long trench coats and have a hardened, bleak attitude toward life. Goths are not organized, per se, but they band together to fight common enemies. What fascinates people about goths is the noir kind of existence they live: they're nihilists, who've lost faith in everything good. They feature heavily in video game battles and make for some of the coolest characters.

This is the classic goth. He's long and lanky, covered in a loose trench coat that billows at the bottom. His face remains expressionless, his eyes blank, his clothes dark and joyless. But, he's not necessarily a villain. Don't be fooled by the bleak clothing; goths are actually very stylish dressers, and you have to be fashion conscious to create them. Their clothes must make a strong statement about their negative world view. They cover themselves in darkness from head to toe.

DRAWING TIP

To draw a figure that's clothed like this, you absolutely must rough out the entire character before you draw the garment—even if the garment will cover most of the figure, as the trench does here. There's simply no other way to be sure you're getting the foot positions or the length of the legs correct.

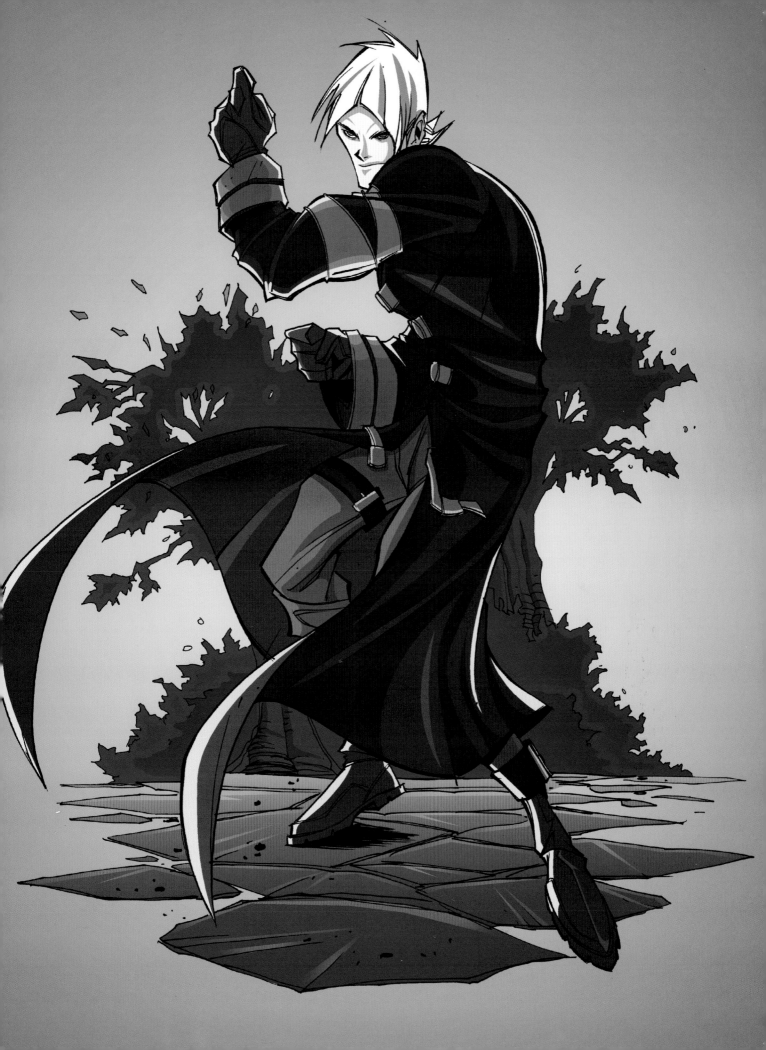

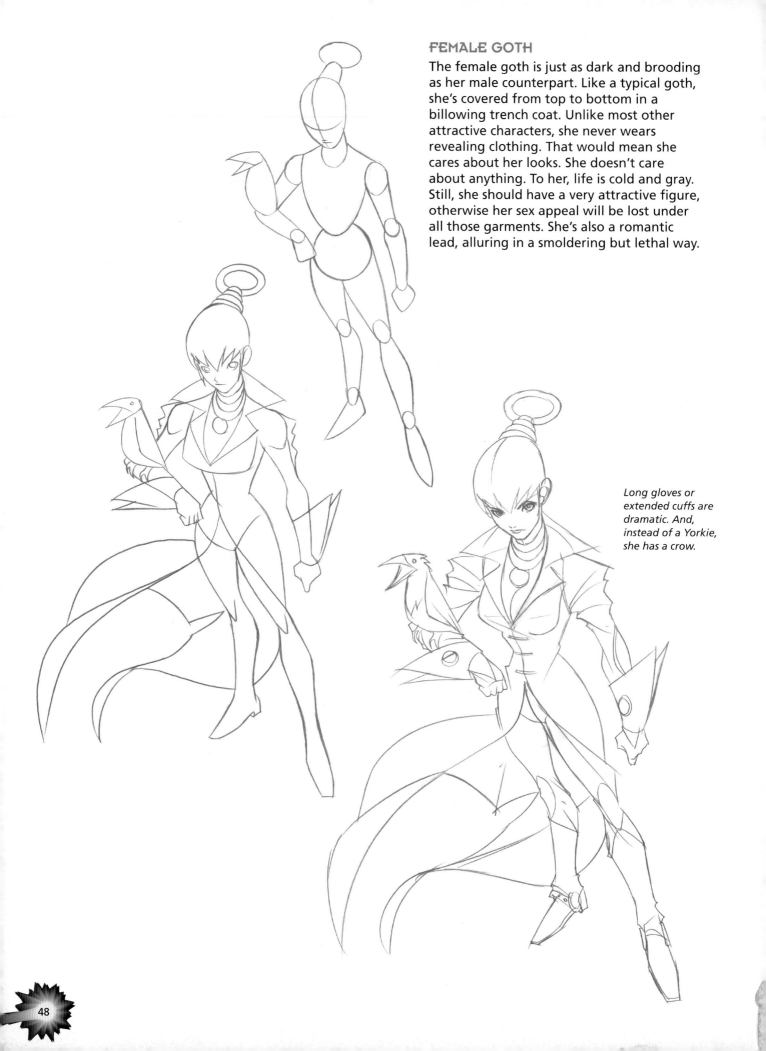

FEMALE GOTH

The female goth is just as dark and brooding as her male counterpart. Like a typical goth, she's covered from top to bottom in a billowing trench coat. Unlike most other attractive characters, she never wears revealing clothing. That would mean she cares about her looks. She doesn't care about anything. To her, life is cold and gray. Still, she should have a very attractive figure, otherwise her sex appeal will be lost under all those garments. She's also a romantic lead, alluring in a smoldering but lethal way.

Long gloves or extended cuffs are dramatic. And, instead of a Yorkie, she has a crow.

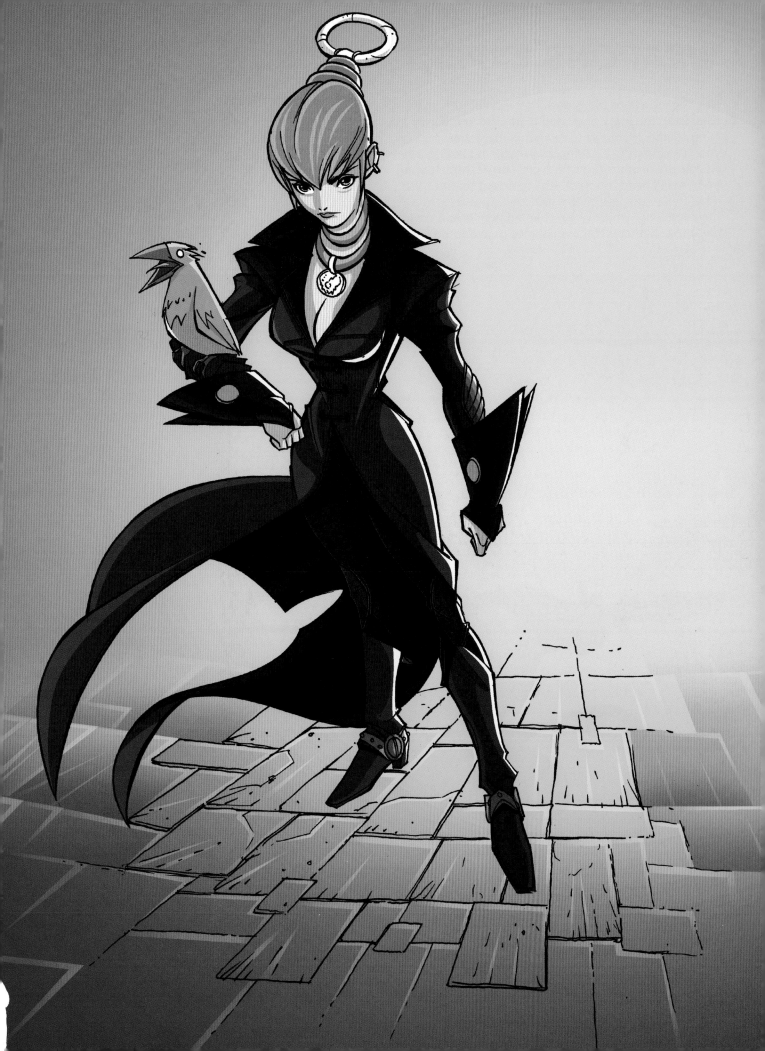

WEAPONS EXPERT

He's the muscle of the group. He's insane. He's mysterious (thanks to the mask and head markings) and barely controllable. If you try to restrain him, he may turn on you. It's kind of like having an irritable pit bull as a pet. He has the proportions of a typical brute: huge upper body, small head, no neck. It's important to place the head below the line of the shoulders. This creates a hunched look, which when coupled with broad shoulders gives the character the appearance of awesome power.

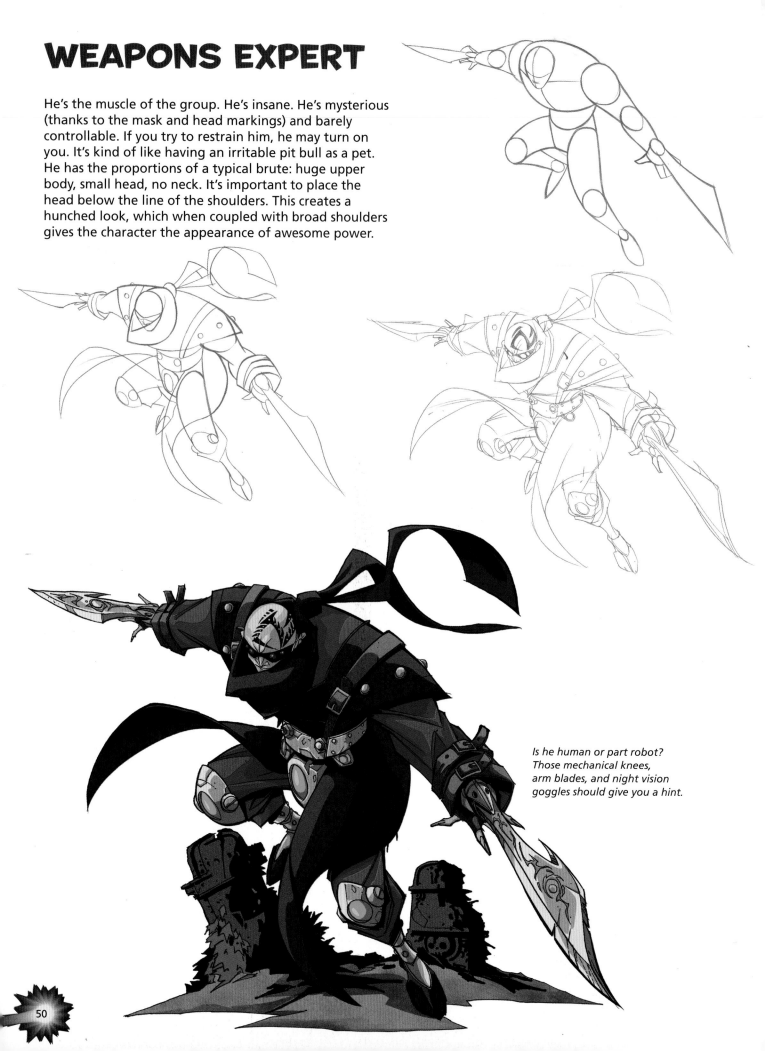

Is he human or part robot? Those mechanical knees, arm blades, and night vision goggles should give you a hint.

WHEELS

Every band of video rebels needs a man with wheels—someone who can outrun the law and rack up those game points. This kind of character needs a superhog (a giant bike that snarls and can ride up the side of a tree if necessary). The character sits low on the bike. This gives him a relaxed posture and allows the artist to draw a superlarge front tire, which makes the bike impressive. Plus, confident characters are relaxed. He's also a big guy, but not a brute. The difference between him and a brute is that we can see his neck, and his head appears above the line of his shoulders.

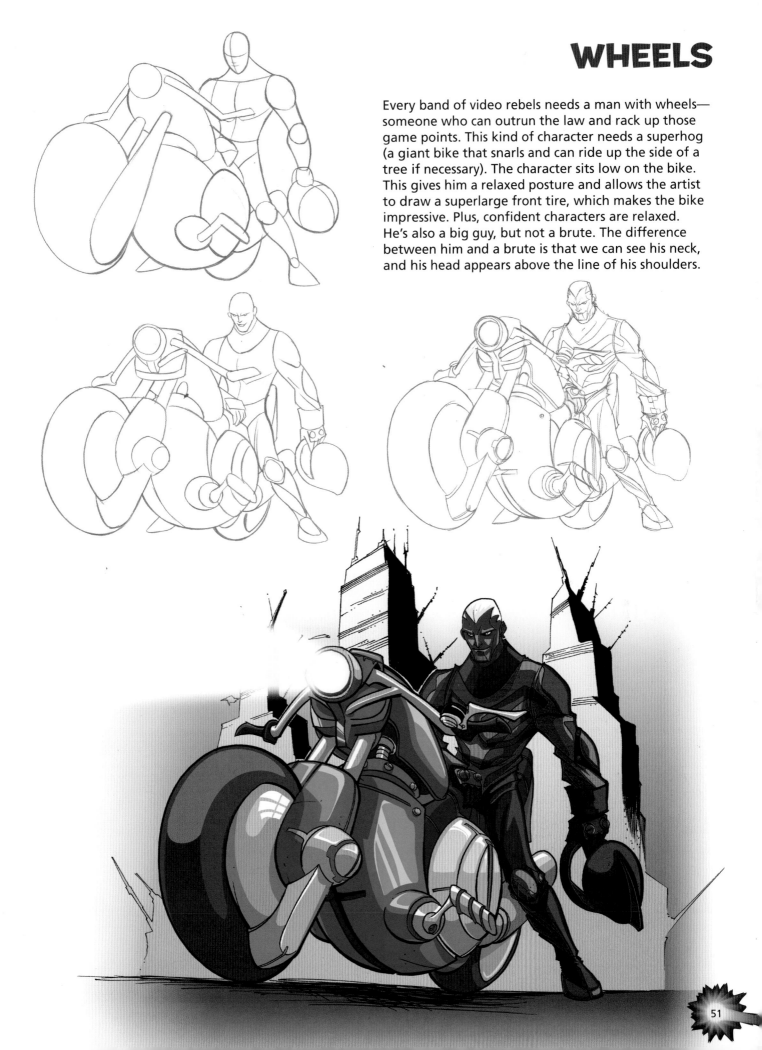

CLASSIC ACTIONPOSES

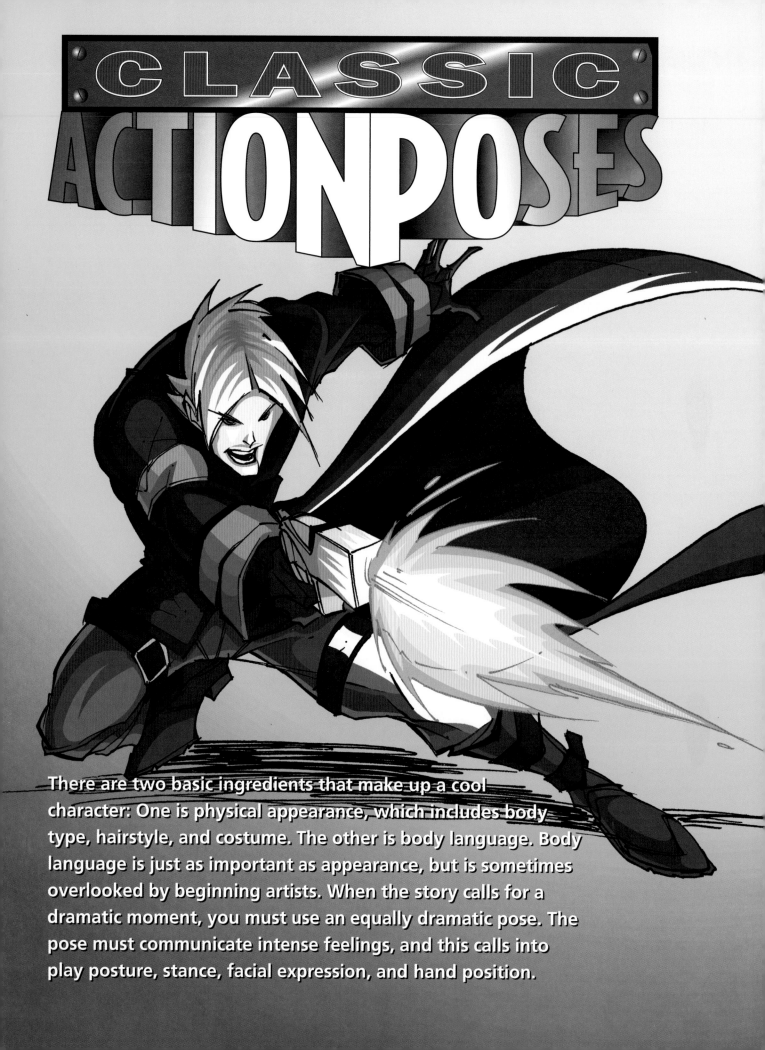

There are two basic ingredients that make up a cool character: One is physical appearance, which includes body type, hairstyle, and costume. The other is body language. Body language is just as important as appearance, but is sometimes overlooked by beginning artists. When the story calls for a dramatic moment, you must use an equally dramatic pose. The pose must communicate intense feelings, and this calls into play posture, stance, facial expression, and hand position.

BODY LANGUAGE AND BASIC EMOTIONS

The poses on the next three pages illustrate how an expressive body position can communicate a range of emotions and attitudes.

FIGHTING MAD

Her legs are placed wide apart because she's steeling herself for a fight. She's looking directly ahead, keeping her opponent in her sights at all times. The fists are clenched and the head tucks into the chin.

COMMANDING

The back is straight. One arm extends fully; the other has a clenched fist. The shoulders are up, flexed.

INTENSE PAIN

Wounded by an enemy, she grits her teeth, doubles up, and hugs herself with both arms. The knees buckle and the eyes are shut tight.

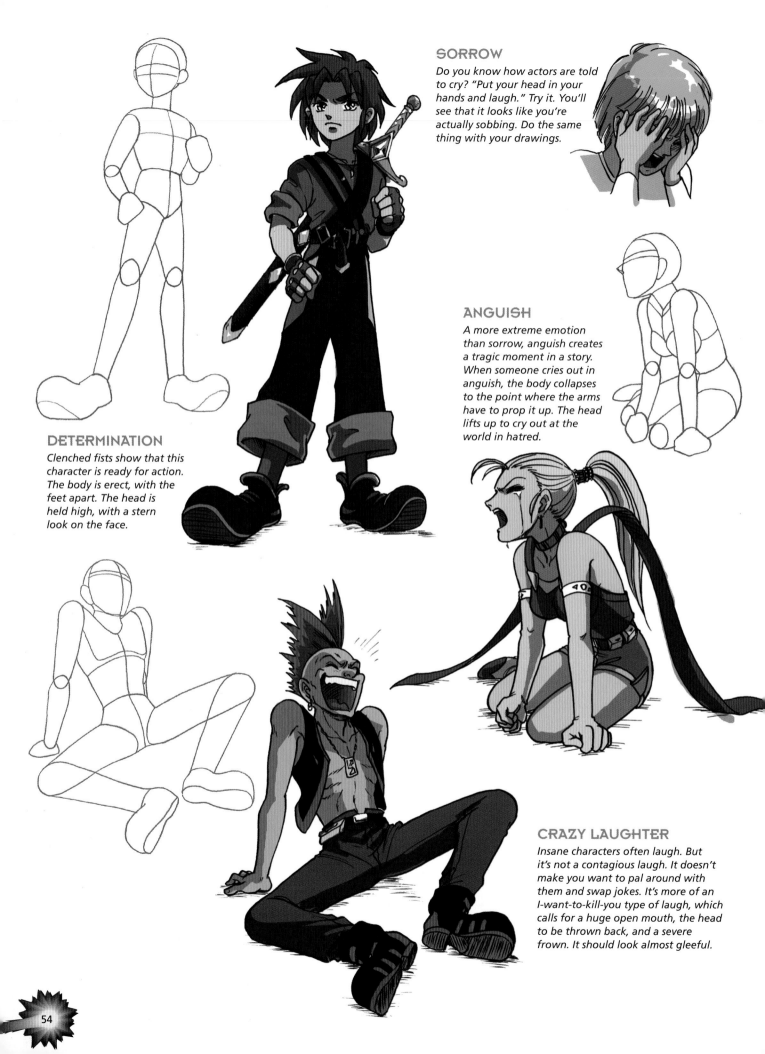

SORROW

Do you know how actors are told to cry? "Put your head in your hands and laugh." Try it. You'll see that it looks like you're actually sobbing. Do the same thing with your drawings.

ANGUISH

A more extreme emotion than sorrow, anguish creates a tragic moment in a story. When someone cries out in anguish, the body collapses to the point where the arms have to prop it up. The head lifts up to cry out at the world in hatred.

DETERMINATION

Clenched fists show that this character is ready for action. The body is erect, with the feet apart. The head is held high, with a stern look on the face.

CRAZY LAUGHTER

Insane characters often laugh. But it's not a contagious laugh. It doesn't make you want to pal around with them and swap jokes. It's more of an I-want-to-kill-you type of laugh, which calls for a huge open mouth, the head to be thrown back, and a severe frown. It should look almost gleeful.

JOY

Jumping for joy is the surest sign of victory. The body is arched back, the hands are raised over the head, and the knees are bent. The eyes are closed, and the mouth must be open in a huge smile.

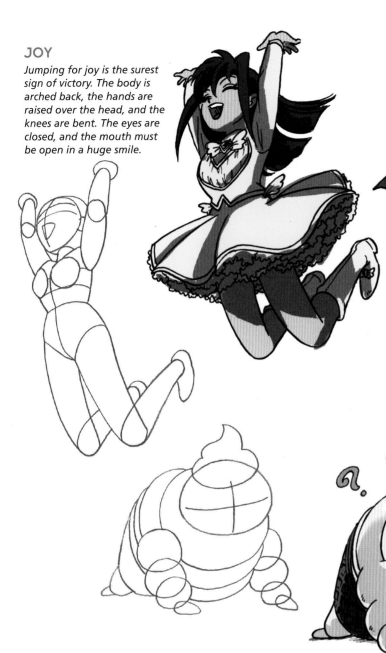

JOY—CHIBI STYLE

Due to their compact, smaller size, chibis are not as flexible as the girl jumping for joy (left). The chibi body doesn't bend as much, so these characters jump up with their hands up and their legs far apart.

APPREHENSION

Nervously peeking around a corner or over someone's shoulder clearly communicates apprehension. Don't show all of the head over the shoulder; the character is too afraid to pop her head all the way up.

TREPIDATION

All characters revert to being babies when they're really afraid. They get down on their hands and knees and crawl!

DEFEAT

In video games, you frequently see this pose—lying on the back, arms at sides, eyes closed, mouth slightly open—when a character is knocked out.

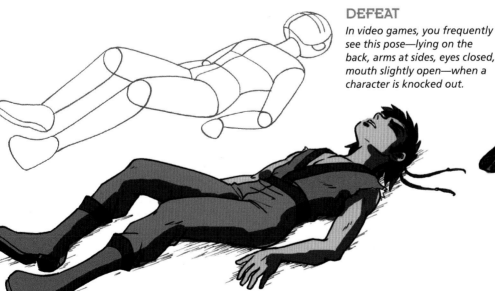

RETREAT

It's often necessary for a character in a video game to make a fast getaway. This is typically a running pose, with the hands holding the head.

ACTION AND DIRECTION

Action poses require characters to move boldly. The more extreme the action, the more the body leans into the pose. With video games, in which action is king, your characters should throw all of their weight into a motion whenever possible, and the limbs should be going in the direction of the action.

Note that the line of the spine is shown to visually convey that the character is twisting away from the laser beam and revealing more of his back.

LIMBS FORWARD

EXTREME RUNNING

When a character runs forward, the body leans forward as well. Rather than tilting back, the head tucks down and forward in the direction of the run. The arms extend, with one coming way out in front of the body, exaggerating the motion of striving forward. This conveys the urgency of the action.

DIVING OUT OF THE WAY

This action occurs a lot in flashy, high-tech video game battle scenes. Here, the character dives out of the way of a laser beam, and as he does, his entire body and all of his limbs move forward. Nothing should drag behind except any loose-fitting garments your character might be wearing.

LEGS DRAG BEHIND

BEING HIT BY A BLAST

When a character is hit by a blast or some other type of force, the entire body is flung backward, and the limbs drag behind. This is because the body doesn't want to go in the direction in which it is being propelled—an outside force causes this motion. It's a highly effective look.

THROWING A KICK

When a character throws a kick to the side, the body should arch forward. If it were to lean backward to counterbalance the action, the torso would lean away from the kick, sapping the strike of its energy and making it appear weak.

BLAM

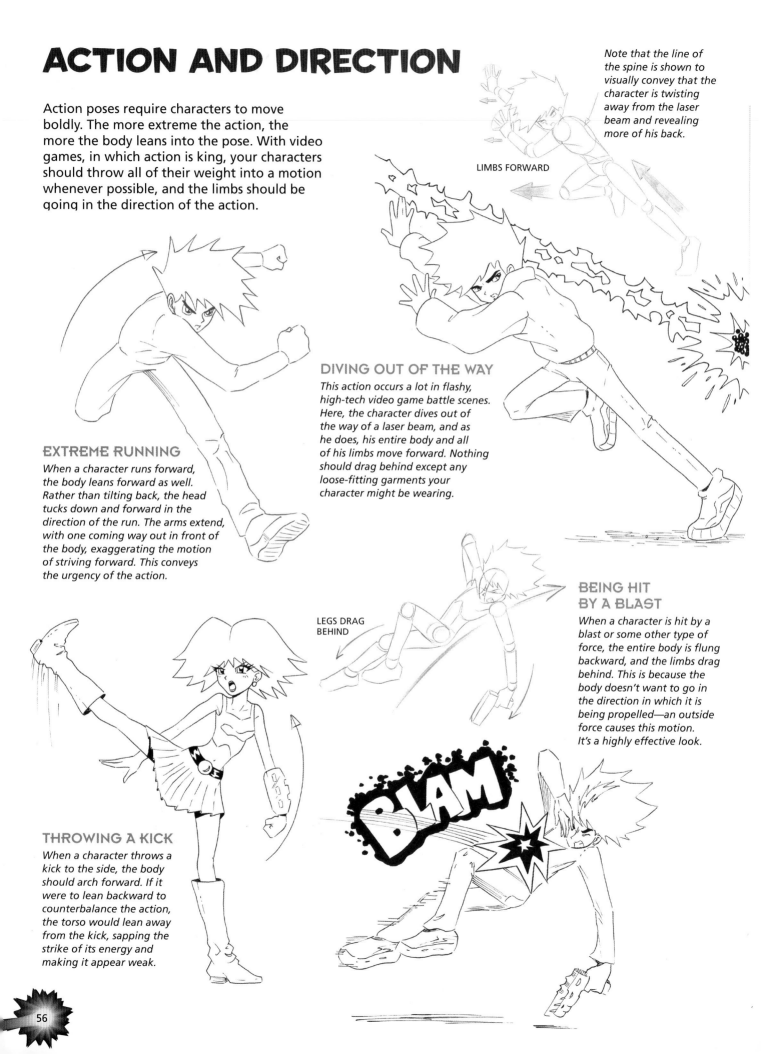

THE DYNAMIC WINDUP

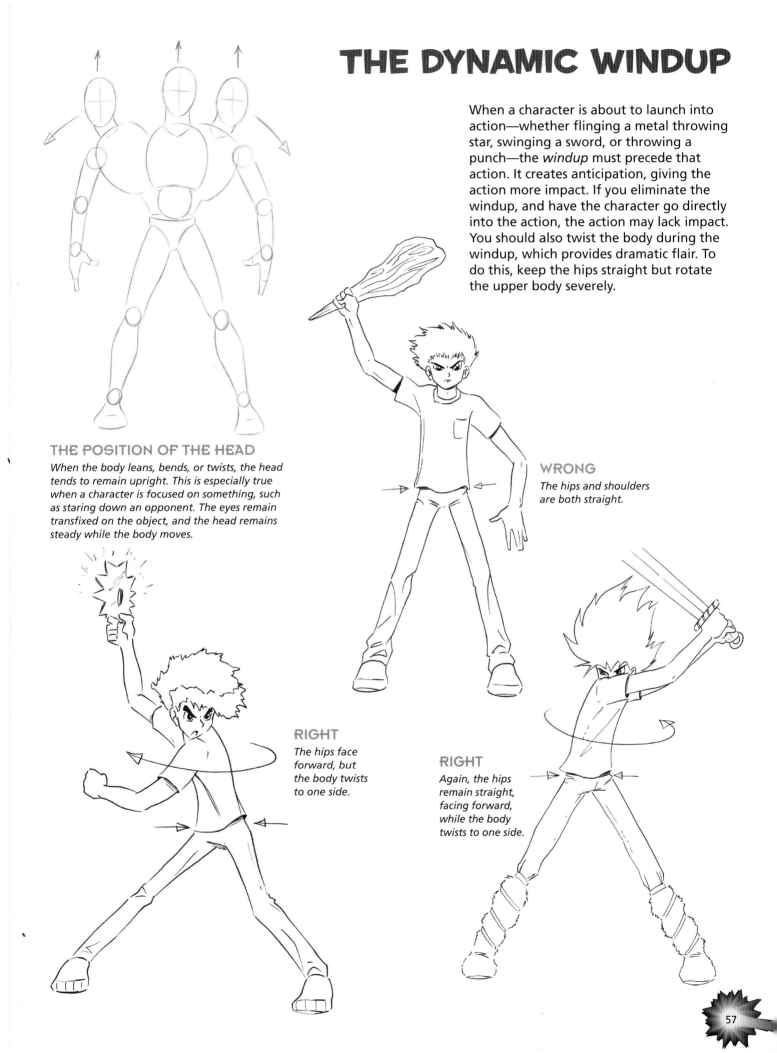

When a character is about to launch into action—whether flinging a metal throwing star, swinging a sword, or throwing a punch—the *windup* must precede that action. It creates anticipation, giving the action more impact. If you eliminate the windup, and have the character go directly into the action, the action may lack impact. You should also twist the body during the windup, which provides dramatic flair. To do this, keep the hips straight but rotate the upper body severely.

THE POSITION OF THE HEAD

When the body leans, bends, or twists, the head tends to remain upright. This is especially true when a character is focused on something, such as staring down an opponent. The eyes remain transfixed on the object, and the head remains steady while the body moves.

WRONG

The hips and shoulders are both straight.

RIGHT

The hips face forward, but the body twists to one side.

RIGHT

Again, the hips remain straight, facing forward, while the body twists to one side.

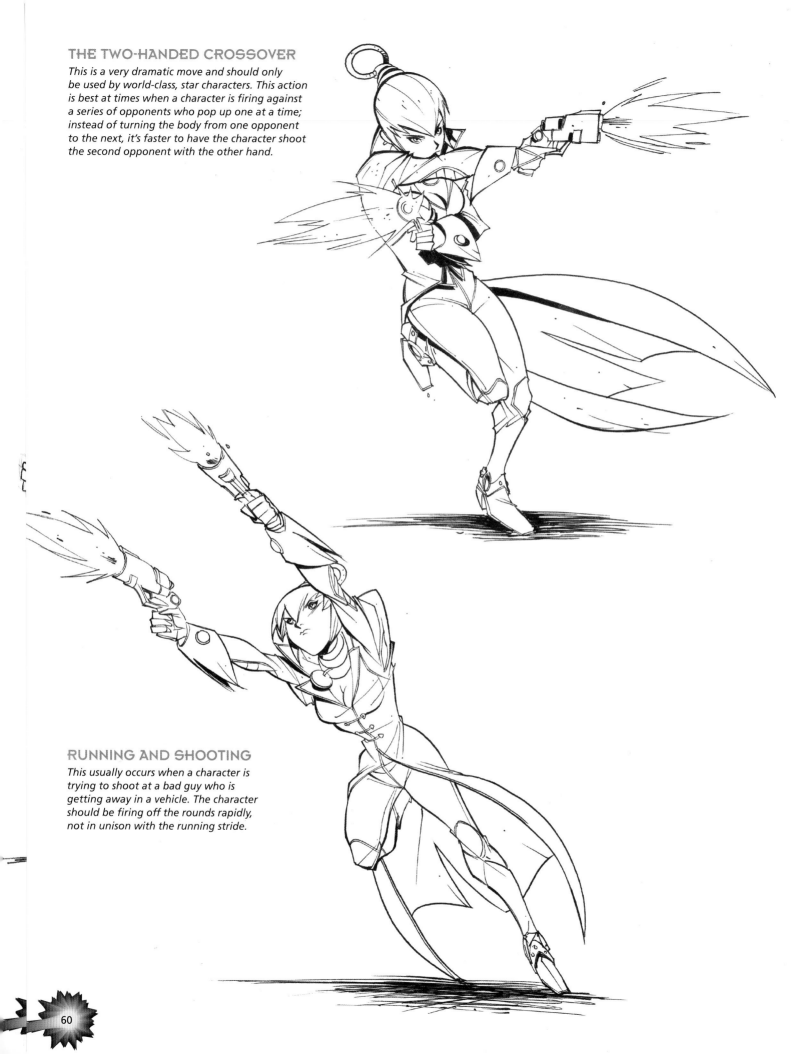

THE TWO-HANDED CROSSOVER

This is a very dramatic move and should only be used by world-class, star characters. This action is best at times when a character is firing against a series of opponents who pop up one at a time; instead of turning the body from one opponent to the next, it's faster to have the character shoot the second opponent with the other hand.

RUNNING AND SHOOTING

This usually occurs when a character is trying to shoot at a bad guy who is getting away in a vehicle. The character should be firing off the rounds rapidly, not in unison with the running stride.

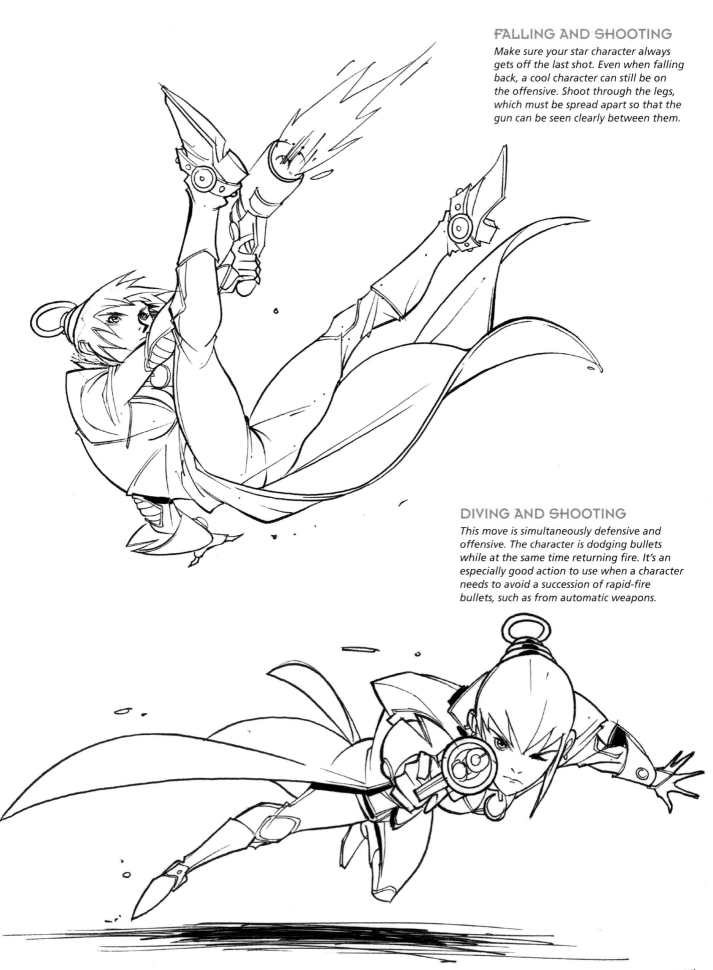

FALLING AND SHOOTING

Make sure your star character always gets off the last shot. Even when falling back, a cool character can still be on the offensive. Shoot through the legs, which must be spread apart so that the gun can be seen clearly between them.

DIVING AND SHOOTING

This move is simultaneously defensive and offensive. The character is dodging bullets while at the same time returning fire. It's an especially good action to use when a character needs to avoid a succession of rapid-fire bullets, such as from automatic weapons.

HAND-TO-HAND COMBAT

Hand-to-hand combat scenes are a must for any action-oriented video game. As a manga artist, you need to know how to stage them. There are many types of game characters, but one thing's for sure: they all fight a lot! It's often the highlight, if not the point, of the game. And why not? The action is fun and exciting. It provides good competition between the player and the game's forces of evil. Since the average game player has a high level of sophistication, you've got to know more than the old-fashioned haymaker. Most video game characters fight using an assortment of sophisticated martial arts moves. Each type of blow has certain advantages and should be used for specific situations. The variety of blows creates interest. When used in combination, these moves create a convincing fight scene. We'll start with punches.

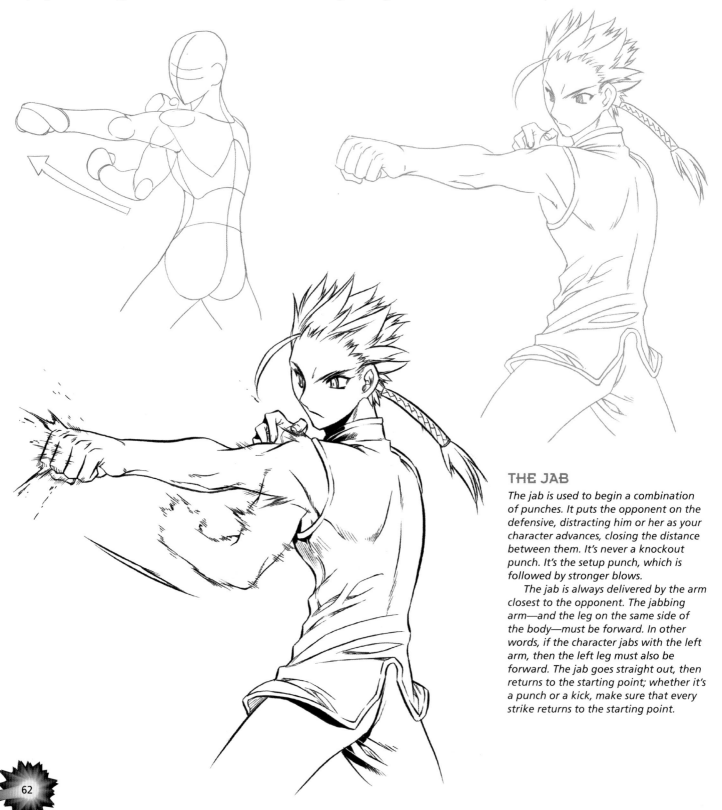

THE JAB

The jab is used to begin a combination of punches. It puts the opponent on the defensive, distracting him or her as your character advances, closing the distance between them. It's never a knockout punch. It's the setup punch, which is followed by stronger blows.

The jab is always delivered by the arm closest to the opponent. The jabbing arm—and the leg on the same side of the body—must be forward. In other words, if the character jabs with the left arm, then the left leg must also be forward. The jab goes straight out, then returns to the starting point; whether it's a punch or a kick, make sure that every strike returns to the starting point.

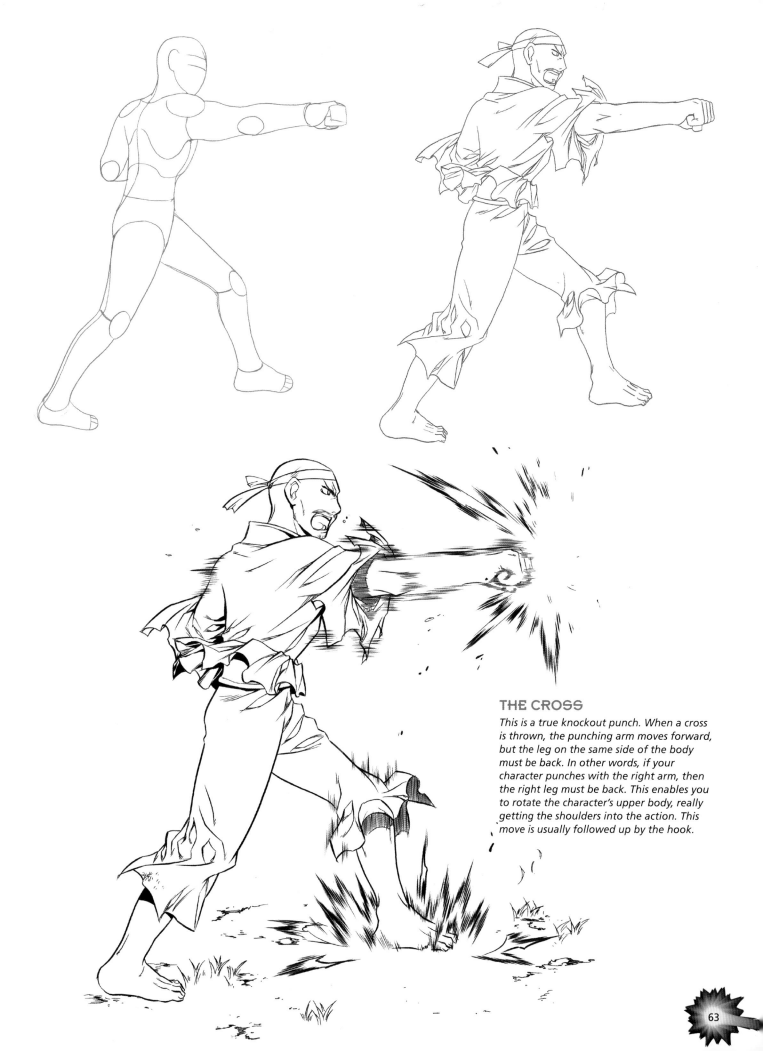

THE CROSS

This is a true knockout punch. When a cross is thrown, the punching arm moves forward, but the leg on the same side of the body must be back. In other words, if your character punches with the right arm, then the right leg must be back. This enables you to rotate the character's upper body, really getting the shoulders into the action. This move is usually followed up by the hook.

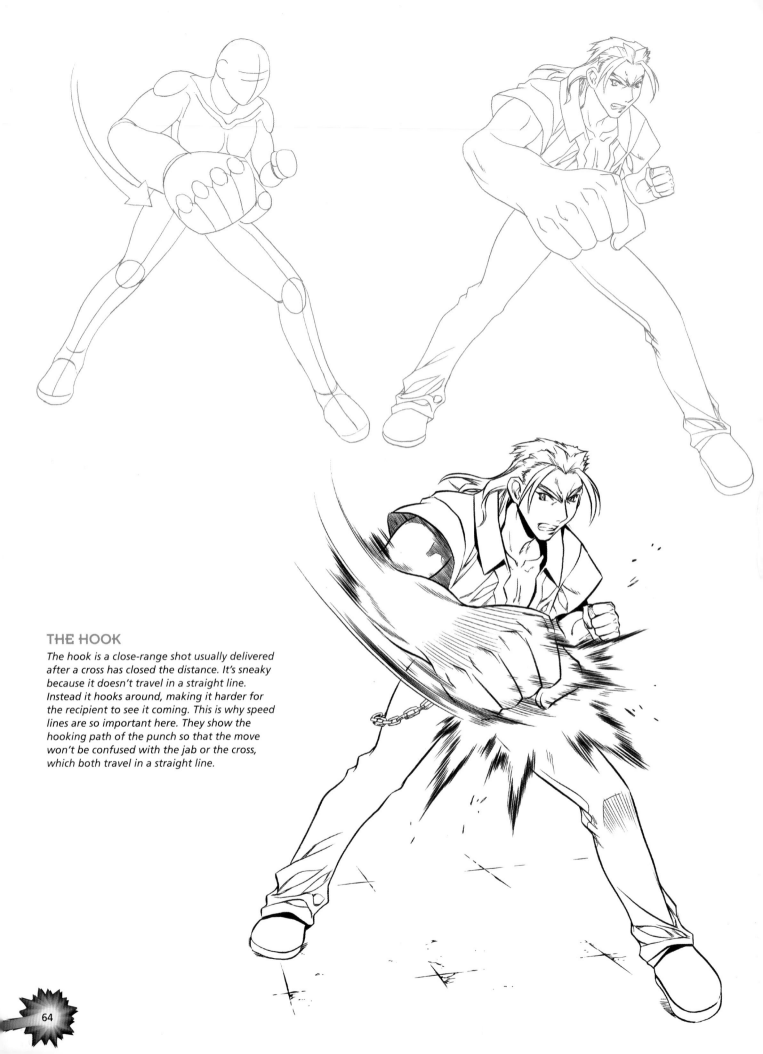

THE HOOK

The hook is a close-range shot usually delivered after a cross has closed the distance. It's sneaky because it doesn't travel in a straight line. Instead it hooks around, making it harder for the recipient to see it coming. This is why speed lines are so important here. They show the hooking path of the punch so that the move won't be confused with the jab or the cross, which both travel in a straight line.

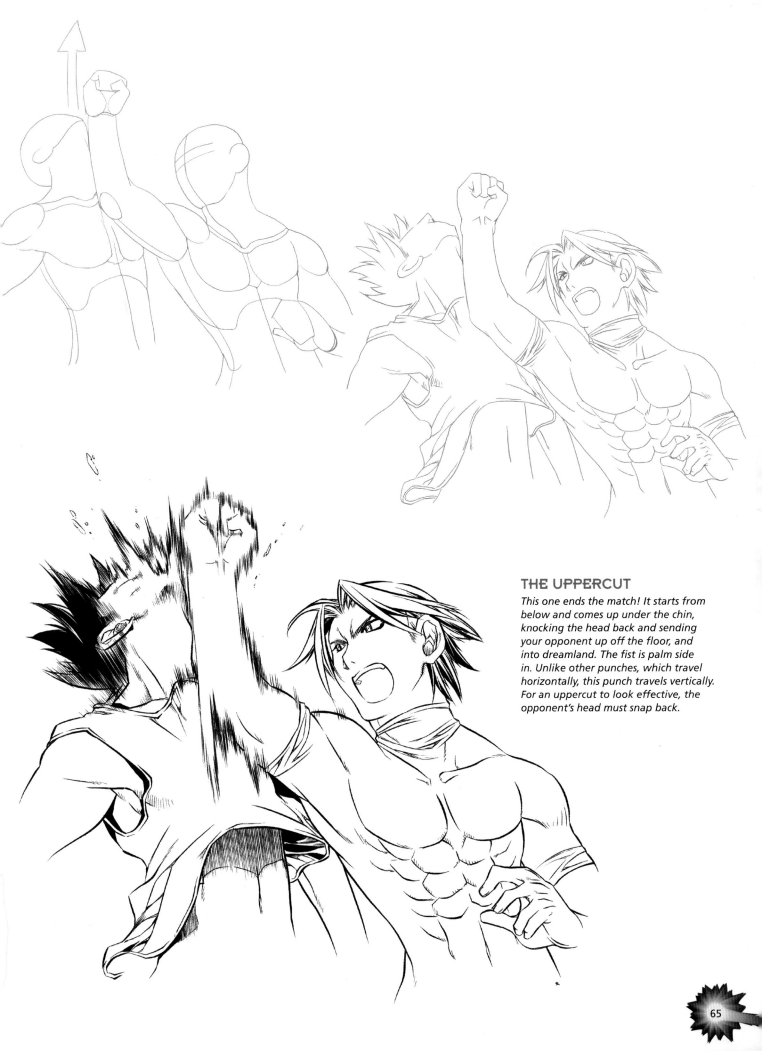

THE UPPERCUT

This one ends the match! It starts from below and comes up under the chin, knocking the head back and sending your opponent up off the floor, and into dreamland. The fist is palm side in. Unlike other punches, which travel horizontally, this punch travels vertically. For an uppercut to look effective, the opponent's head must snap back.

JUST FOR KICKS

Nothing gives a character more flair than a well-executed kick. And although any martial artist will tell you that kicks to the body are the most effective, kicks to the head are flashier and, therefore, the only ones used in video games. Kicking allows your character to deliver strikes at a greater distance from the opponent because legs are longer than arms. Unfortunately for you, your opponent is most likely also an expert at kicking. And when two fighters trade kicks, watch the sparks fly!

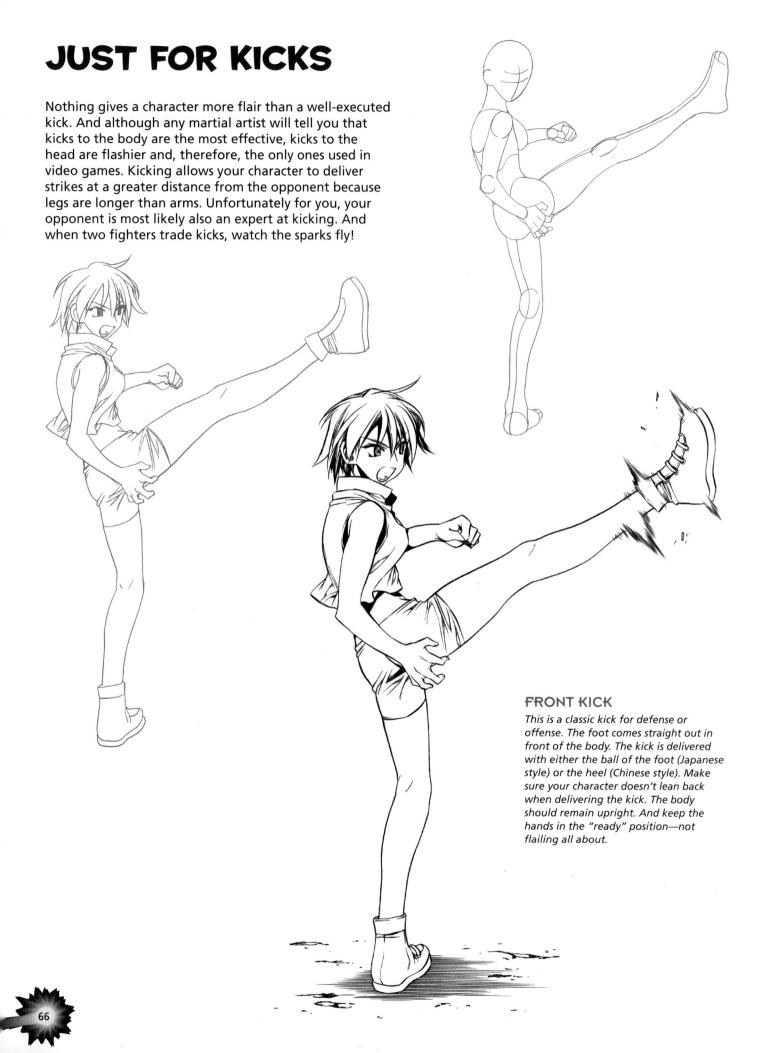

FRONT KICK

This is a classic kick for defense or offense. The foot comes straight out in front of the body. The kick is delivered with either the ball of the foot (Japanese style) or the heel (Chinese style). Make sure your character doesn't lean back when delivering the kick. The body should remain upright. And keep the hands in the "ready" position—not flailing all about.

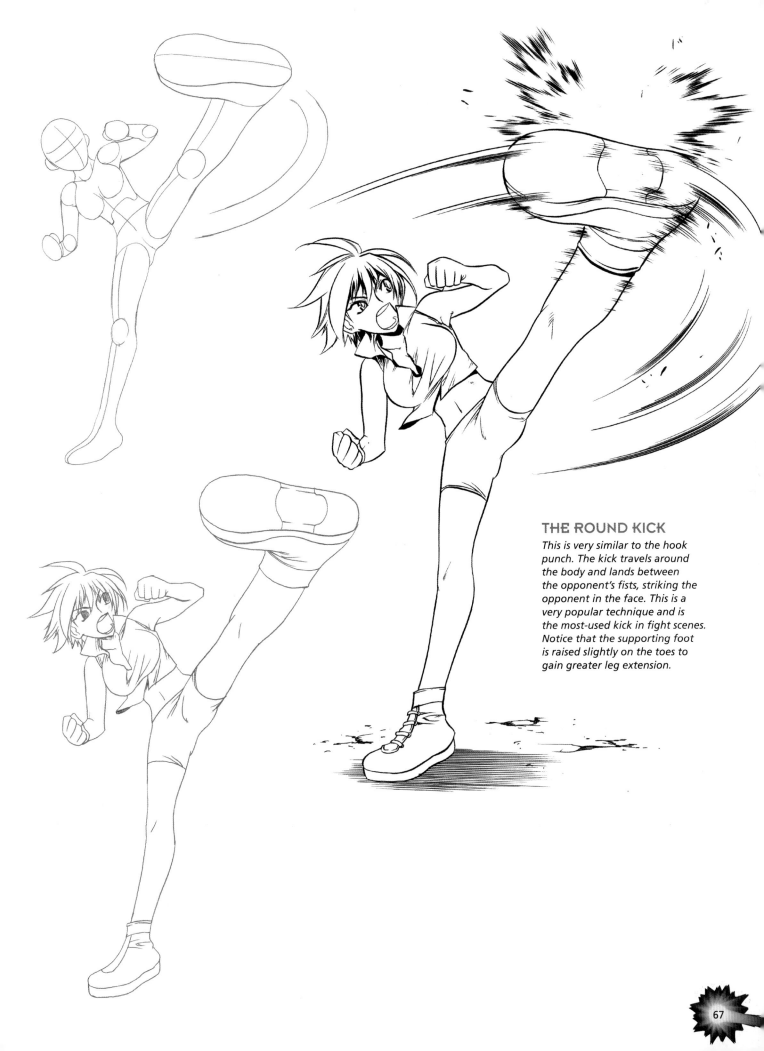

THE ROUND KICK

This is very similar to the hook punch. The kick travels around the body and lands between the opponent's fists, striking the opponent in the face. This is a very popular technique and is the most-used kick in fight scenes. Notice that the supporting foot is raised slightly on the toes to gain greater leg extension.

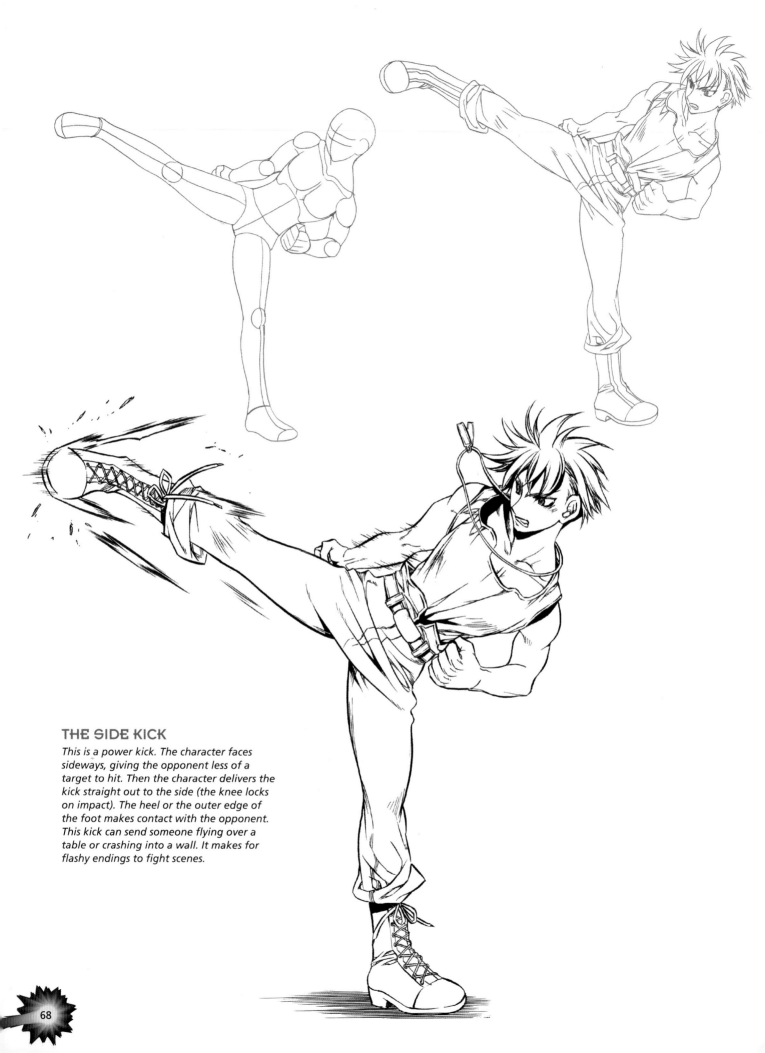

THE SIDE KICK

This is a power kick. The character faces sideways, giving the opponent less of a target to hit. Then the character delivers the kick straight out to the side (the knee locks on impact). The heel or the outer edge of the foot makes contact with the opponent. This kick can send someone flying over a table or crashing into a wall. It makes for flashy endings to fight scenes.

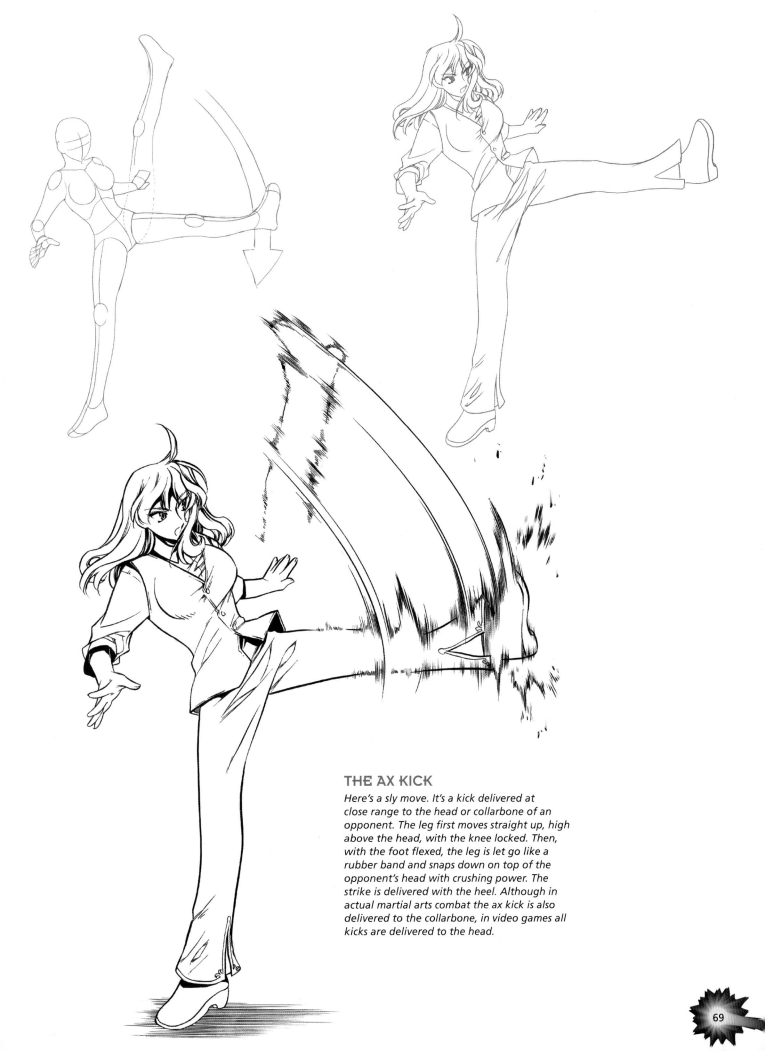

THE AX KICK

Here's a sly move. It's a kick delivered at close range to the head or collarbone of an opponent. The leg first moves straight up, high above the head, with the knee locked. Then, with the foot flexed, the leg is let go like a rubber band and snaps down on top of the opponent's head with crushing power. The strike is delivered with the heel. Although in actual martial arts combat the ax kick is also delivered to the collarbone, in video games all kicks are delivered to the head.

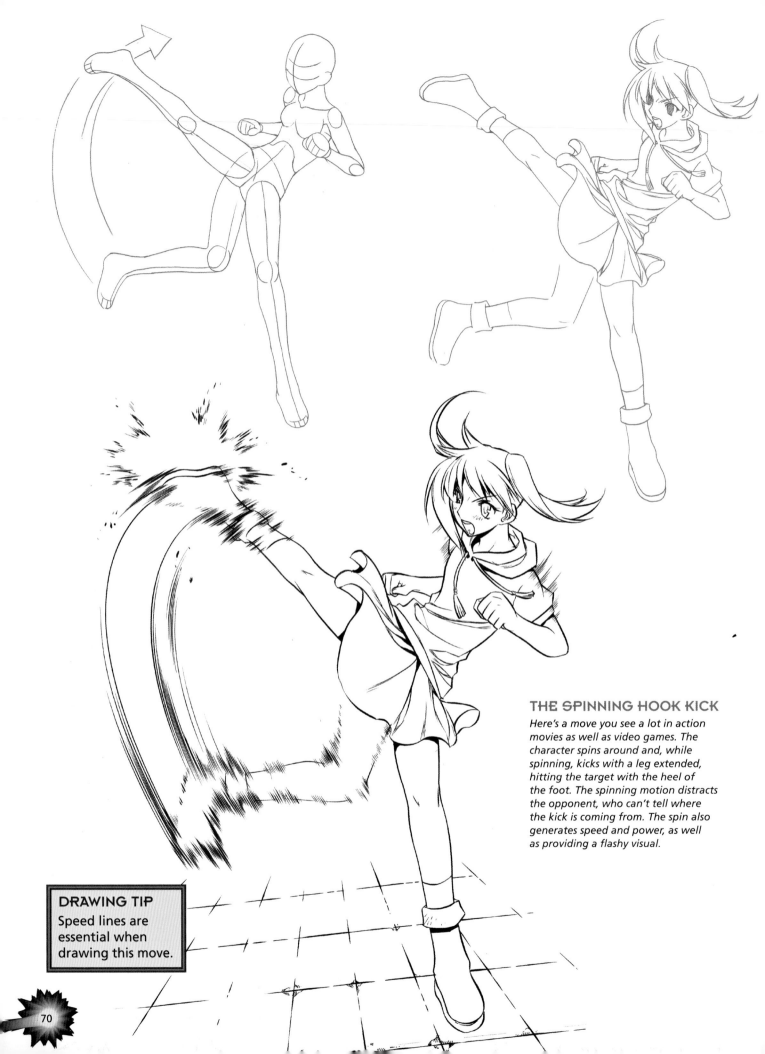

THE SPINNING HOOK KICK

Here's a move you see a lot in action movies as well as video games. The character spins around and, while spinning, kicks with a leg extended, hitting the target with the heel of the foot. The spinning motion distracts the opponent, who can't tell where the kick is coming from. The spin also generates speed and power, as well as providing a flashy visual.

DRAWING TIP
Speed lines are essential when drawing this move.

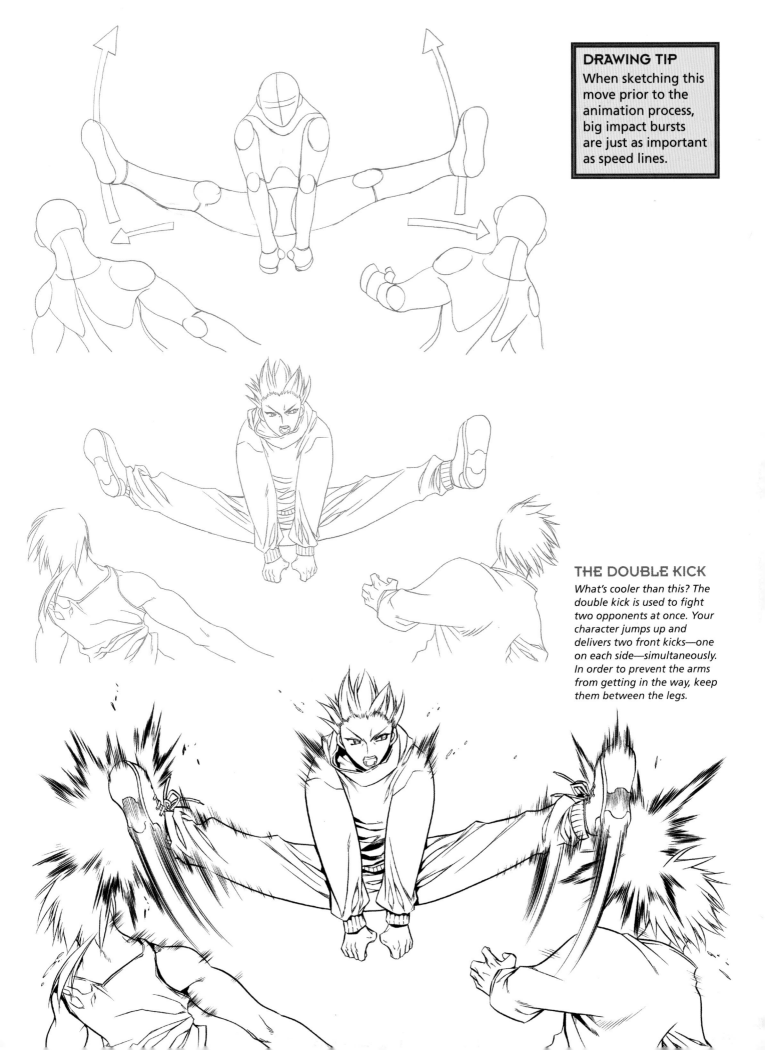

THE DOUBLE KICK

What's cooler than this? The double kick is used to fight two opponents at once. Your character jumps up and delivers two front kicks—one on each side—simultaneously. In order to prevent the arms from getting in the way, keep them between the legs.

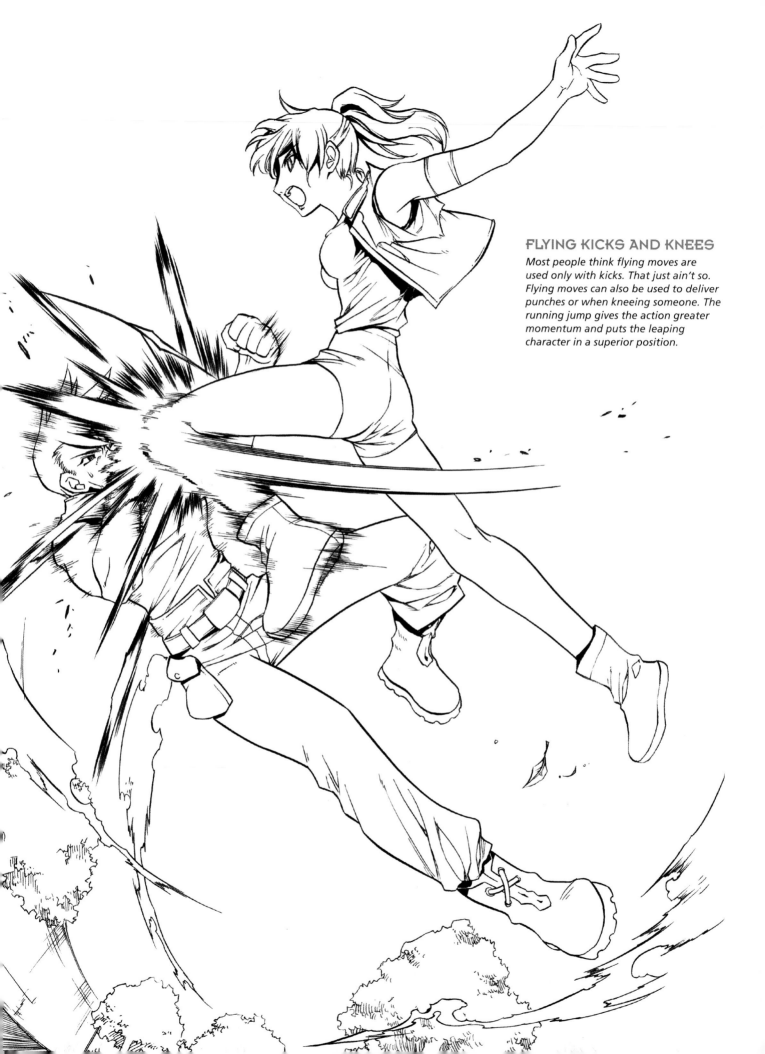

FLYING KICKS AND KNEES

Most people think flying moves are used only with kicks. That just ain't so. Flying moves can also be used to deliver punches or when kneeing someone. The running jump gives the action greater momentum and puts the leaping character in a superior position.

REACTIONS TO FIGHTING BLOWS

No matter how expertly you position a character delivering a punch or kick, the scene will be a dud unless the character receiving the blow reacts dramatically. In order to make any blow look really effective, it must appear to cause a big impact.

And that means that the person receiving the blow has to be thrown for a loop. The whole body not only crumples but is thrown back. Remember, if the punch or kick is a devastating force, then it has to cause an equally devastating reaction.

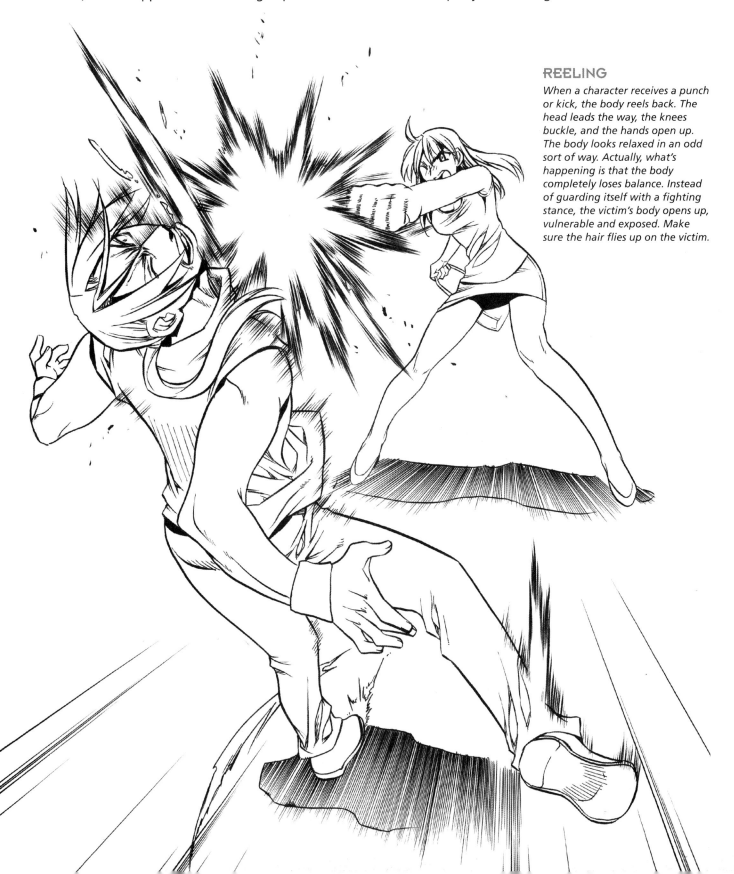

REELING

When a character receives a punch or kick, the body reels back. The head leads the way, the knees buckle, and the hands open up. The body looks relaxed in an odd sort of way. Actually, what's happening is that the body completely loses balance. Instead of guarding itself with a fighting stance, the victim's body opens up, vulnerable and exposed. Make sure the hair flies up on the victim.

GETTING THROWN . . .

Characters who are thrown will fall on their back—the most vulnerable area. They'll be airborne for a moment, which not only makes the throw more dramatic but causes a greater impact on landing. The legs lag behind as the victim descends to the ground.

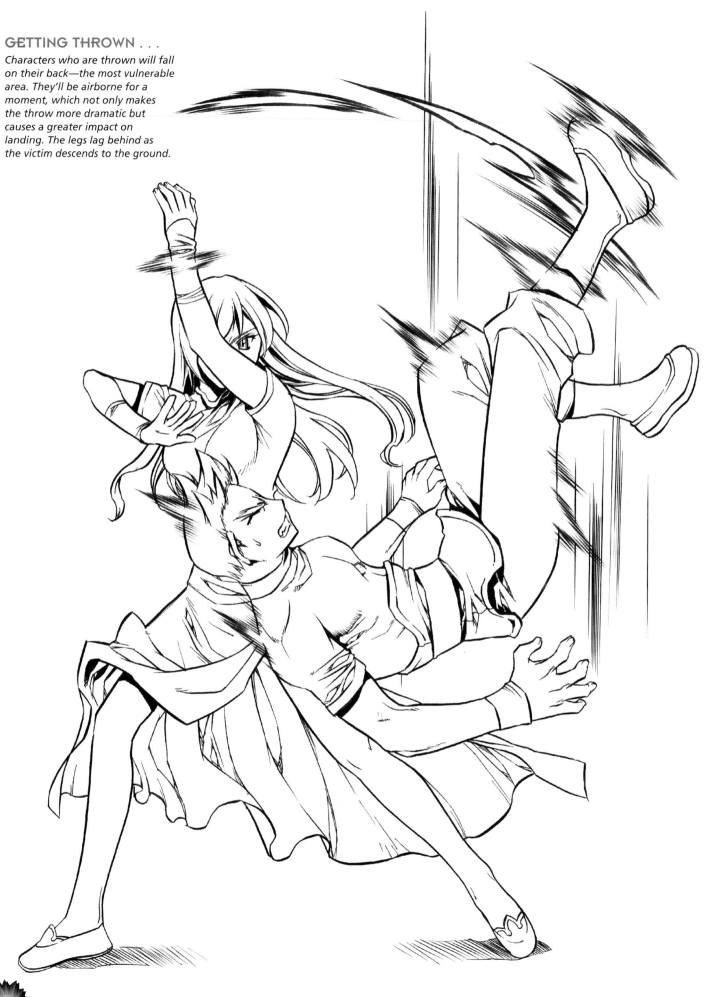

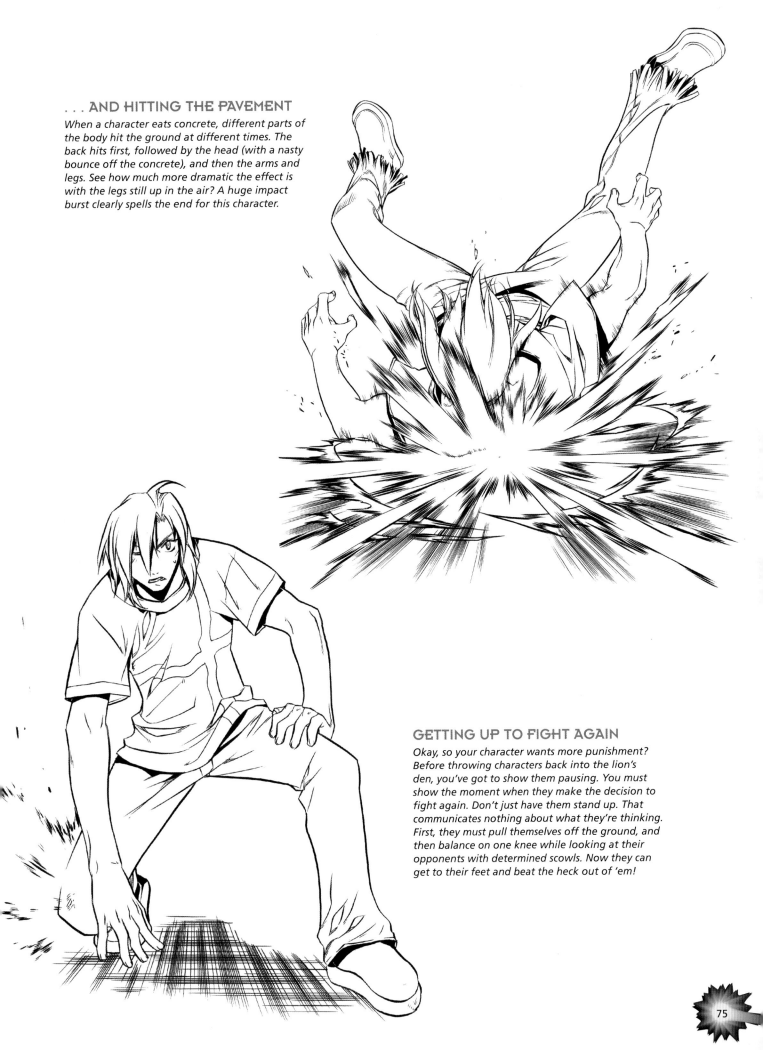

. . . AND HITTING THE PAVEMENT

When a character eats concrete, different parts of the body hit the ground at different times. The back hits first, followed by the head (with a nasty bounce off the concrete), and then the arms and legs. See how much more dramatic the effect is with the legs still up in the air? A huge impact burst clearly spells the end for this character.

GETTING UP TO FIGHT AGAIN

Okay, so your character wants more punishment? Before throwing characters back into the lion's den, you've got to show them pausing. You must show the moment when they make the decision to fight again. Don't just have them stand up. That communicates nothing about what they're thinking. First, they must pull themselves off the ground, and then balance on one knee while looking at their opponents with determined scowls. Now they can get to their feet and beat the heck out of 'em!

JUMPING AND LEAPING

Jumping out of the way—or even leaping a dozen or more feet into the air—is a popular move that shows the almost supernatural fighting abilities of manga characters in video games. Nothing makes opponents look so ineffective as jumping over them without even bothering to block their blows. It's an embellished approach to fighting that creates incredible scenes.

AVOIDING A FOOT SWEEP

It's just not possible to block a foot sweep. If you try to keep your leg on the ground, it'll get smashed by the opponent's leg, and you'll land on your bottom faster than you can say "rematch." The only defense is to jump out of the way and let the sweep miss.

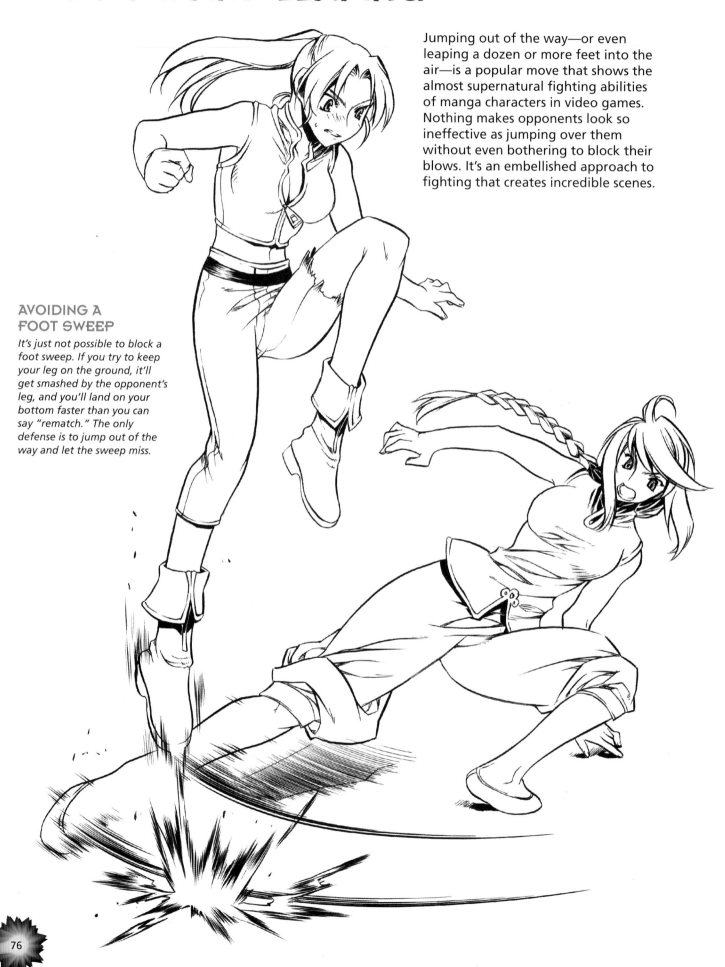

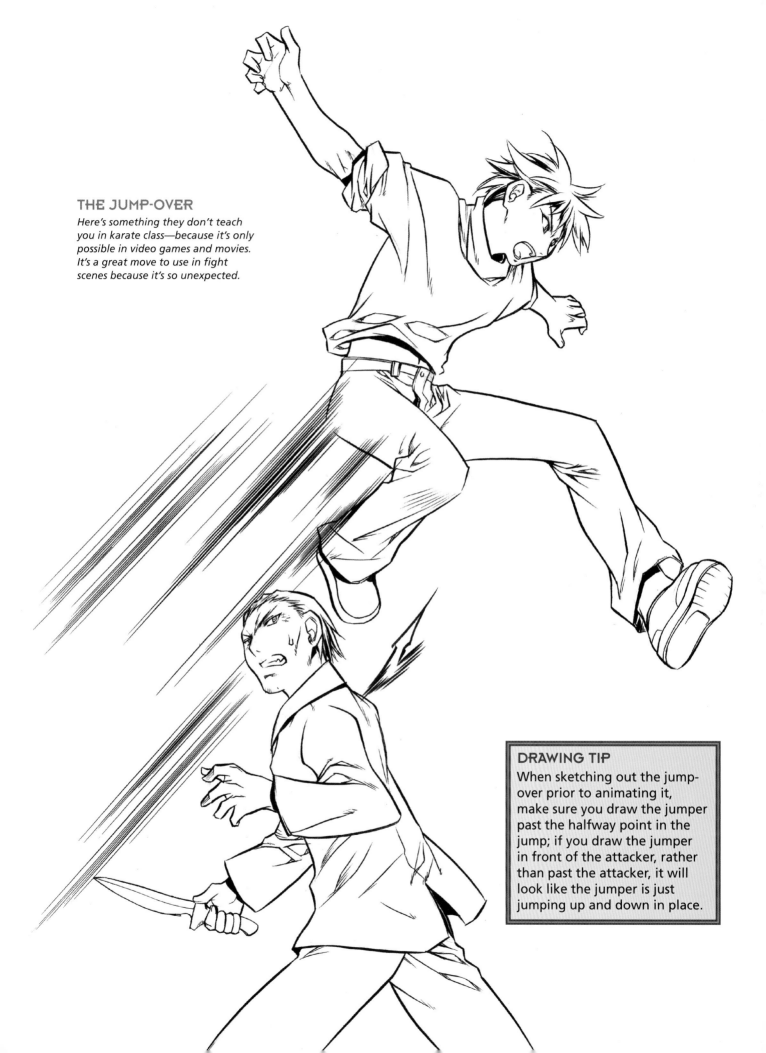

THE JUMP-OVER

Here's something they don't teach you in karate class—because it's only possible in video games and movies. It's a great move to use in fight scenes because it's so unexpected.

DRAWING TIP

When sketching out the jump-over prior to animating it, make sure you draw the jumper past the halfway point in the jump; if you draw the jumper in front of the attacker, rather than past the attacker, it will look like the jumper is just jumping up and down in place.

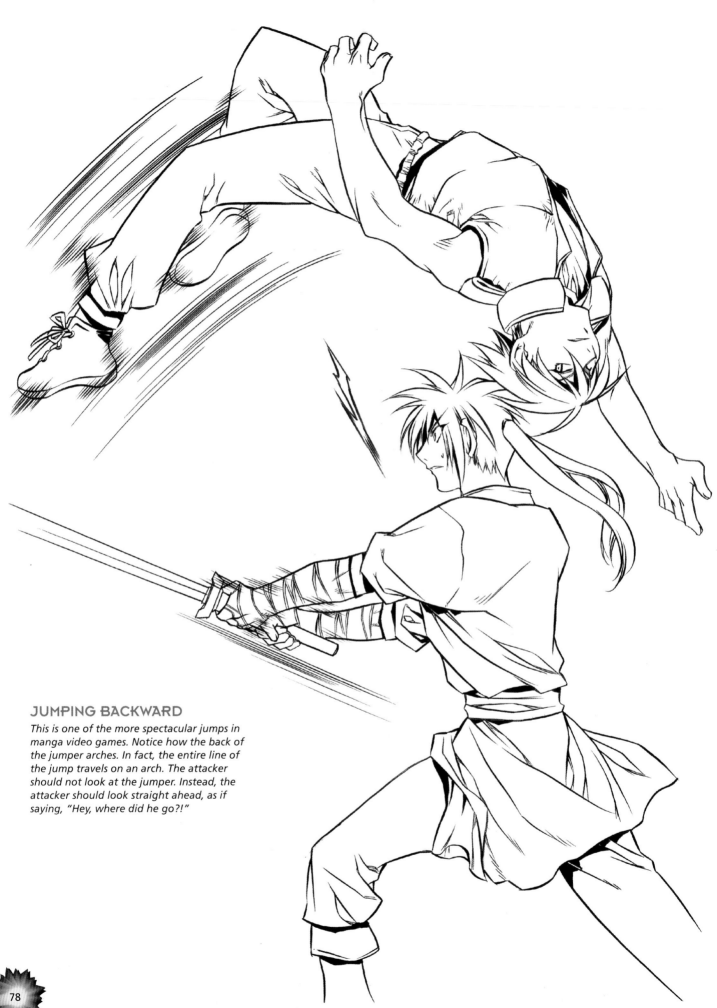

JUMPING BACKWARD

This is one of the more spectacular jumps in manga video games. Notice how the back of the jumper arches. In fact, the entire line of the jump travels on an arch. The attacker should not look at the jumper. Instead, the attacker should look straight ahead, as if saying, "Hey, where did he go?!"

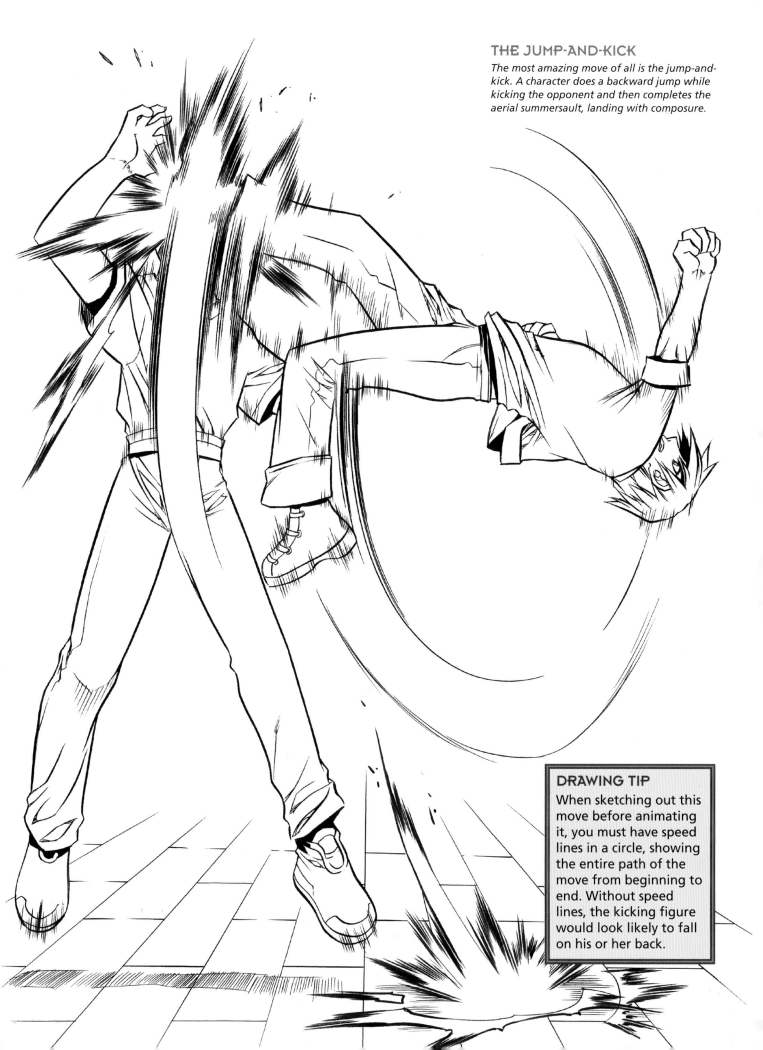

THE JUMP-AND-KICK

The most amazing move of all is the jump-and-kick. A character does a backward jump while kicking the opponent and then completes the aerial summersault, landing with composure.

DRAWING TIP

When sketching out this move before animating it, you must have speed lines in a circle, showing the entire path of the move from beginning to end. Without speed lines, the kicking figure would look likely to fall on his or her back.

AERIAL FIGHT SCENES

If one character jumping is good, then two characters jumping is even better. If you want the ultimate fight scene, this is it. The characters should both be off the ground—not several feet off the ground, but several *stories*. Keep perspective in mind: if the action is seen from above, the trees must be shown in perspective and must taper as they travel down to the ground.

Include stuff that indicates where the ground is, for example grass, tree roots, or rocks. These things help the reader gauge how high up the characters are. The characters should exchange a few blows before momentarily landing on a craggy tree trunk or back on the ground. When they resume fighting, they both leap back into the air and continue.

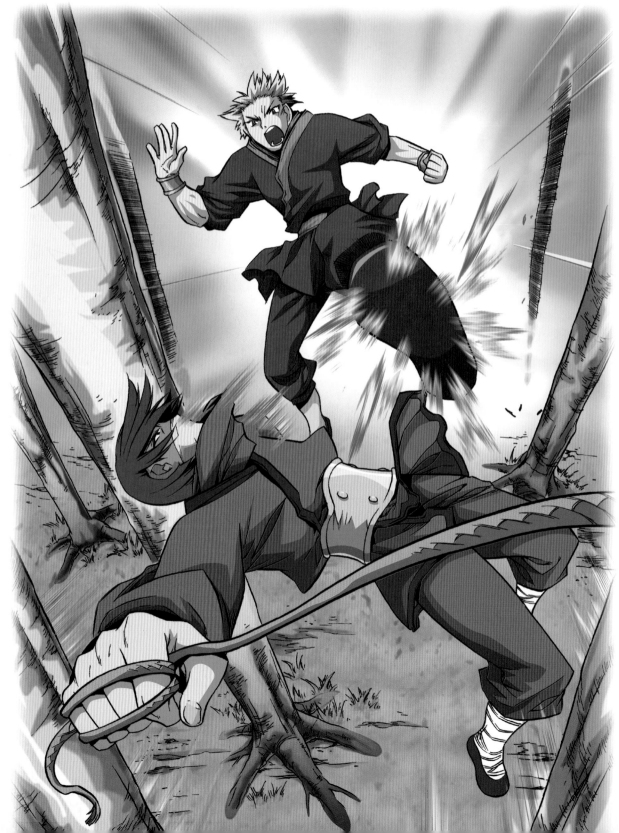

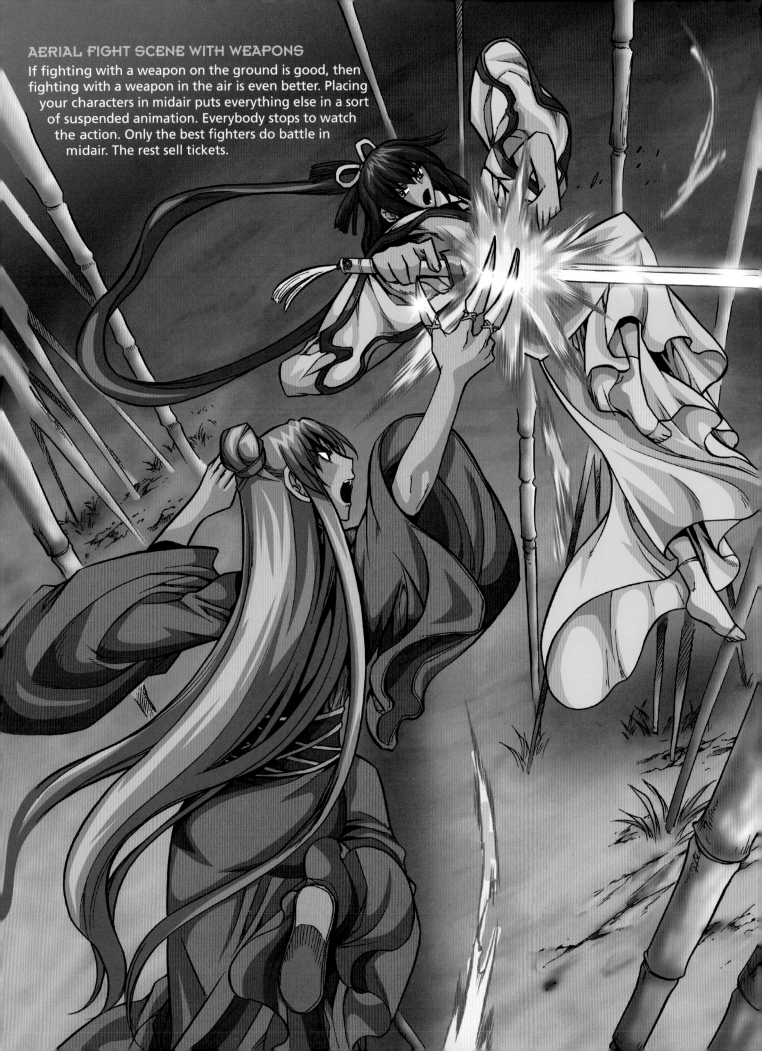

AERIAL FIGHT SCENE WITH WEAPONS

If fighting with a weapon on the ground is good, then fighting with a weapon in the air is even better. Placing your characters in midair puts everything else in a sort of suspended animation. Everybody stops to watch the action. Only the best fighters do battle in midair. The rest sell tickets.

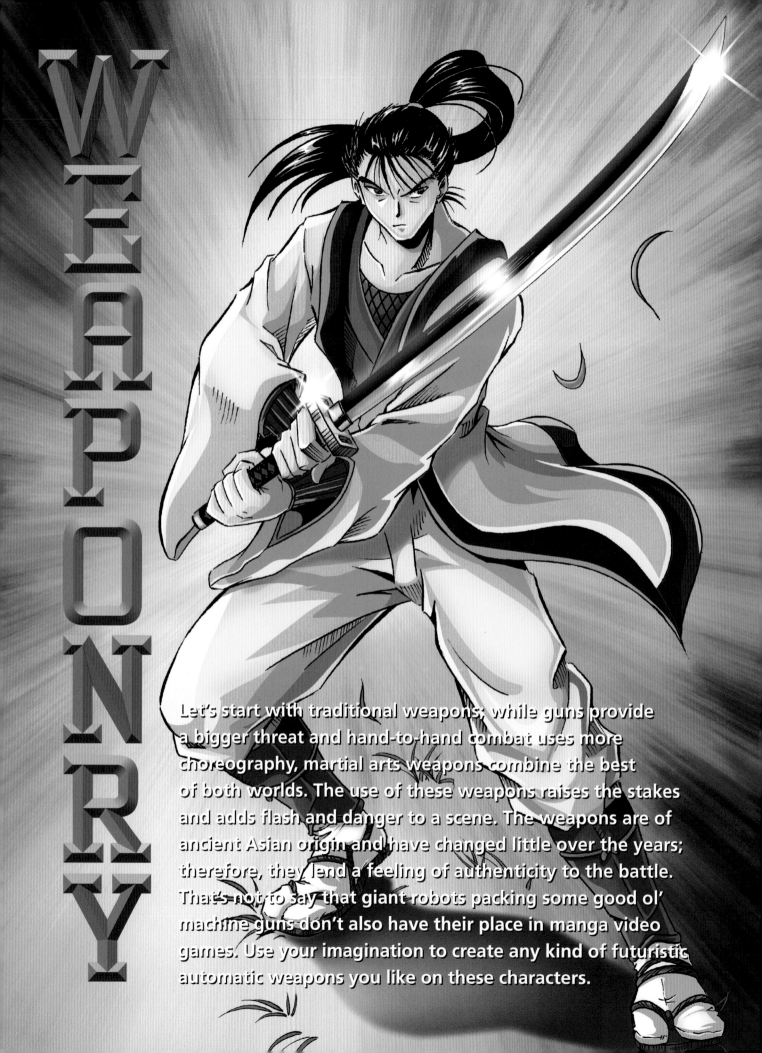

WEAPONRY

Let's start with traditional weapons; while guns provide a bigger threat and hand-to-hand combat uses more choreography, martial arts weapons combine the best of both worlds. The use of these weapons raises the stakes and adds flash and danger to a scene. The weapons are of ancient Asian origin and have changed little over the years; therefore, they lend a feeling of authenticity to the battle. That's not to say that giant robots packing some good ol' machine guns don't also have their place in manga video games. Use your imagination to create any kind of futuristic automatic weapons you like on these characters.

NINJA BUTTERFLY KNIFE

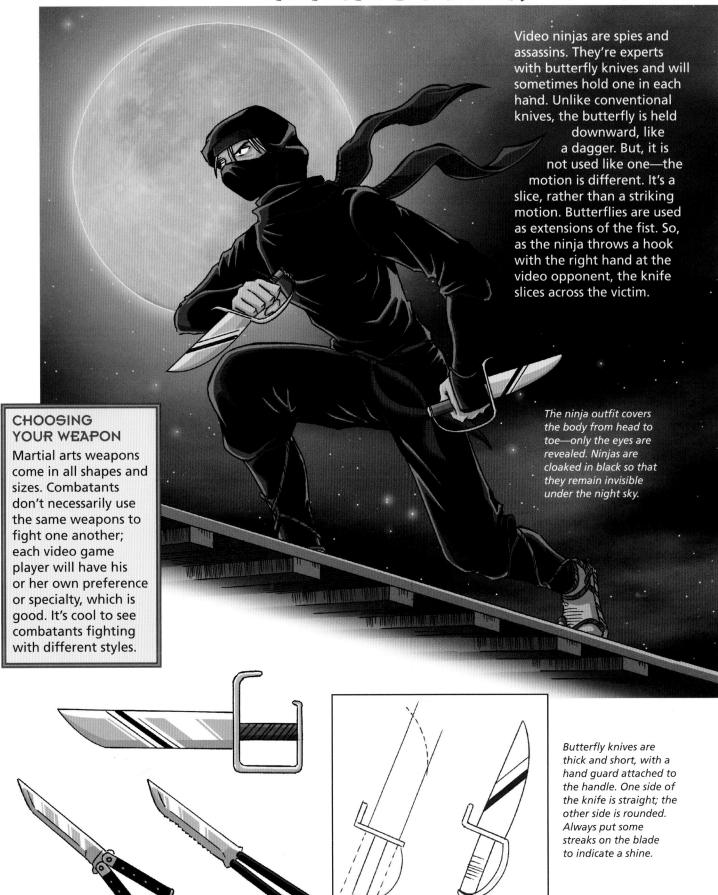

Video ninjas are spies and assassins. They're experts with butterfly knives and will sometimes hold one in each hand. Unlike conventional knives, the butterfly is held downward, like a dagger. But, it is not used like one—the motion is different. It's a slice, rather than a striking motion. Butterflies are used as extensions of the fist. So, as the ninja throws a hook with the right hand at the video opponent, the knife slices across the victim.

The ninja outfit covers the body from head to toe—only the eyes are revealed. Ninjas are cloaked in black so that they remain invisible under the night sky.

CHOOSING YOUR WEAPON

Martial arts weapons come in all shapes and sizes. Combatants don't necessarily use the same weapons to fight one another; each video game player will have his or her own preference or specialty, which is good. It's cool to see combatants fighting with different styles.

Butterfly knives are thick and short, with a hand guard attached to the handle. One side of the knife is straight; the other side is rounded. Always put some streaks on the blade to indicate a shine.

EXECUTIONER'S SHORT AX

It's always a good idea to stay away from anyone wearing a faceplate and carrying an ax bigger than his head. Trust me on this one. But you don't have to have your head on the chopping block to run into this fellow. He makes a great bad guy in any manga video game. And, although this brute has devastating power, he's also slow—and that gives the hero a fighting chance.

The short ax is designed to be carried in one hand. The blades come in a variety of shapes, but the sharp edge is always the widest part of the blade. You can cut out interior shapes in the blade to make cool designs.

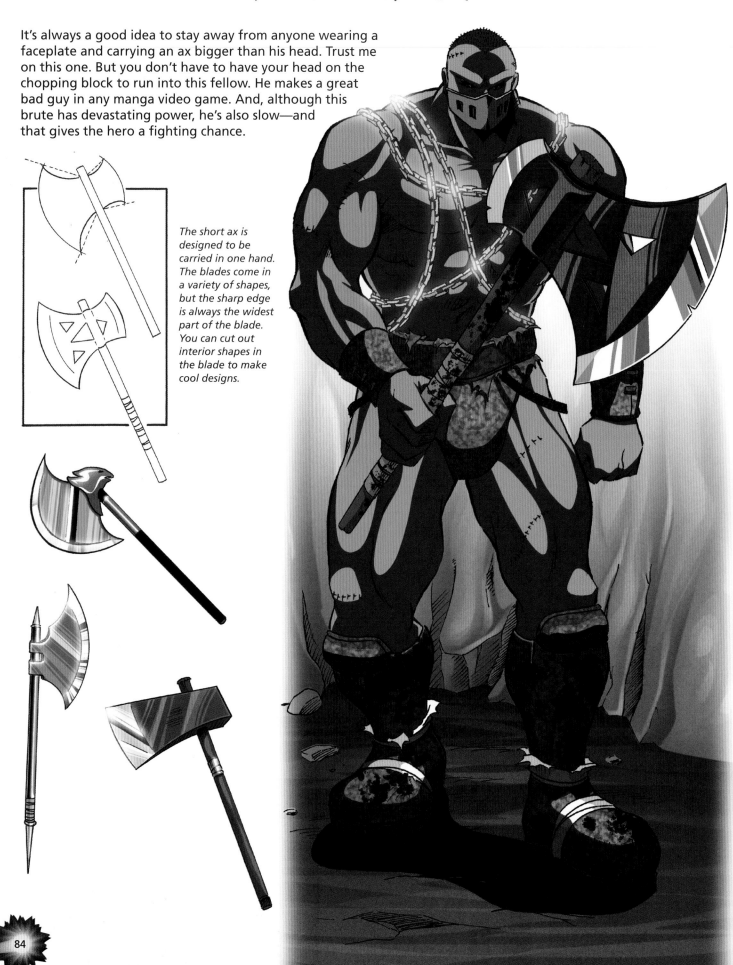

LONG AX

You don't have to be a bulked-up bruiser to handle this ax because it's designed to be held and handled with two hands. Unlike the short ax, the long ax has additional sharp edges cut into the back end of the blade. Sometimes, the staff has an additional point at the end. The staff itself can also be used as a weapon to sweep opponents' feet out from under them.

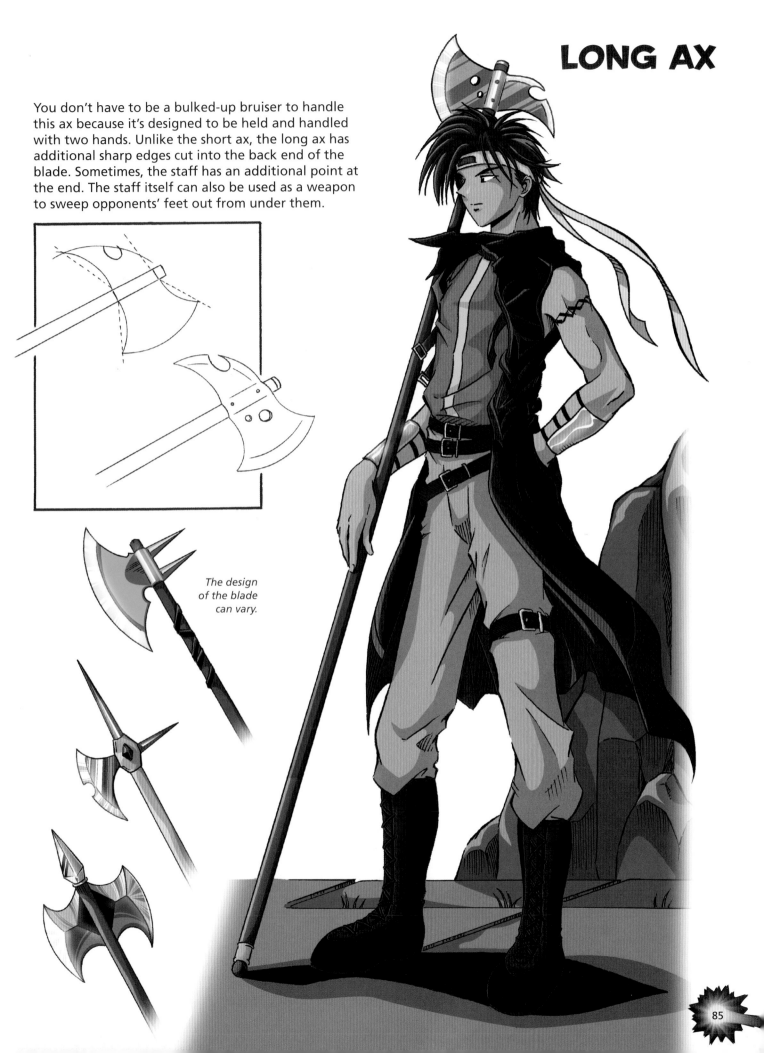

The design of the blade can vary.

SAMURAI SWORD

Samurai are very popular in video games, manga, and anime. The samurai sword has a long, thin blade. One side of the blade is straight, and the other is curved. The long line running the length of the blade indicates where it is beveled to form the sharper side. The hilt (the handle) is thin but long enough for two hands to grasp comfortably. The collar is also short and thin. The pommel (the knob on the end of the hilt) is small and not much wider than the handle itself. The design on the hilt is usually a geometric pattern. Although the sword comes in a scabbard, characters generally don't fight with the scabbard attached to them.

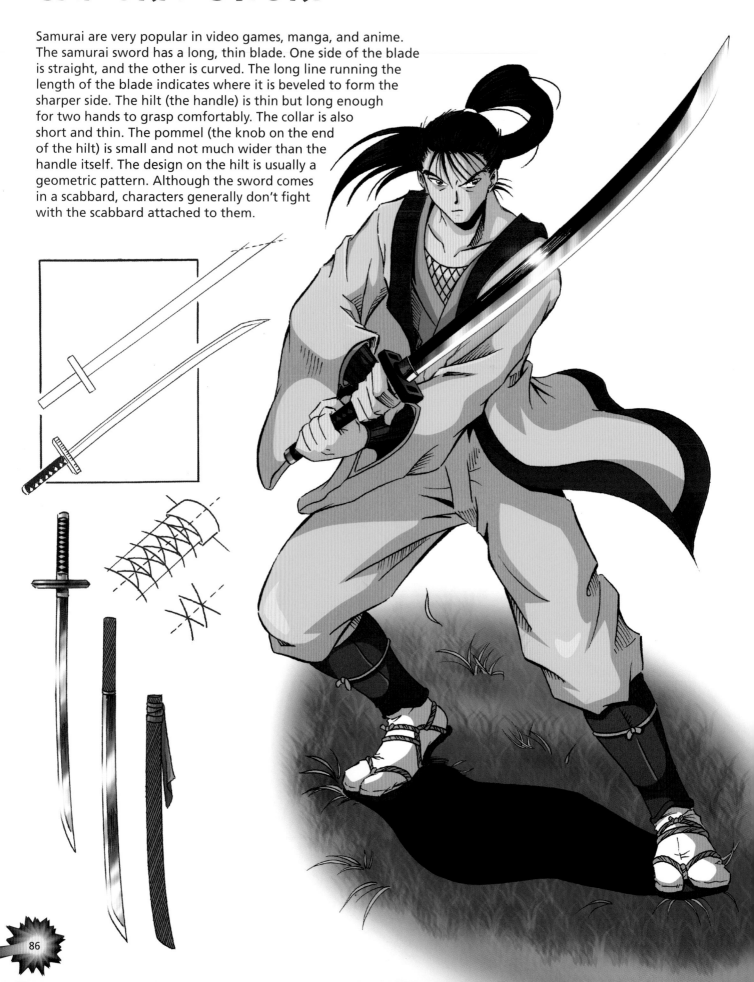

HAMMER-STYLE WEAPONS

These are basically a metal ball on the end of a stick. But the designs on the ball, as well as the cloth wrap, make it look cool. Like so many martial arts weapons, these come in pairs. Characters can wield them high or low, or can twirl them like batons.

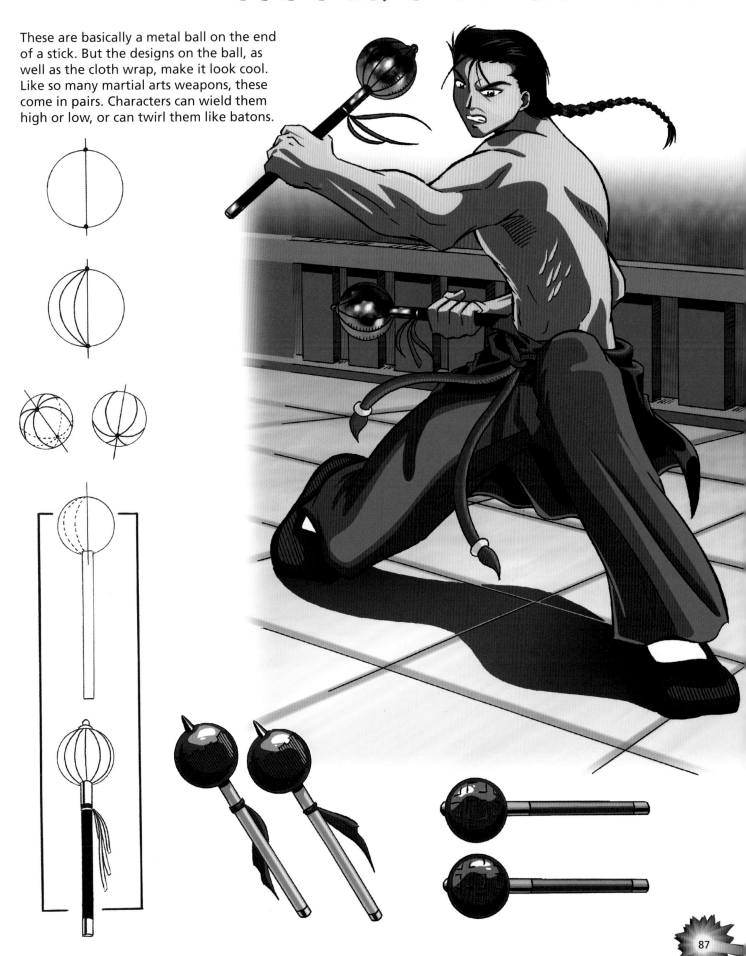

MAN VS. BEAST WITH WEAPONS

Man versus beast is bad enough, but man versus beast with sword and mace? Now that's trouble! Note the perspective, which results in the exaggerated size of the beast's sword. The samurai warrior sidesteps the strike as he reaches for his blade to retaliate. This is a classic fight in which brute strength is met with speed and cleverness.

Note: When you have characters fighting with weapons, use poses that emphasize lots of movement. Show the legs and arms opening up. Closed-in poses are defensive and not dramatic. They may be good for actual training sessions in martial arts classes, but not for manga artists.

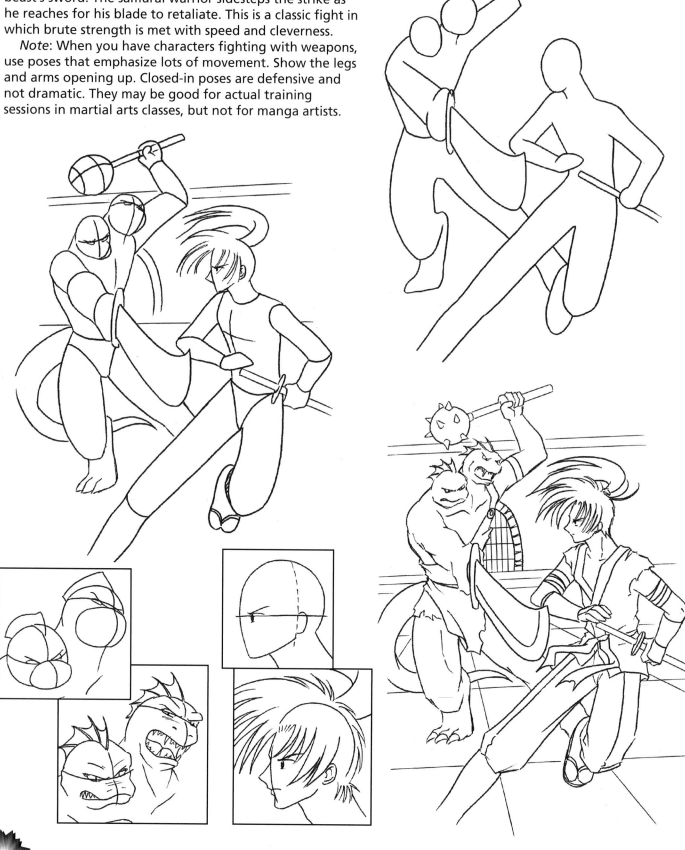

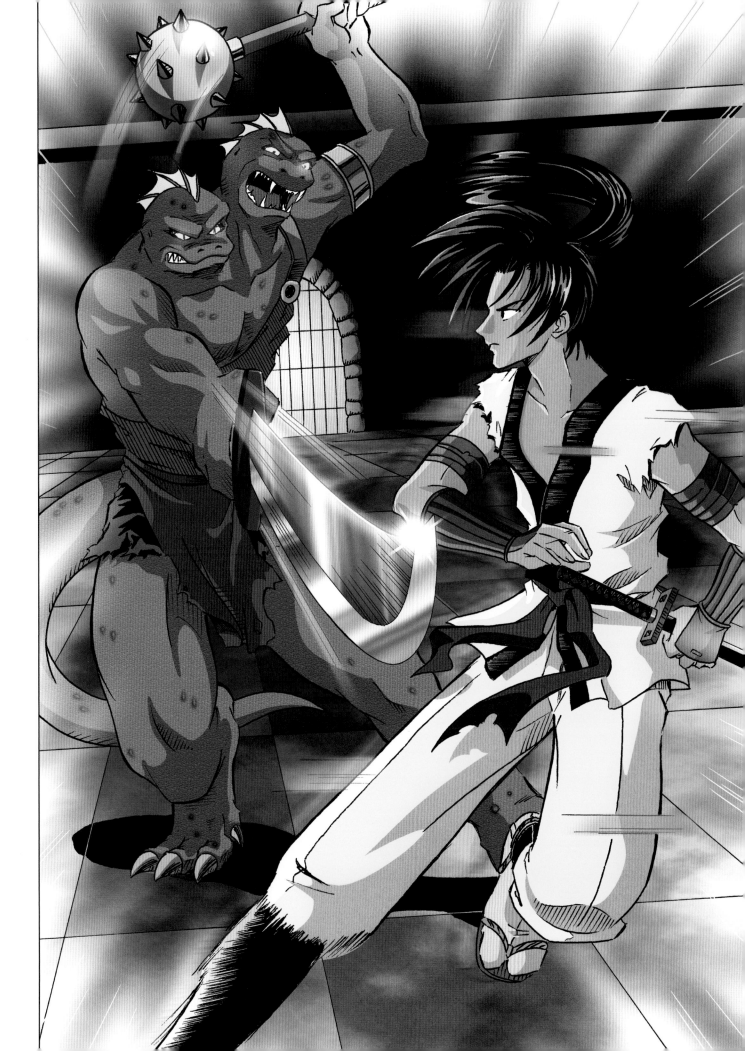

THE SAMURAI SWORD IN MOTION

This is the classic video game samurai sword strike. The blade travels from side to side. It's essential that you show the complete follow-through. Also, never show the point of impact, but do show the aftereffects, i.e. the blood spurting.

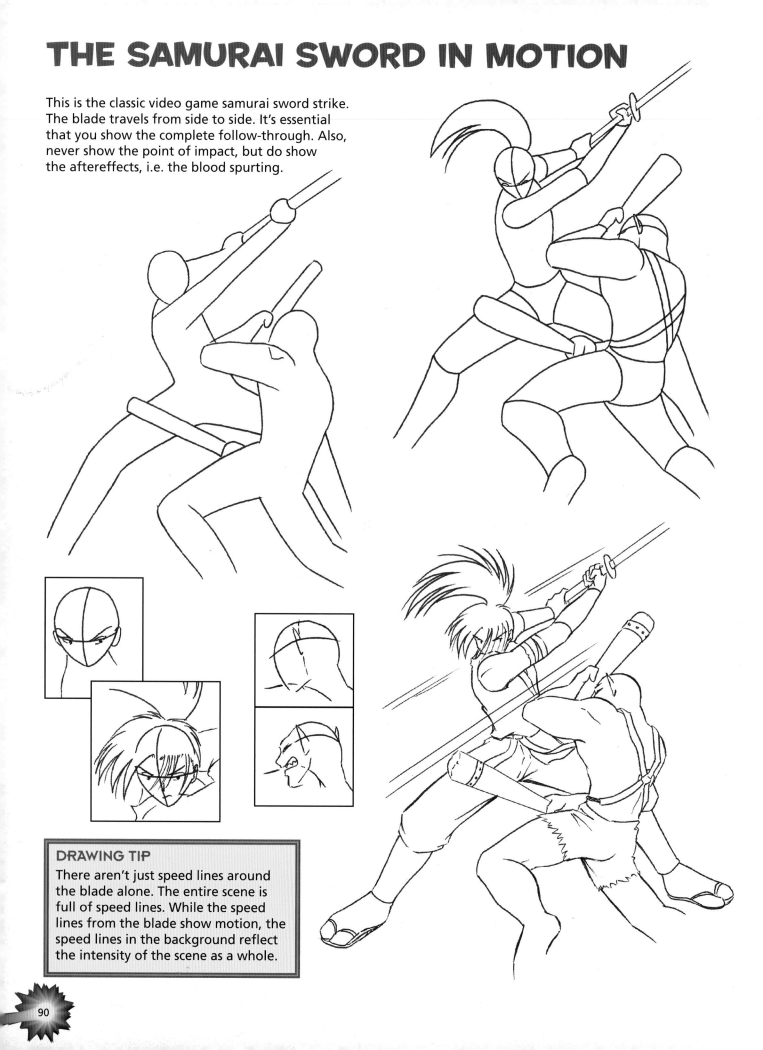

DRAWING TIP

There aren't just speed lines around the blade alone. The entire scene is full of speed lines. While the speed lines from the blade show motion, the speed lines in the background reflect the intensity of the scene as a whole.

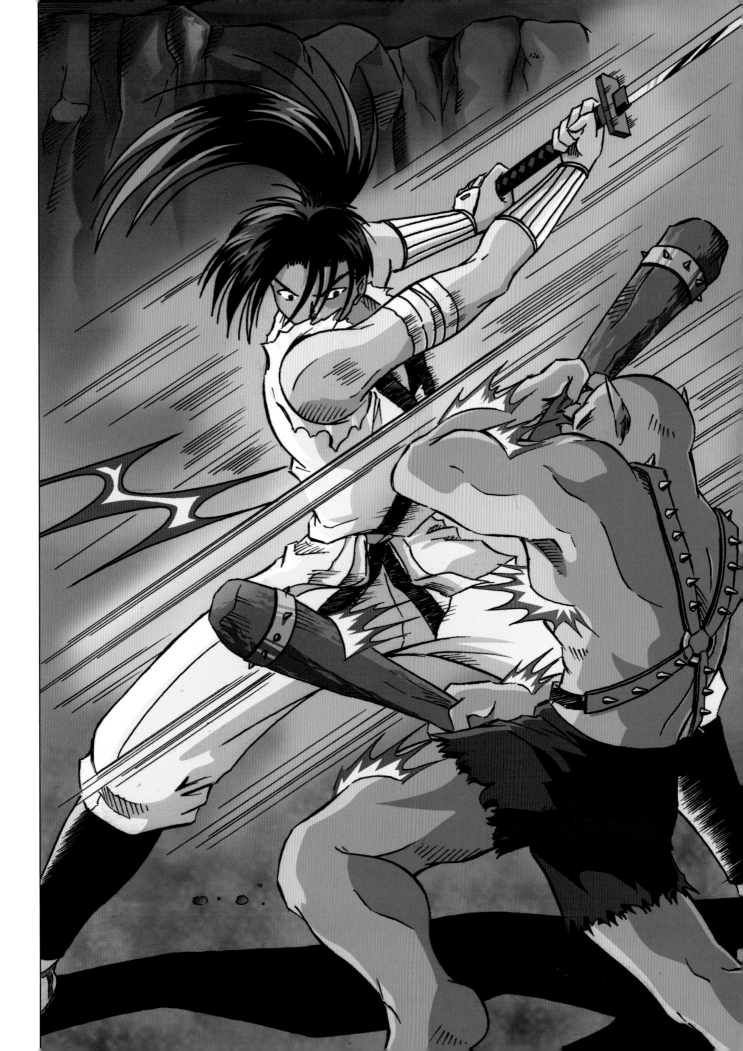

BLADE STRIKE—FRONT TO BACK

After the samurai slashes with a blade, he doesn't return it to its scabbard. He slashes back in the other direction. He's a stickler for finishing what he starts. Video games are famous for unending action, so it's important to build moves onto moves.

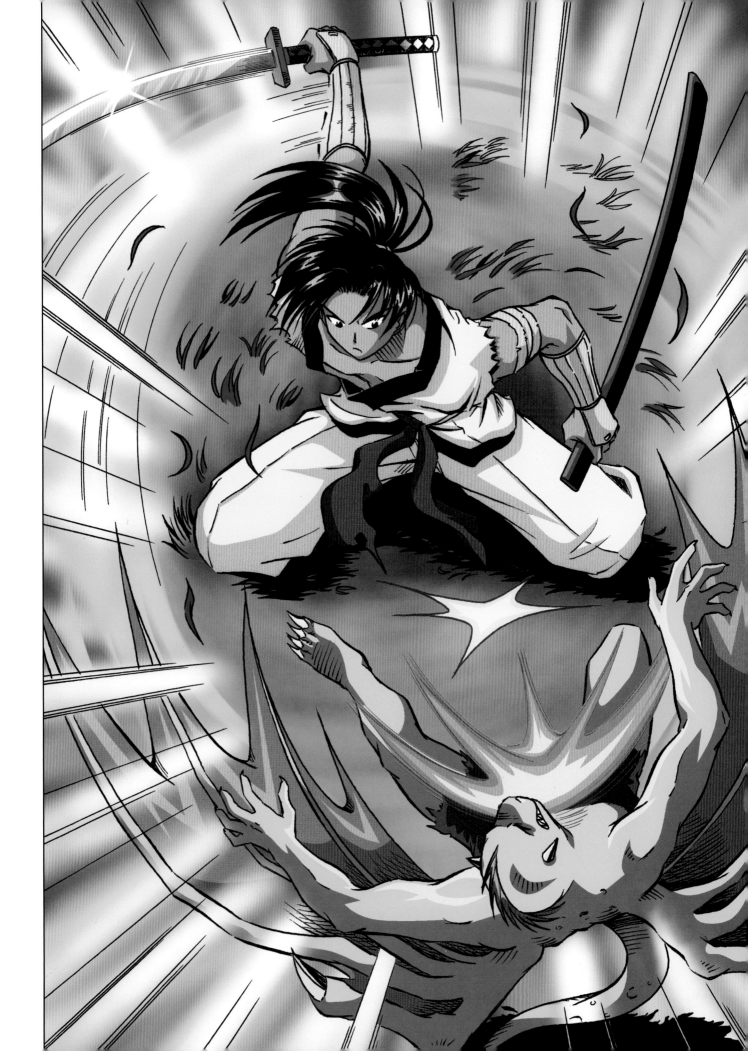

SPECIAL EFFECTS

A character can also be attacked with special effects, like a ring of fire. For example, it's good to confuse the hero once in a while so that he doesn't seem indestructible. And, as any video game player knows, it's fun—and challenging—to figure out how to get out of difficult situations.

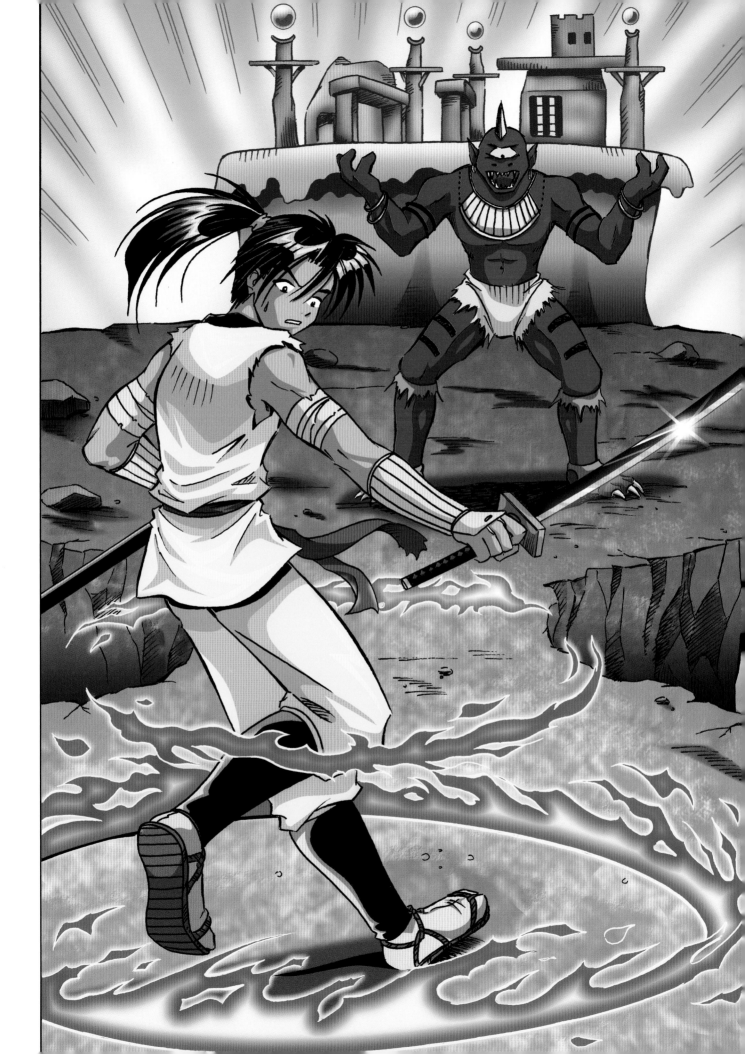

GIANT ROBOTS

What do you call something that's a vicious, merciless attacking machine? No, not an attorney. It's a giant robot. These characters are great fun because they have so many advanced weapons systems—such as missiles, rockets, and flamethrowers—built into their frame. They're practically walking weapons! Some robots are based on the human form, some on animals and insects. The fun is that they don't just attack people, they go after entire towns! As a result, the humans must mobilize their pitiful resources to defend themselves and their homes. It's humanity against a supremely powerful, faceless invader. It's classic sci-fi.

GIANT DESTROYER

Tall as an eight-story building, this powerful metal warrior is typically armed to the teeth. Weapons emerge from its shoulder guards, forearms, lower legs, and shoulder canons. Besides being designed for aggression, it should also be designed for defense since it'll have to deflect air assaults and ground bombardments. The body frame is massive and tanklike. Special protective guards are welded on to vulnerable joints. The stance must always be wide and stable. Narrow stances would make the robot easy to tip over.

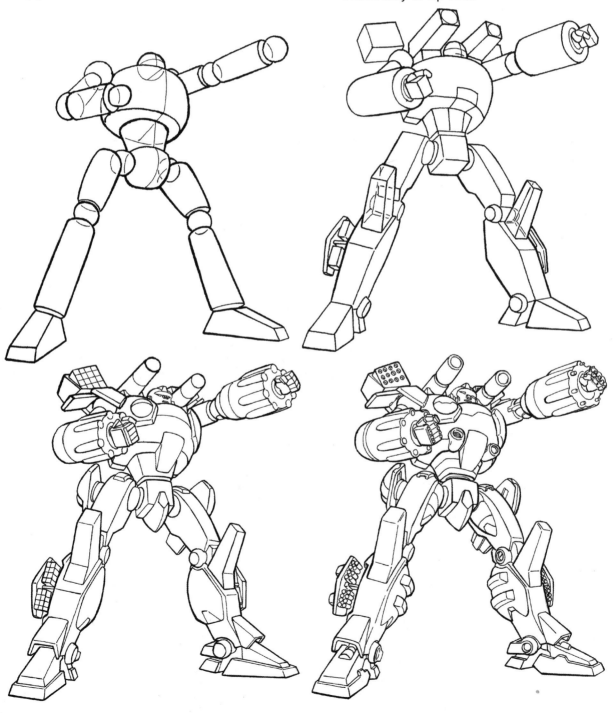

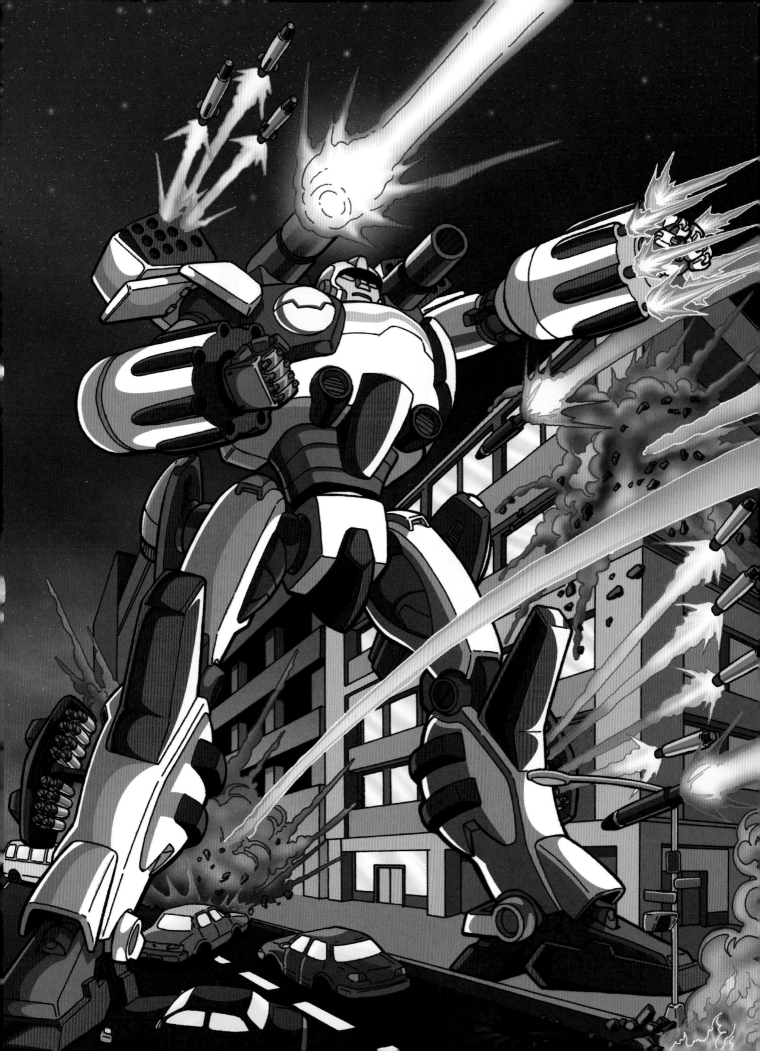

HYBRID MECHA

Weird-looking machines are a great addition to any video game battle. Since these creations have no head (only legs and a torso piled to the max with assault weapons), they give the appearance of being relentless fighting machines. Here, the legs are based on bird leg anatomy, with the backward bend at what appears to be the knee (but on birds is actually the heel). The feet mimic two bird claws. The juxtaposition of the horizontal body on vertical legs gives it a creepy look.

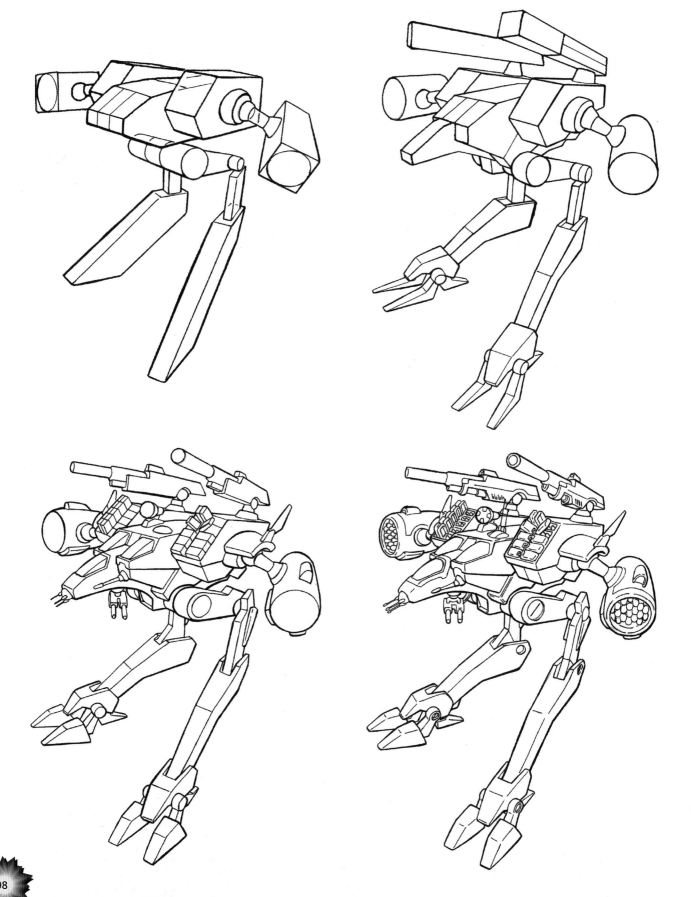

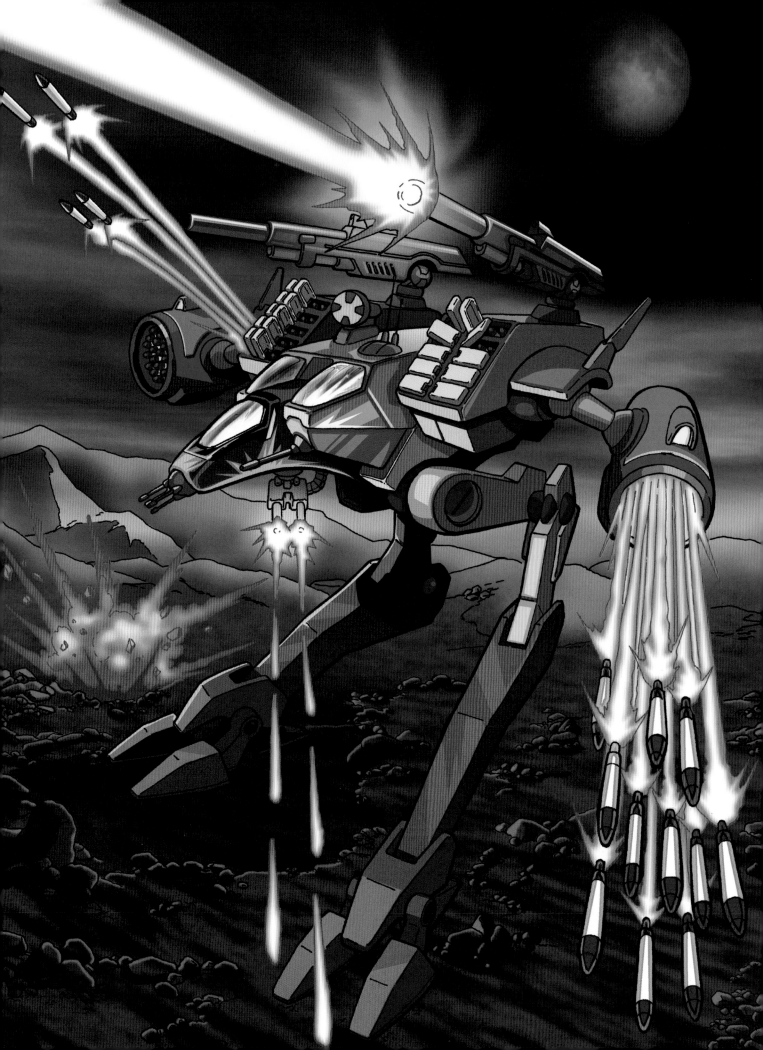

MECHANIZED ANIMALS

Giant robots are known for their destructive powers but not for speed or agility. The advantage to the mechanized *animal* robot, then, is that it's superfast. Since the animal's shape must mimic that of a real animal, there are fewer opportunities to pile on weapons systems (they would clutter up the animal's form). Therefore, it's a trade-off between speed and firepower.

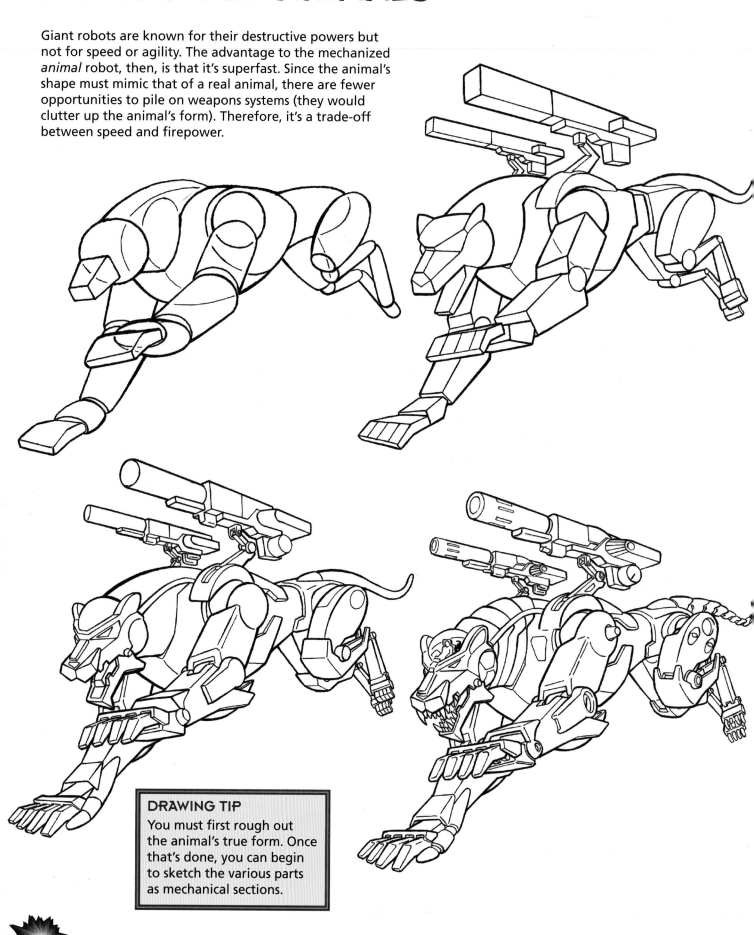

DRAWING TIP
You must first rough out the animal's true form. Once that's done, you can begin to sketch the various parts as mechanical sections.

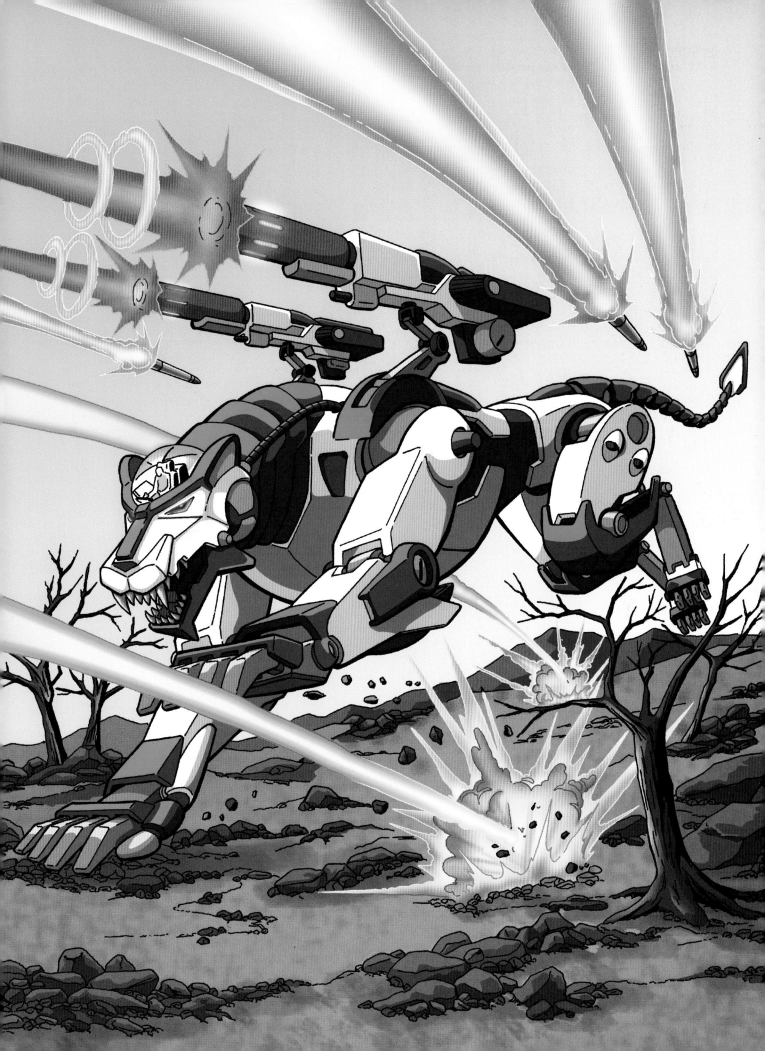

GIANT SCORPION

If you use an insect or arachnid as your model for a giant robot, use one that frightens people. A wasp, a hornet, a scorpion. A giant ladybug won't do the trick. Also, besides the stinger, most insects don't have other offensive weapons. But you're designing a fighting machine that has been created by evil engineers who've thought of everything. So, give your character as much fire power as you like. Turn other parts into weapons, for example the eyes, antennae, mouth, or arms. Or, build cannons on the back. Giant robots can fire many weapons at the same time—they're natural-born multitaskers.

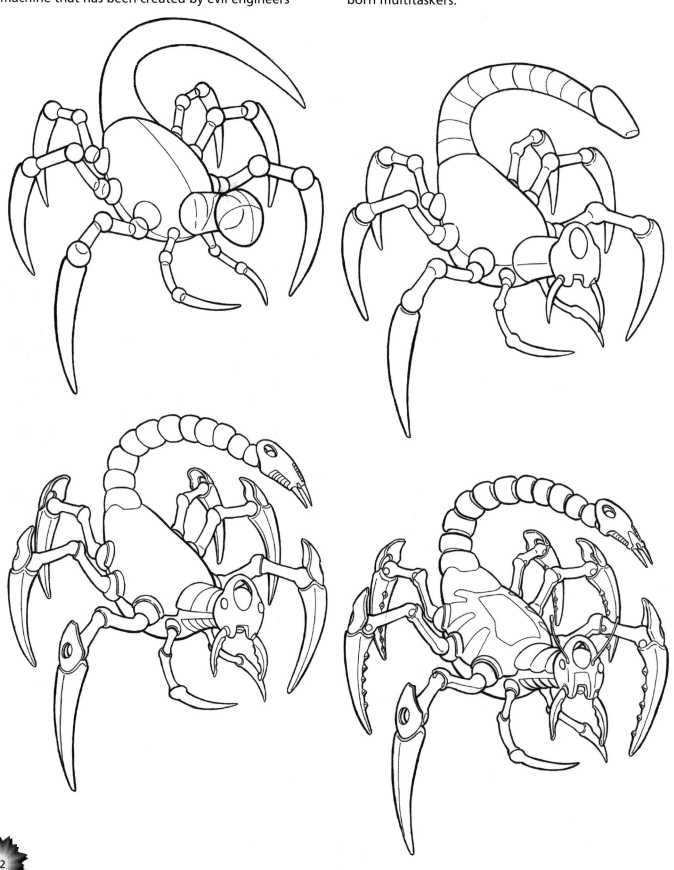

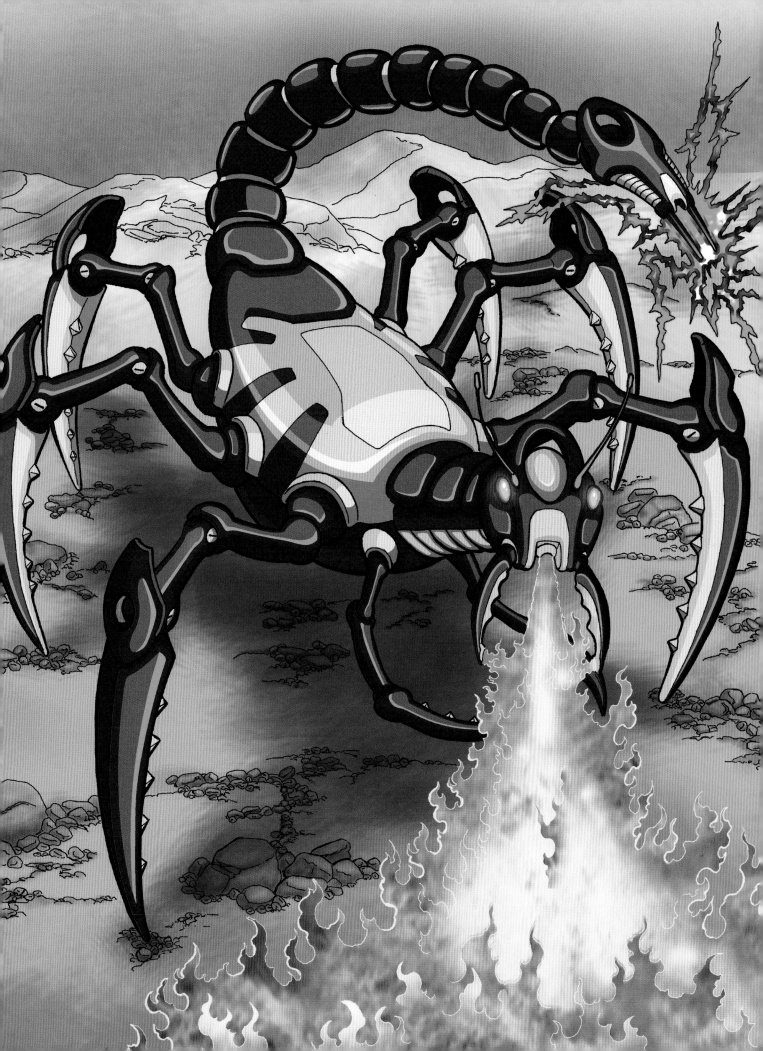

VIDEO GAME
ENVIRONMENTS

Unlike the backgrounds in comic strips or comic books, the backgrounds—called *environments*—in video games are very important to the look of a game. You want the game player to feel that he or she has entered another world as a video game character. You need to be able to create places that set the tone in terms of mood, geography, and history. These could be settings in the past, present, or future. There must be open areas for fighting and action, but also cramped, mysterious quarters from which opponents can suddenly spring. Here's how it's done.

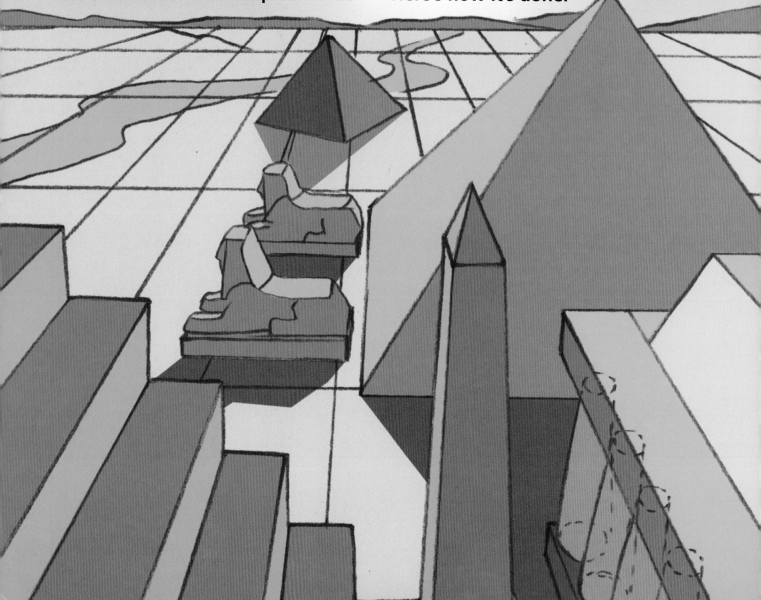

PAINLESS PERSPECTIVE

Perspective is the representation of the spatial relationships between objects as they would appear to the eye. To create successful video game environments, you need a good grasp of perspective. The most basic example of perspective is the converging of parallel lines in a drawing in order to give the illusion of depth and distance. Everything you see is affected by perspective. Sometimes a lot of perspective is called for, while at other times only a tiny amount is necessary. Perspective is used to make things look more realistic, as well as more dramatic. A train speeding toward you will have a much greater effect if the front car is huge while the rest of the cars diminish in size. A giant robot looks more awesome if, when you look up at it, the feet are huge and the head is tiny. This is perspective in action.

There are three types of perspective that are commonly used in video games: one-point perspective, two-point perspective, and three-point perspective. If you keep these ideas simple, they're easy to use.

ONE-POINT PERSPECTIVE

In one-point perspective, all the lines in a scene merge at a single point in the distance.

The first thing you have to establish is the horizon line. This is the place where you want the horizon to fall. The horizon is always at the observer's eye level (which varies depending on the scene/observer). In other words, you're looking down at everything below the horizon line and up at everything above it. The point in the middle of the horizon line is called the vanishing point. The vanishing point is always on the horizon line. All receding parallel lines in a scene (vanishing lines) will appear to converge at this point. If there's only one vanishing point in the center of the horizon line, that's one-point perspective.

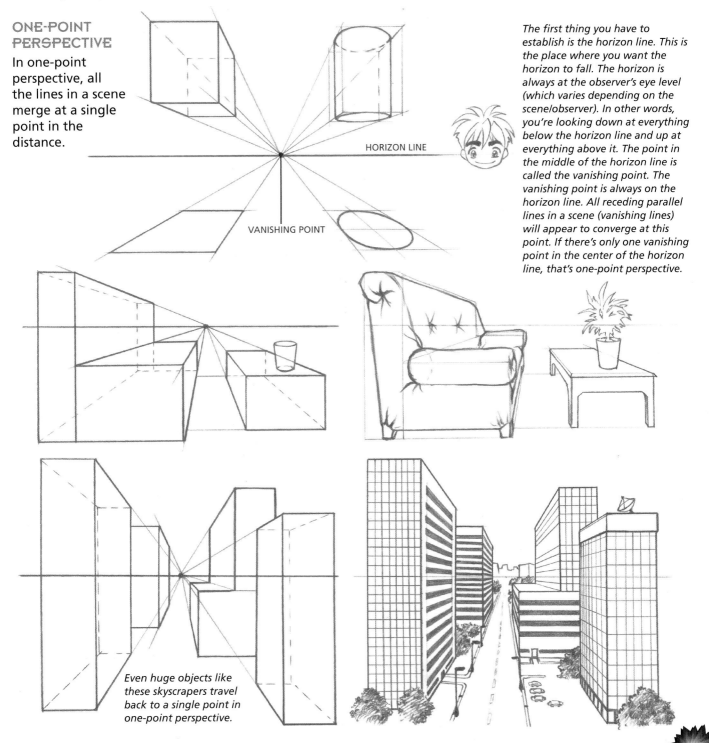

HORIZON LINE

VANISHING POINT

Even huge objects like these skyscrapers travel back to a single point in one-point perspective.

105

TWO-POINT PERSPECTIVE

In two-point perspective, there are two vanishing points along the horizon line, *vanishing point left* and *vanishing point right*. If you were to draw vanishing lines from the objects in the picture, they would vanish to both the left and the right vanishing points.

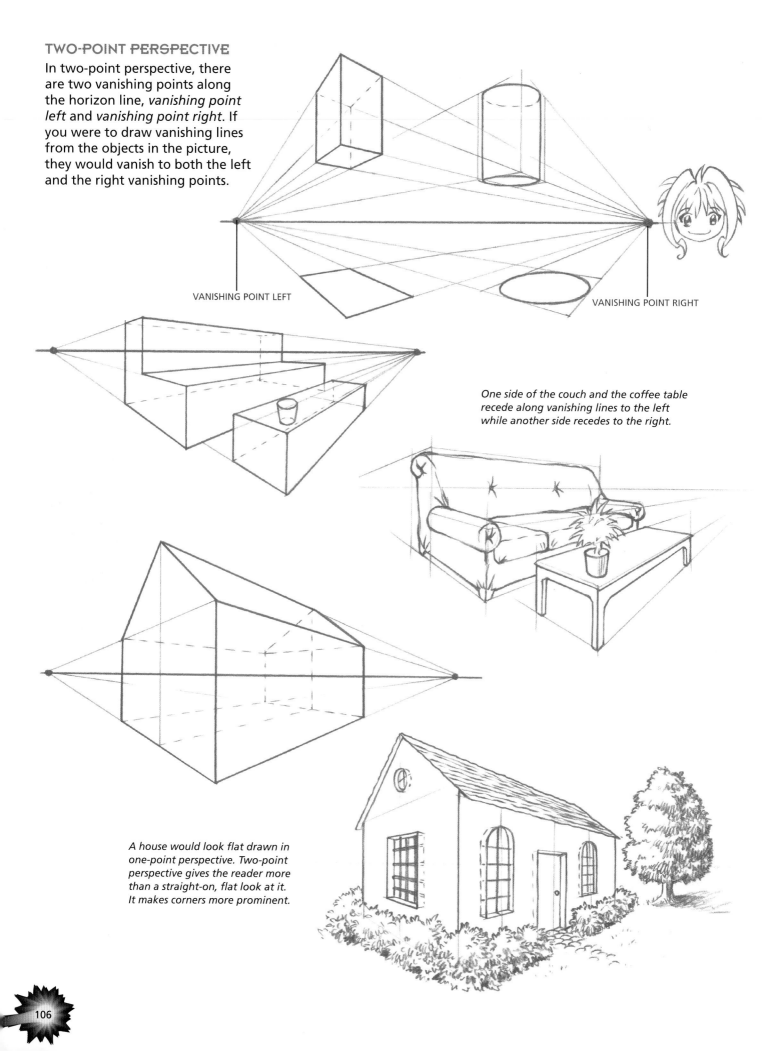

VANISHING POINT LEFT

VANISHING POINT RIGHT

One side of the couch and the coffee table recede along vanishing lines to the left while another side recedes to the right.

A house would look flat drawn in one-point perspective. Two-point perspective gives the reader more than a straight-on, flat look at it. It makes corners more prominent.

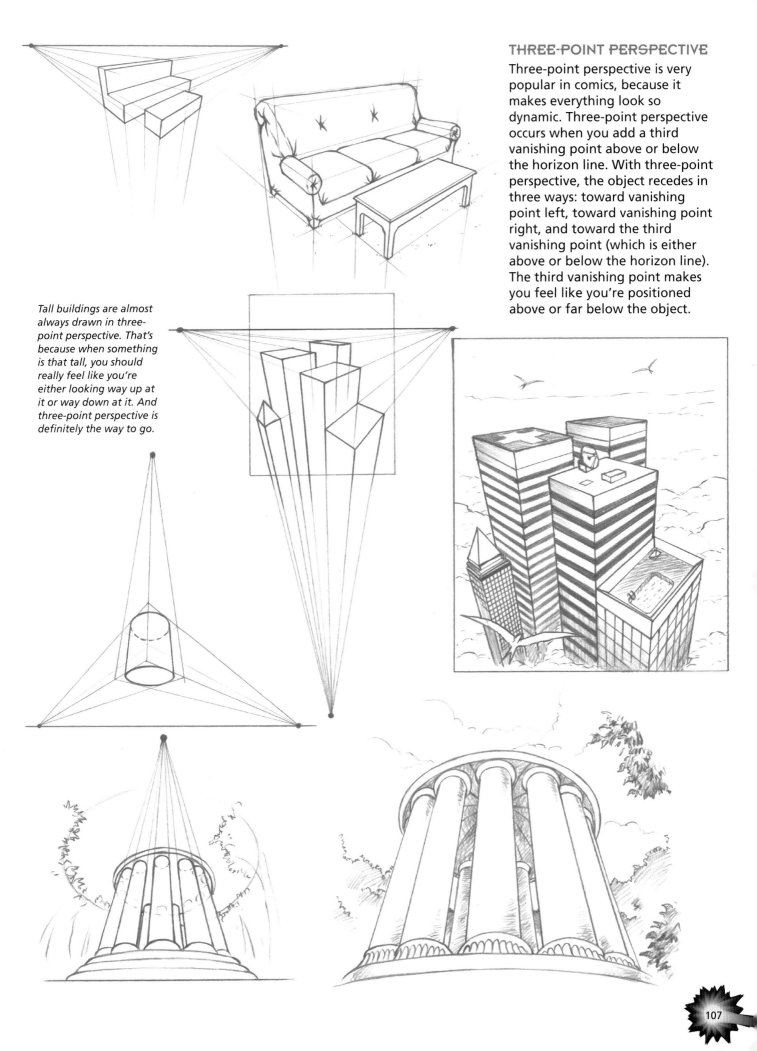

THREE-POINT PERSPECTIVE

Three-point perspective is very popular in comics, because it makes everything look so dynamic. Three-point perspective occurs when you add a third vanishing point above or below the horizon line. With three-point perspective, the object recedes in three ways: toward vanishing point left, toward vanishing point right, and toward the third vanishing point (which is either above or below the horizon line). The third vanishing point makes you feel like you're positioned above or far below the object.

Tall buildings are almost always drawn in three-point perspective. That's because when something is that tall, you should really feel like you're either looking way up at it or way down at it. And three-point perspective is definitely the way to go.

CREATING WORLD ENVIRONMENTS

Every video game has exciting and mysterious locations for the characters to explore. What should you concentrate on when designing the look of an environment? Well, it's not so much the dimensions of the space that matter, it's the style that you choose. You're the art director. You can use any props you like. You control the lighting and the shadows. You decide on the moldings, the floor coverings, whether the walls are made of brick, wood, or stone.

As an example, take a simple layout: an empty room with a door. Depending on the design and decoration, it becomes three completely different environments without the dimensions changing one iota.

THE IRRESISTIBLE DOOR
This is a recurring theme in video games. In the beginning of the game, there's a door that's a portal to another dimension. It's forbidding and yet compelling. And, it's placed in such a way that the character can't help but notice it. Don't allow other objects in the room to overwhelm the door and compete with it visually.

OCCULT

This spooky domain is created by using a witch's brew of props: batlike candelabra sconces, a gargoyle sculpture in the corner, a spooky frame around the mirror, and cobwebs. The lighting also reinforces the theme, with heavy shadows throughout the room. The light gives the door a menacing, yet irresistible, look. You just know the character is going to walk through that door, and you also know that he's going to have to win many battles to find his way back!

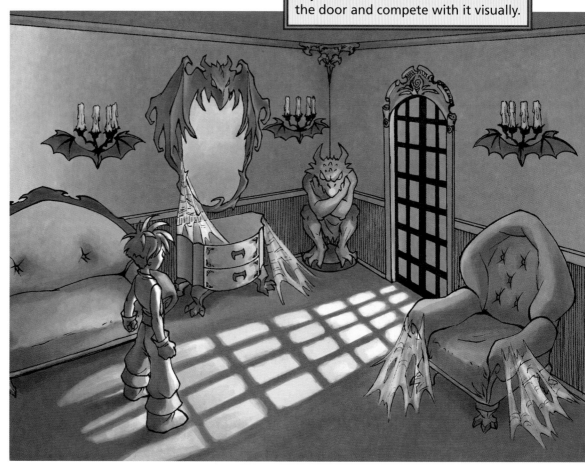

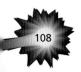

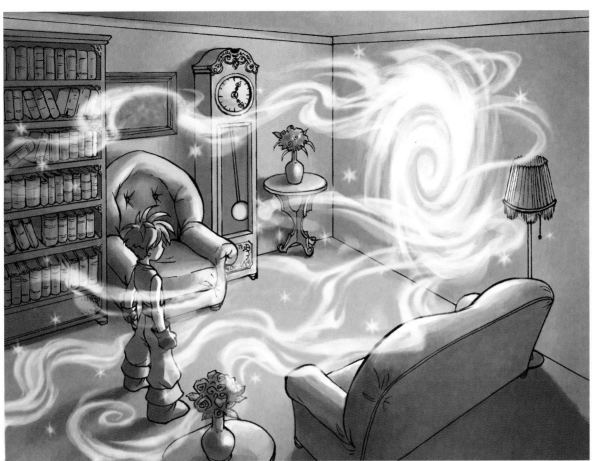

MAGIC AND FANTASY

This is a typical "precursor" scene. It's the scene just before the character is whisked into a fantasy world. The character typically has to overcome lots of obstacles to find his way back to this room. The grandfather clock (connoting the element of time displacement) and the library of books (hinting at magical spells and recipes for potions) are typical of a magical environment. But the most important part is the pervasive stream of light that winds around everything in a serpentine manner. The boy faces the pinwheel of light on the wall, wondering whether he should walk through it. (He shouldn't, but he will!)

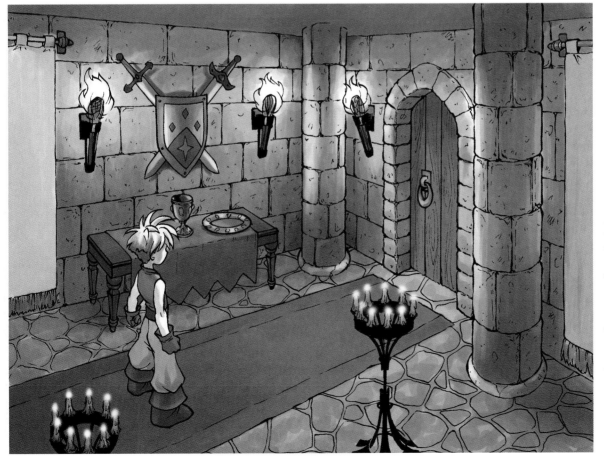

MEDIEVAL

Everything is made of stone, with columns around the wooden door to add some grandeur so that we instantly know we're in a castle. The props are swords and shields, torches to light the way, a royal carpet, and tapestry wall-hangings. The torches provide effective, mysterious lighting. There's only one way out, and it's through that door.

FAVORITE SETTINGS

Video games feature truly creative settings that capture the imagination of game players. And because of that, some favorite environments are used over and over again in a variety of games, each with a new spin. Here are some of the most popular locales in which video game characters find themselves.

ARENA

The arena is as old as the Romans. And it's just as dangerous now as it was then. Sometimes it's an arena of the future, sometimes of the past, and sometimes it's a fantasy arena in the present but in a different world. The walls are high, preventing any hope of escape. The rafters are packed with noisy crowds cheering for the bad guys. Often there are weapons on the floor, to be grabbed by whomever is the quickest. Repeated columns are a popular motif. The arena is easy to represent because it's really just a half-circle with bleachers. And show the crowds—but not with any detail.

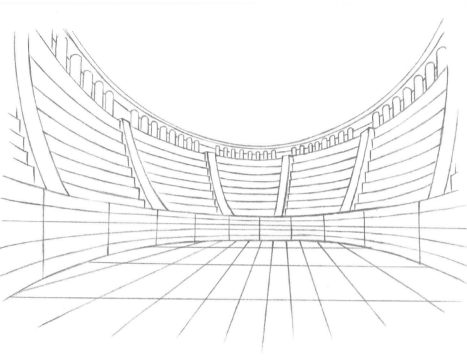

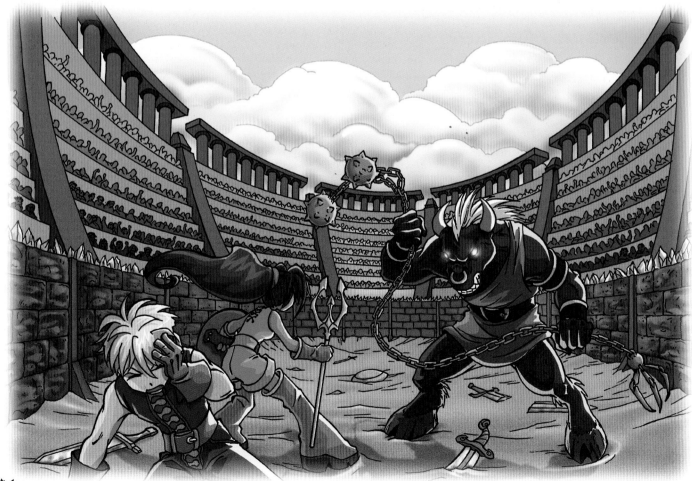

MARTIAL ARTS TRAINING GROUND

Any courtyard can be turned into a training ground for hand-to-hand combat. To give it an authentic Japanese look, include a stacked tile roof. A roof with raised corners is also a uniquely Asian type of element, as are the wooden pane designs within the round windows. The wooden fence ties in with the window design. The columns, stone steps, and stone ground give it the solid look of a martial arts temple.

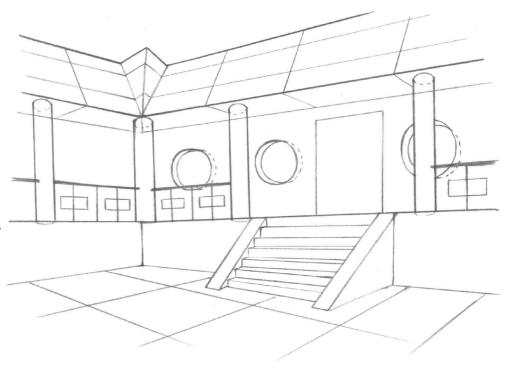

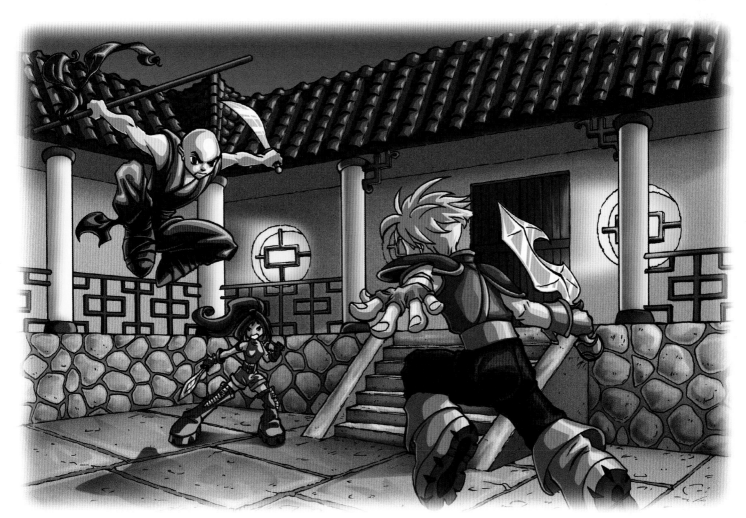

UNDERGROUND AZTEC TEMPLE

Underground temples and secret passageways are exciting because anything can pop out of them. The floors can open up to an alligator-infested pool. Secret doors can lead to escape or to doom. The designs on the stones are geometric, which is a typical Aztec style. And get a load of the skeletons! Skeletons always mean that someone else was there before—and didn't manage to find a way out. They heighten the peril for your heroes. (Note that this passageway is shown in simple one-point perspective.)

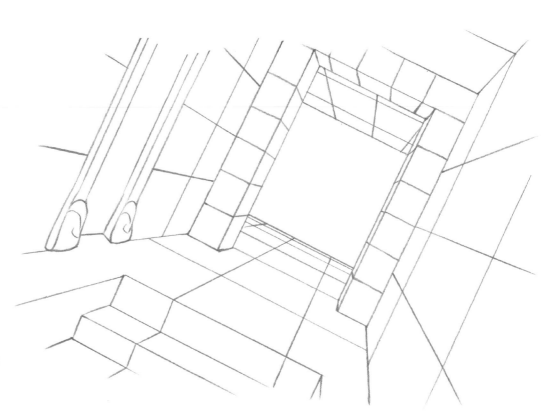

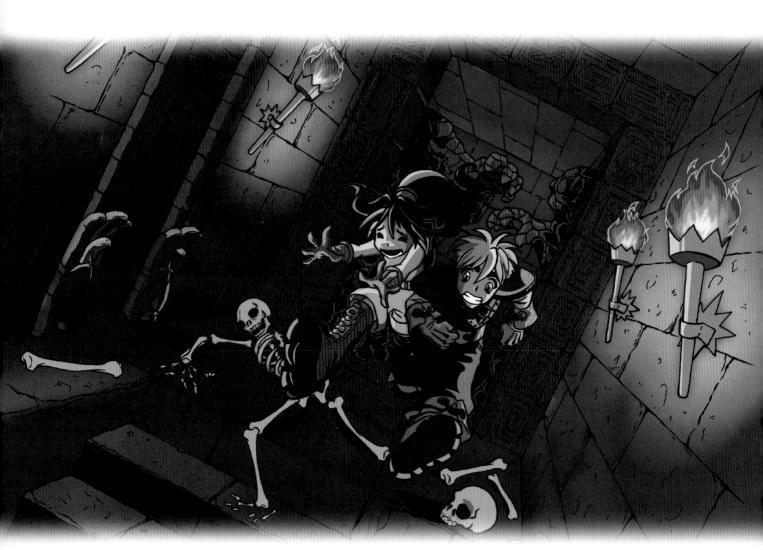

PYRAMIDS

Rumors and legends have endured for centuries about the great powers of the pyramids—and the curses that befall anyone who dares to breech their sanctity! If you dare to enter their ruins, you'll be attacked by all types of evil beings, including the living dead who guard the treasures of the deceased pharaohs. Inside, the pyramids are mazes, with serpents, mummies, immortal queens, and brutish guards. You must fight ghostly spirits and birdlike creatures to get to the entranceway. Me? I'd take a pass and go to Capri.

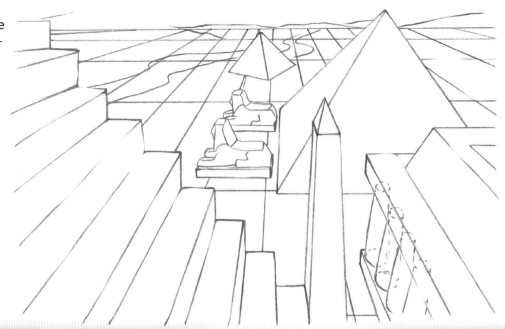

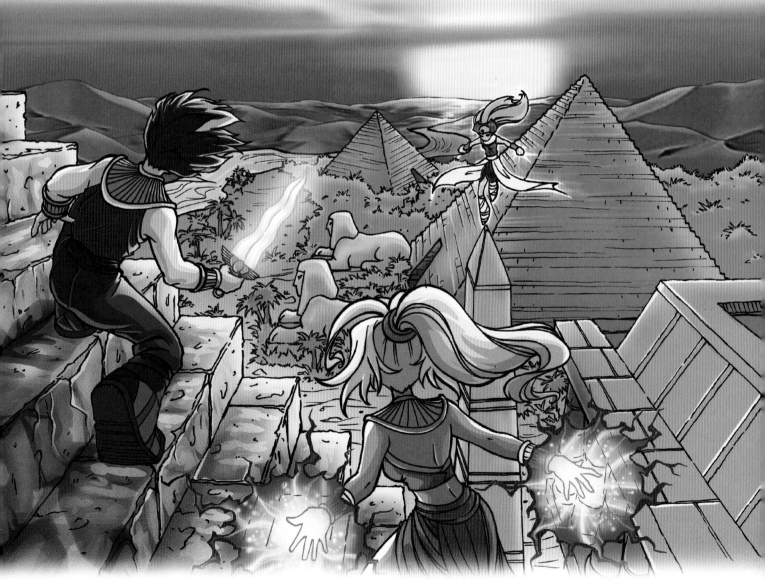

113

FANTASY FOREST

In a manga video game in which your characters are lost and must find their way out there's no environment more effective than the fantasy forest. It's so overgrown that hardly any of the sky can be seen. The trees seem to curve inward in a way that looks like they're trapping anyone who dares to walk through them. There are no right angles, nothing to help you get a sense of direction. It's intentionally confusing. Of course, there's an archway, which is a threshold that begs to be traversed (in effect, another irresistible door). Is it my imagination or does that archway look like bad news?

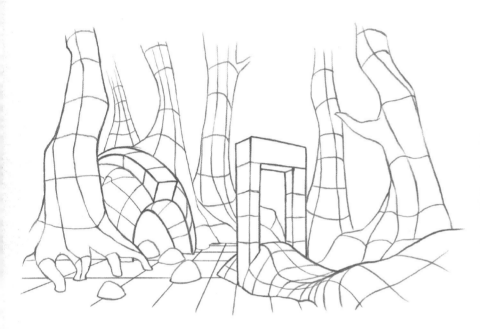

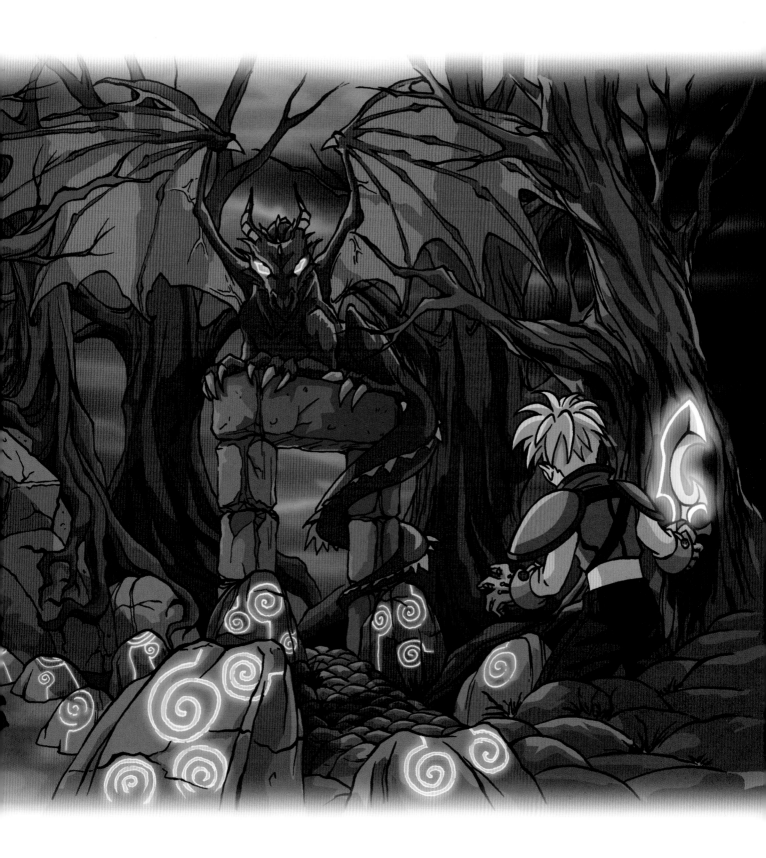

HIGH-TECH FUTURE

The high-tech future makes a great backdrop. When you lay down a futuristic environment, you can use all sorts of cool weapons, like laser blasters. Evil alien creatures abound. And cool stuff—like narrow bridges over alien goo—is the norm. Think *industrial* when you think of futuristic interiors. Nothing soft or fuzzy here. It's a world without upholstery.

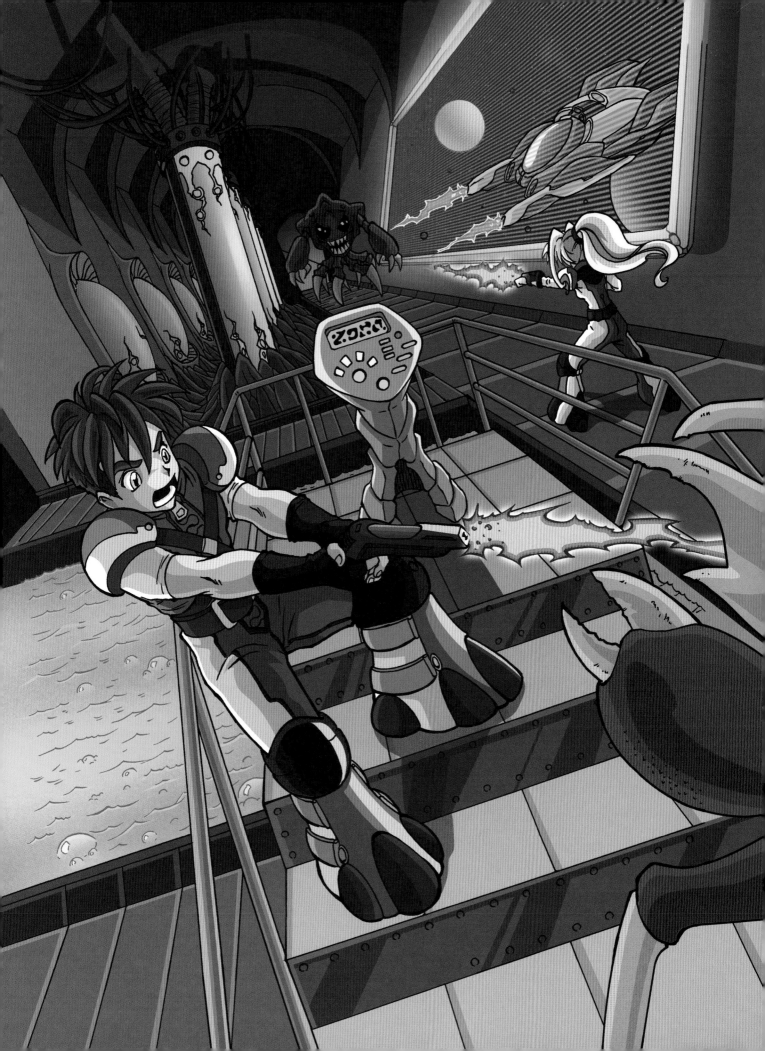

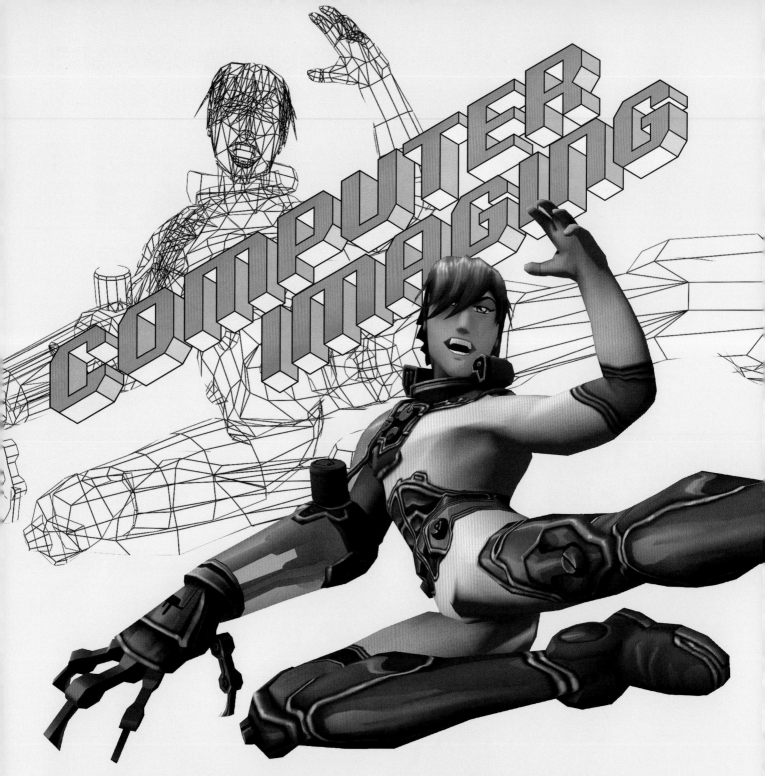

COMPUTER IMAGING

The pencil drawing serves as the foundation for the character and the environment. Known as *concept sketches*, these pencil renditions must then be translated into computer code in order to create the images that appear on-screen. It's a reciprocal process: the computer programmer tries to make the model reflect the artist's drawing, while the artist tries to draw something that the programmer will be able to reproduce digitally. As a freehand artist, it's very cool to see your work transposed into three dimensions. This chapter takes a look at how it's done.

COMPUTER-UNFRIENDLY IMAGES

Some drawings don't translate well into computer images. You may have to make some adjustments to your drawings to tailor them to the computer's capabilities and limitations. But this turns out to not be very creatively restrictive, actually. Most characters fall comfortably within the guidelines of computer software capability. However, there are always some exceptions.

FLOWING ELEMENTS

Long, flowing elements are difficult for the computer to tackle gracefully. This includes flowing hair, drapery, and swirling shapes. Not only would these look awkward in computer animation, but the complexity would slow down the movement, not to mention add to the labor costs.

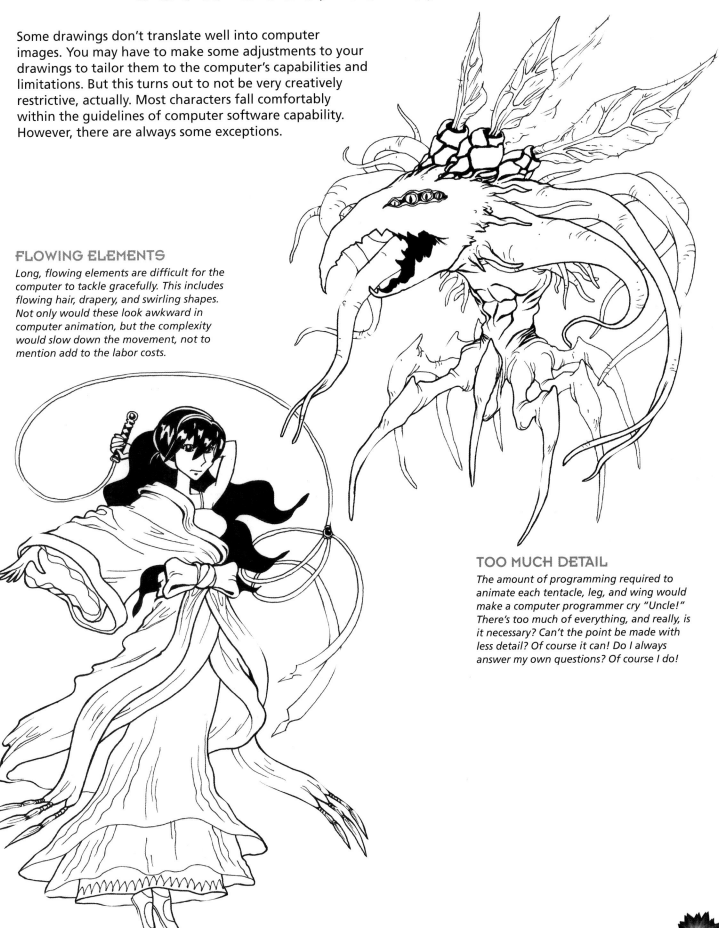

TOO MUCH DETAIL

The amount of programming required to animate each tentacle, leg, and wing would make a computer programmer cry "Uncle!" There's too much of everything, and really, is it necessary? Can't the point be made with less detail? Of course it can! Do I always answer my own questions? Of course I do!

ROUGH SKETCH

This character starts as your basic hero character, but the artist adds a mechanized arm with razor claws because, heck, we don't want him to be a Goody Two-shoes. Begin your drawing for a video game character or environment as you would any other: start off with a general pose, then refine it and add detail. Don't use scratchy shading, because the computer won't be able to reproduce that. You also don't want to leave areas that are vague and sketchy; the computer likes solid, closed lines. Simple shapes and the basic humanoid form are easy to animate.

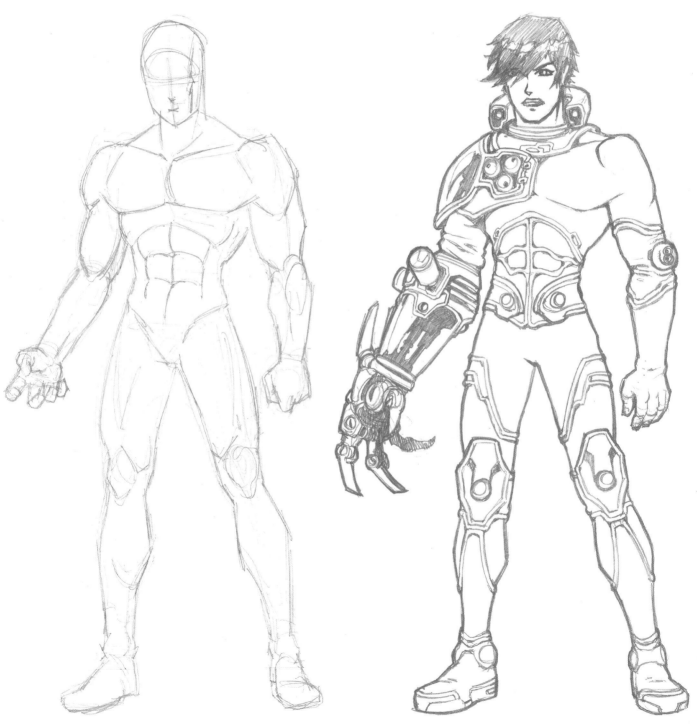

INKING AND COLORING

Once the character is established, it can be turned into a successful three-dimensional computer image. To begin the process of taking the pencil stage toward a finished concept, it needs to be inked. Then the rough pencil marks should be erased. Color can be added with marker to serve as a color guide for the computer artist to follow and embellish.

What makes this image work? It's really what has been left out, not what has been included: There's no long hair that would blow in the wind. There's no draping cloth that would require lots of overlapping action (i.e., dragging a beat behind the rest of the action). It's important that your character cuts a clean silhouette, as it will help the action read more clearly.

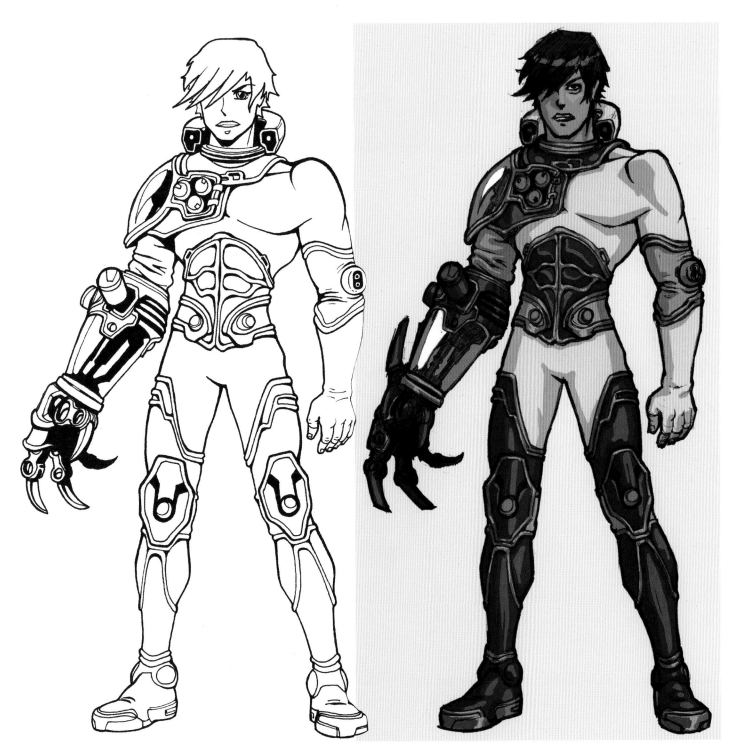

POLYGONS

Polygons—multisided shapes—are used to make up the surface of a digitized character. On a finished digitized character, they're unseen by the human eye, but they're embedded in the computer code just the same. It takes a whole lot of polygons to create the head and a whole lot more to create the body. Typically, these polygons are triangular in shape, with three points (vertices) and sides (edges) establishing the area of each polygon. Occasionally, the polygons have more than three edges, as on the ears in these images. (See pages 124–125 to see how the digitizing process starts.)

THE ELEMENTS OF THE POLYGON

VERTEX
A vertex is the point at which two edges of a polygon meet. Triangular polygons have three vertices. There will be many vertices over the entire surface of a digitized image.

EDGE
An edge is a line that connects two vertices.

POLYGON
The polygon is the solid shape formed by the edges and vertices, and that now is a section of the surface of the face. The polygons in video game animation are always triangles (and the polygons that aren't triangles can easily be divided up into triangular shapes).

MESH

Mesh is what you call all the combined vertices and edges that make up all the polygons in a model. Figures covered in polygons look like they're made out of chicken wire, and in a sense, they are. But it's virtual wire, based on the assembled polygons. (Note that even the polygons that look like squares or rectangles are actually two triangles placed together.)

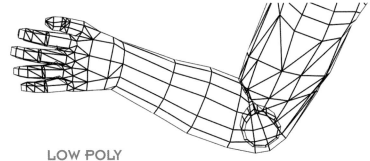

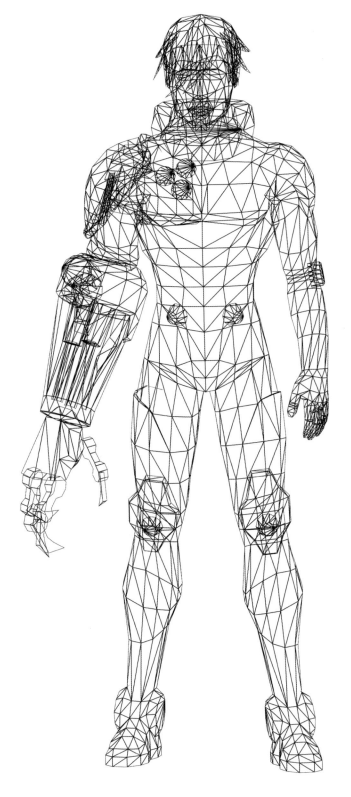

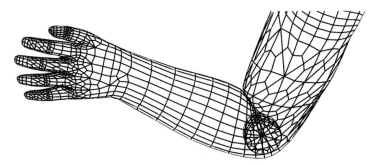

LOW POLY

Low poly *is a game developer's term that refers to a low density of polygons, or simple mesh. Low-poly figures result in less-complex characters.*

When you're playing a video game and you input a command, the computer has to create an image right then and there—in real time—in order to make the figure do what you tell it to do. To make the computer image respond quickly to your commands, a low-poly treatment is used. The simpler the wire mesh, the quicker the character obeys commands because less information needs to be processed.

MID-POLY (GAME MOVIES)

When there are actions or scenes in video games that are not controlled by the player, the images don't need quite the speed of response that player-controlled low-poly elements require. So, these elements can have a more complex mesh, which in turn makes for smoother movements. These types of elements are called video game movies, or sometimes "cinematics."

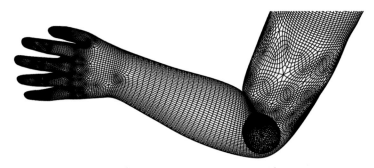

HIGH POLY (THEATRICAL MOVIES)

The wide screen of a theatrical feature is vastly larger than your video game screen at home. It allows the audience to see every part of a character in minute detail. Therefore, a character's wire mesh must be much denser and much more detailed in order to look believable.

123

MODELING

Just like a sculptor working with clay (but instead using a computer program like 3D Studiomax or another advanced three-dimensional program for game development), a computer programmer views wire mesh as something to work with, change, and mold into a variety of shapes. Unlike a sculptor, however, the programmer must build one individual section at a time (and also gets a lot less messy than a sculptor and rarely wears a smock). The programmer can manipulate shapes, bending, stretching, and compressing them. Here's the basic process:

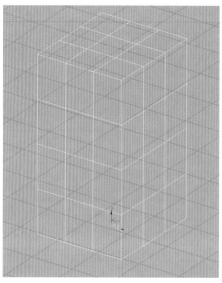

The computer programmer starts with a box that has been divided into sections. Although it looks like a series of squares stuck together at this point, the squares are made up of two triangles stuck together. Everything is made up of triangles. This will be one section of the final figure.

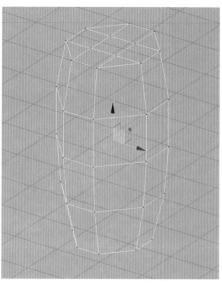

The programmer then pushes and pulls the polygon vertices to create the desired shape for that section.

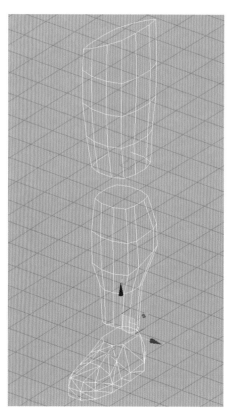

Subsequent sections are created from additional blocks and are gradually assembled.

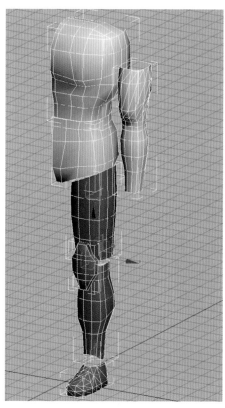

By adding more "verts" (vertices), more detail and a smoother surface are attained.

Mirror imaging and patch modeling are cool time-saving applications that make a programmer's life easier. They allow programmers to focus more attention on the creative aspects of digitizing.

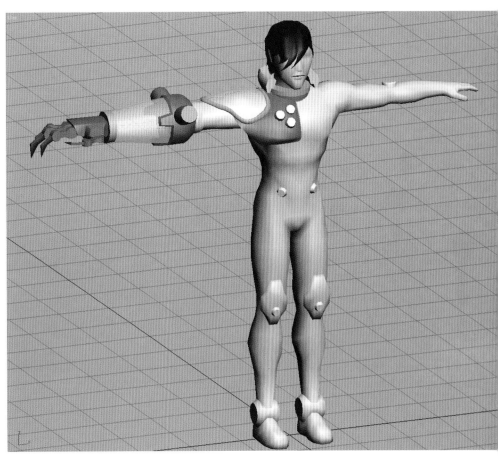

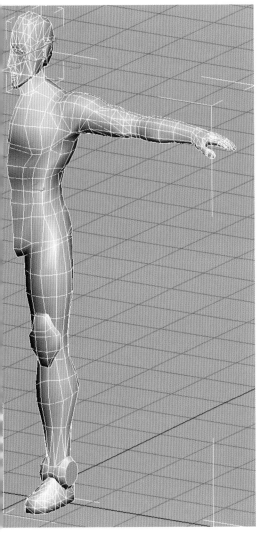

MIRROR IMAGING

Once the first half of a figure is done, it would be arduous and time consuming to build the second half of the body in the same way. A special mirror tool in the software program can duplicate the first side of the body, completing the figure in half the time.

PATCH MODELING

This technique in effect creates a mesh support for a more complex part of a figure and then drapes the finished surface over it. In this example, it was used to create the hair, which is composed of many complex shapes and is, therefore, difficult to make. Patch modeling allowed the programmer to create a mesh for the hair and then drape a "cloth" of hair over it.

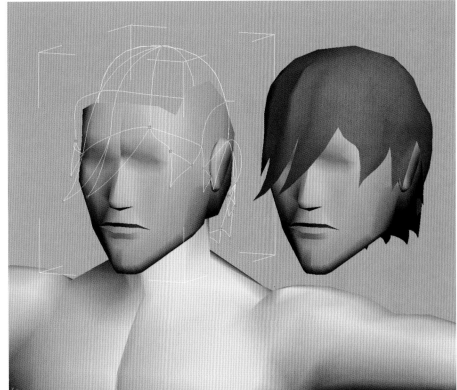

TEXTURING

In a process called *texturing*, textures are applied to the character to create the costume and the features of the face to make the image look real. Like the body structure, these textures are created out of patterns and polygons. Programmers will sometimes revert back to the model without the texture, to troubleshoot and see if the underlying frame is correct. The process of texturing is also referred to as *skinning*.

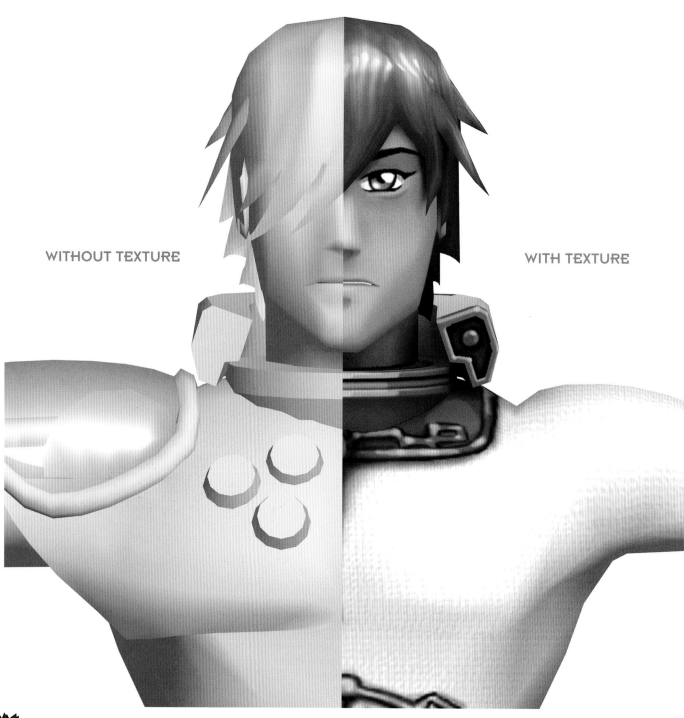

WITHOUT TEXTURE

WITH TEXTURE

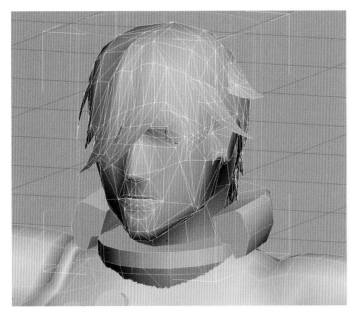

The first step in the texturing process is to use a special 3-D tool in the computer program to "unwrap" the mesh foundation (left) of the figure, or face in this case. It's the same concept as flattening out a globe to make a map. The two ovals in the section below are the ears after the face has been unwrapped.

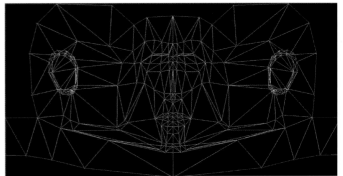

After being unwrapped, all the flattened elements are positioned to make the most efficient use of space in order to take up as little computer memory as possible.

Patches of color are added to the appropriate elements. The tan patch will be the skin, the black patches are the hair, and the reddish patch is the tongue.

PAINTING THE DETAILS OF THE FACE

With the basic textures in place, the next step is to create the
details that turn a generic character into a more lifelike one.

*This is where you're
starting out after
completing the basic
texturing: the wire
mesh has been
flattened out and
arranged as
conservatively as
possible, and the basic
areas of color have
been blocked in.*

*Using the software's
special 3-D tools, the
programmer can add
shadows. When you
think about shadows,
you probably think of
a character bathed in
darkness, but that's
not what we're
talking about here.
These shadows are
more like accents.
They create a feeling
of depth so that the
character doesn't look
flat. The software
program generates
the shadows almost
automatically.*

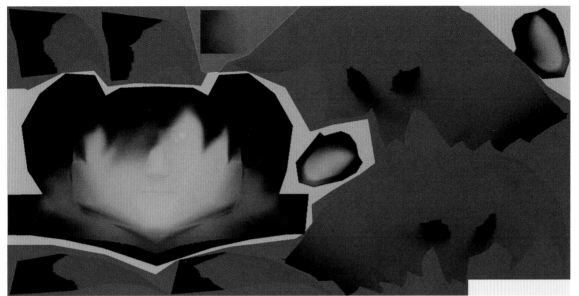

Next, the two previous stages are combined, with the second image being laid over the first. The white areas in the previous step are translucent; therefore, only the shadow areas show when that layer is placed over the first one. The result is that shadows are added to the colored areas.

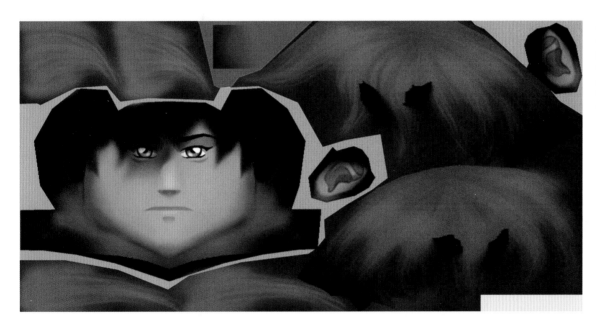

For more detailed areas, the programmer goes in and completes the job by hand, adding details like eyes, ears, and hair texture.

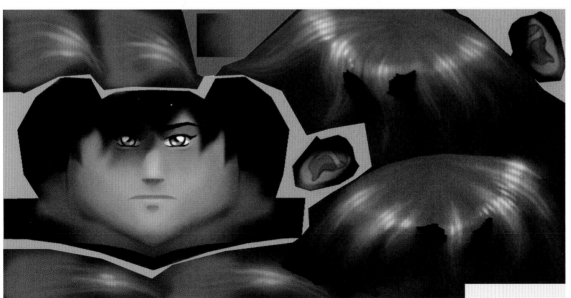

The final stage is the "polish pass." At this stage, the programmer takes a look at what has been created, keeping an eye out for any details that may have been left out. These include highlights on the hair and facial coloring, such as flushed cheeks.

BODY TEXTURING IN FINER DETAIL

This is similar to adding the details to the head. The body is separated into parts, mapped out with coordinates, and given more refined surface detailing. So, if you compare these texturing stages to the figure on page 132, you can see how the different areas relate to one another: the gray areas are the metal elements of the character's armor; the brown areas correspond to the leg and arm elements; the blue sections are the waist, arm, and leg bands; and the peachy sections are the fingertips of the left hand.

This is the final body texturing stage, before all the flattened elements are assembled to form the finished, three-dimensional figure.

Once the textures have been applied to the underlying foundation, both front and back, you can see the impressive transformation from simple wire mesh form to real video game character.

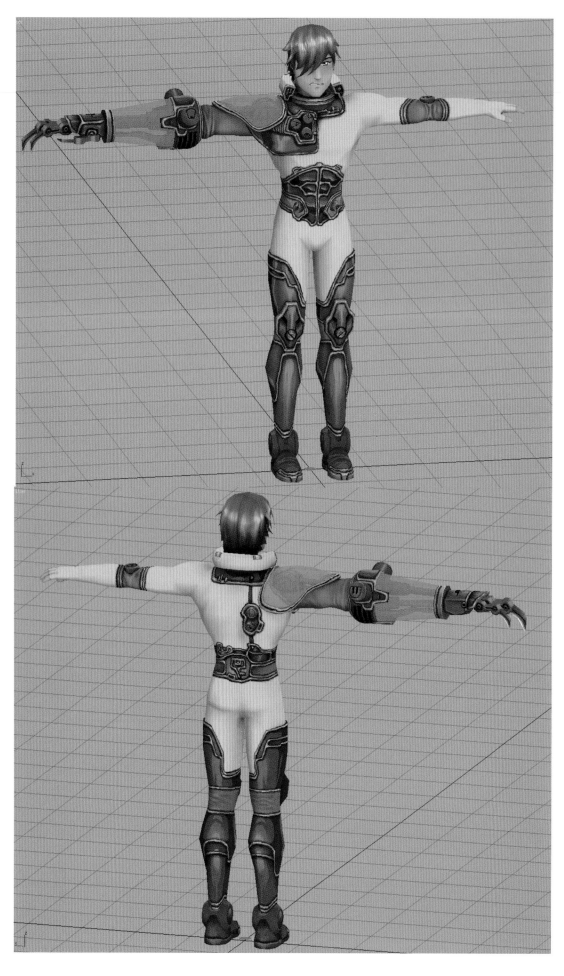

COMPUTER ANIMATION

Once a figure has its texture, the animation process can begin. Traditional 2-D animation is the kind you see on most animated television shows. This approach requires the artist to draw what are known as "extremes." Extremes are the key poses in a movement. For example, if a character were to throw a ball, the extremes would be when the character winds up, when the character throws, and when the character returns to the starting position. Once the extremes are drawn, another animator fills in all of the drawings that represent the movements in between the extremes, to make the action flow smoothly. An animated motion needs many "in-betweens" to be successful, requiring a lot of additional time and labor.

In computer-generated animation, the in-betweens are created in *automatically* by the computer. Pretty cool, huh?

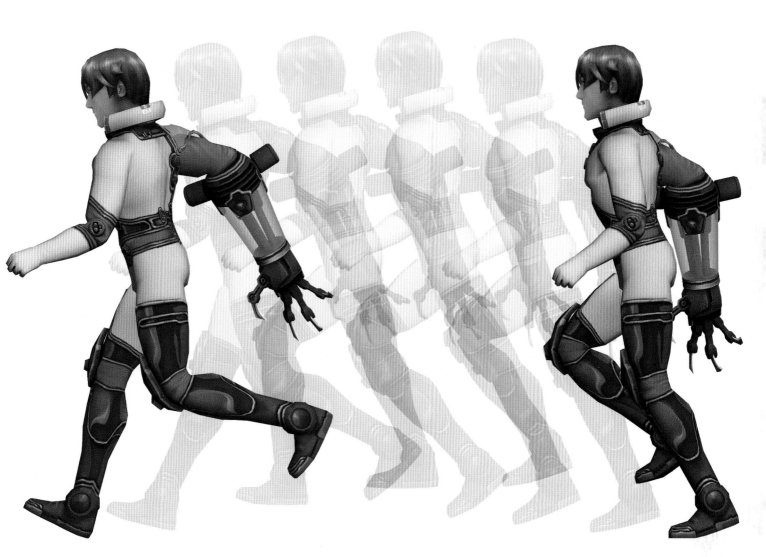

The bold figures are the extremes. The light figures are the "in-betweens." You can see just how much time, effort, and money is saved by eliminating the handdrawn in-betweening process.

TURNAROUNDS

The computer model of the figure must be viewable from every possible angle, and in every pose. The model must work in all three dimensions—this isn't just a 2-D drawing anymore. Unlike animation artists who work in 2-D and can sometimes "fake it" if they can't draw certain poses, the computer must be able to produce it all.

Once all of the information is input into the computer, the computer can rotate the character automatically. This is when you can also see what happens if you've left something out or if the design doesn't quite work as a whole. Then it gets sent back for a quick tune-up.

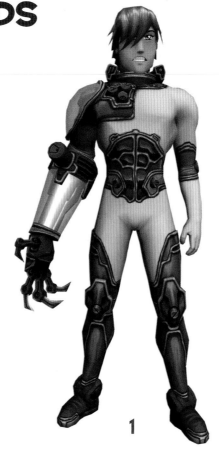

1

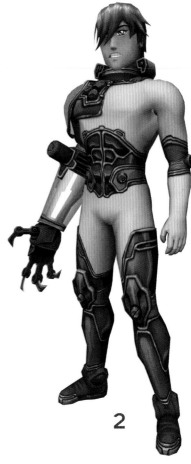

2

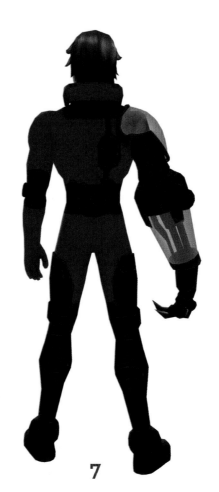

7

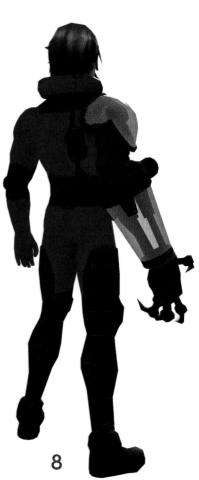

8

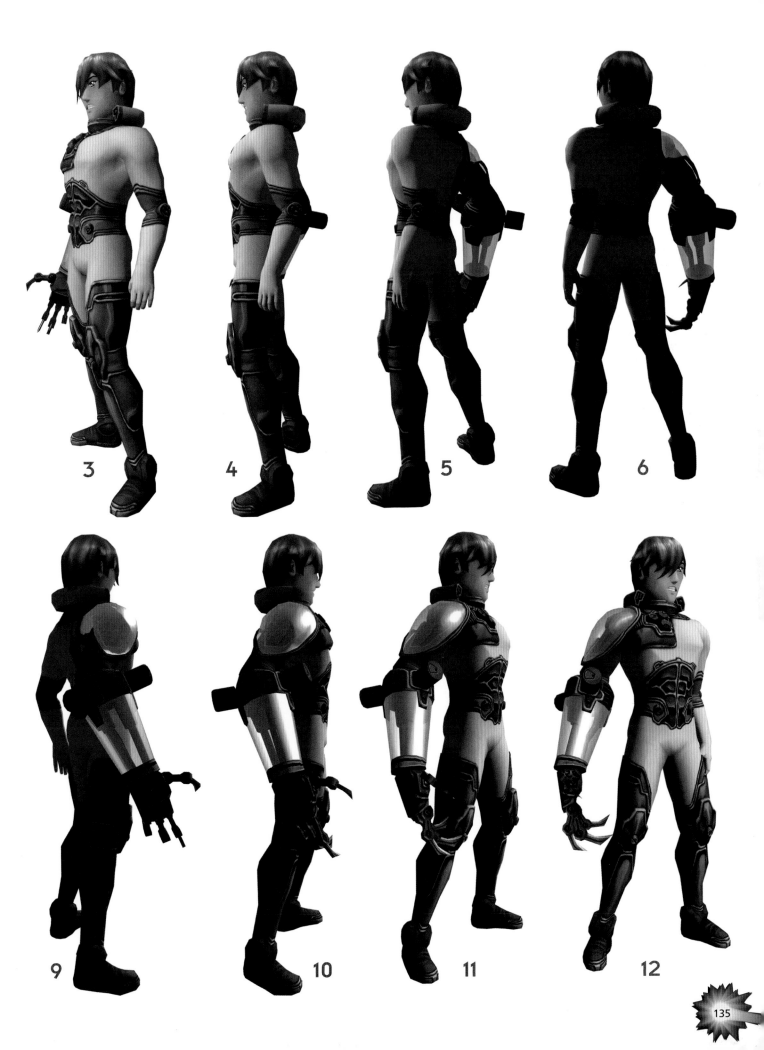

3

4

5

6

9

10

11

12

POSES

Just like their handdrawn, 2-D counterparts, computer-generated characters must strike convincing poses. They can't only look cool standing at attention, as when you first design them. And although the final, textured figure looks the most compelling, the real action takes place at the wire mesh design stage. By the time the wire mesh is in place, the main stance of the figure is set, and the rest of the work is really window dressing. Important window dressing, but window dressing nonetheless. If you need to rework the pose, you have to go back to the wire mesh.

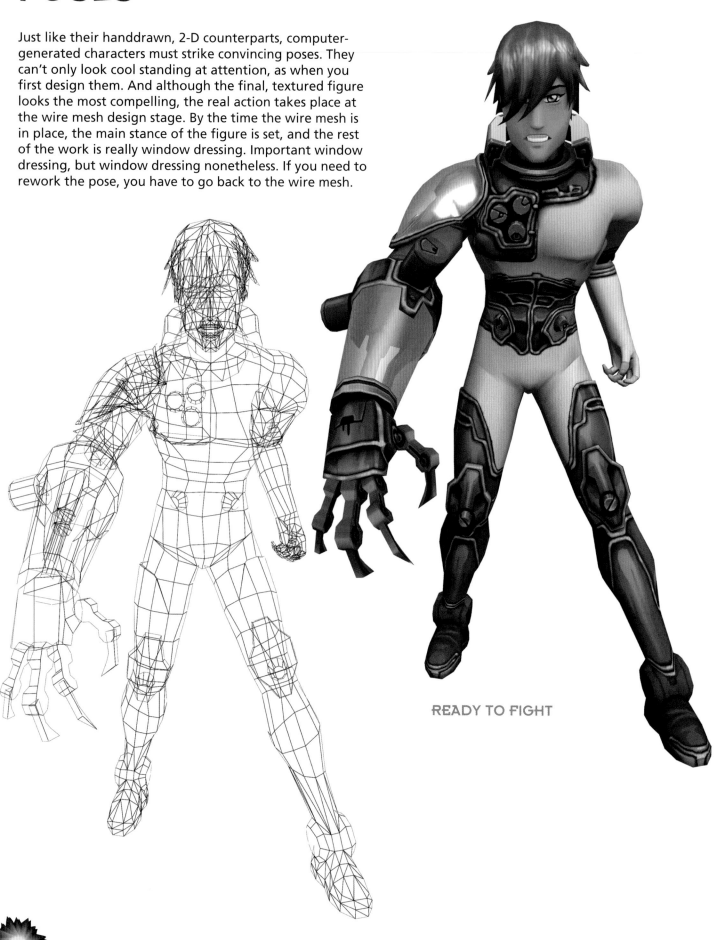

READY TO FIGHT

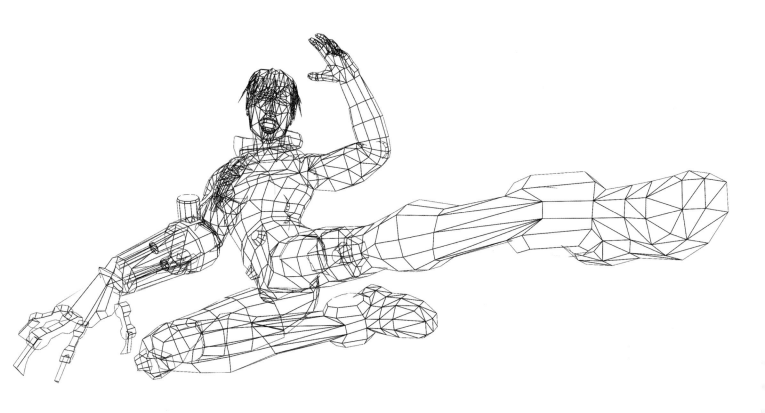

JUMPING SIDE KICK

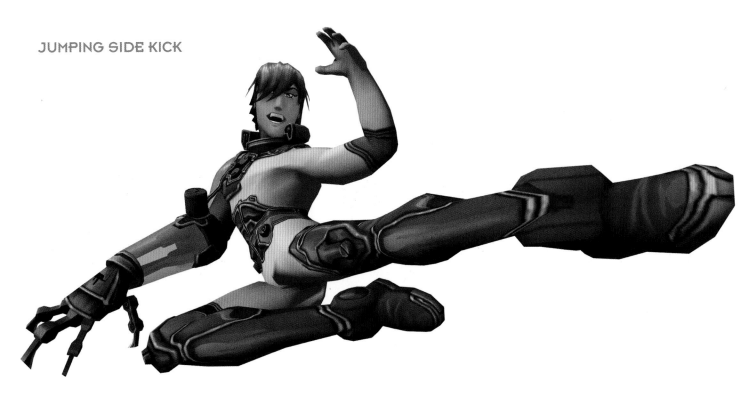

ATTITUDE

Any attitude that you can draw, you can also portray in CGI (computer-generated imaging). Still, the expressions and body language on a computer video game character may not have quite the same degree of personality as handdrawn versions, and part of this is due to the fact that video game characters are designed with simple wire meshes. Movie CGIs, on the other hand, are much more convincing. For video game action, nothing beats CGI. For comics, you can't beat good handdrawn manga. Still, you can get a sense of a video game character's attitude and emotion through its pose.

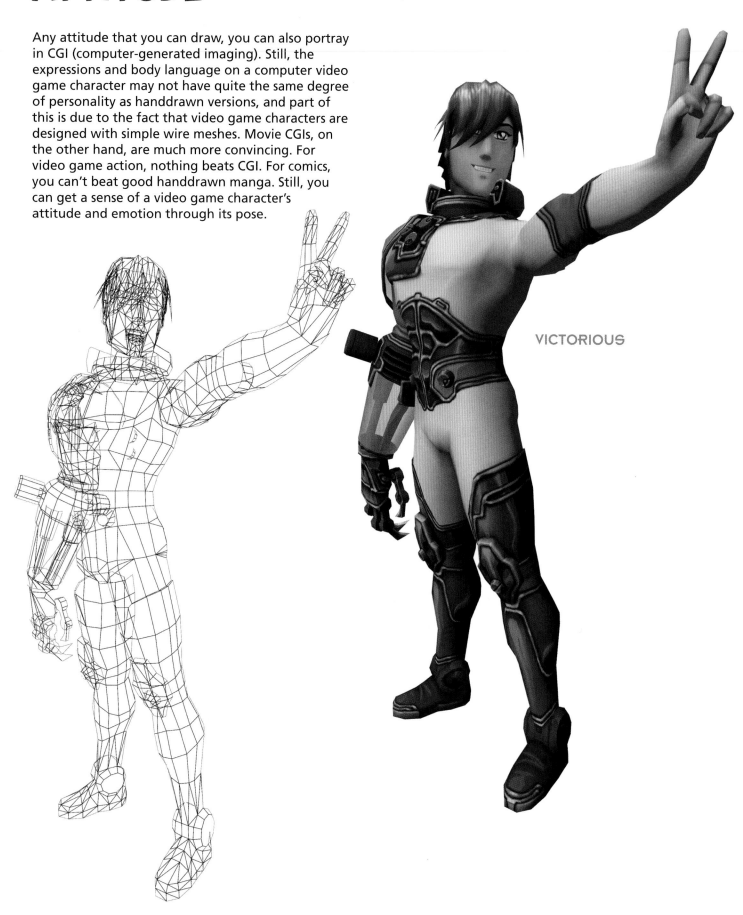

VICTORIOUS

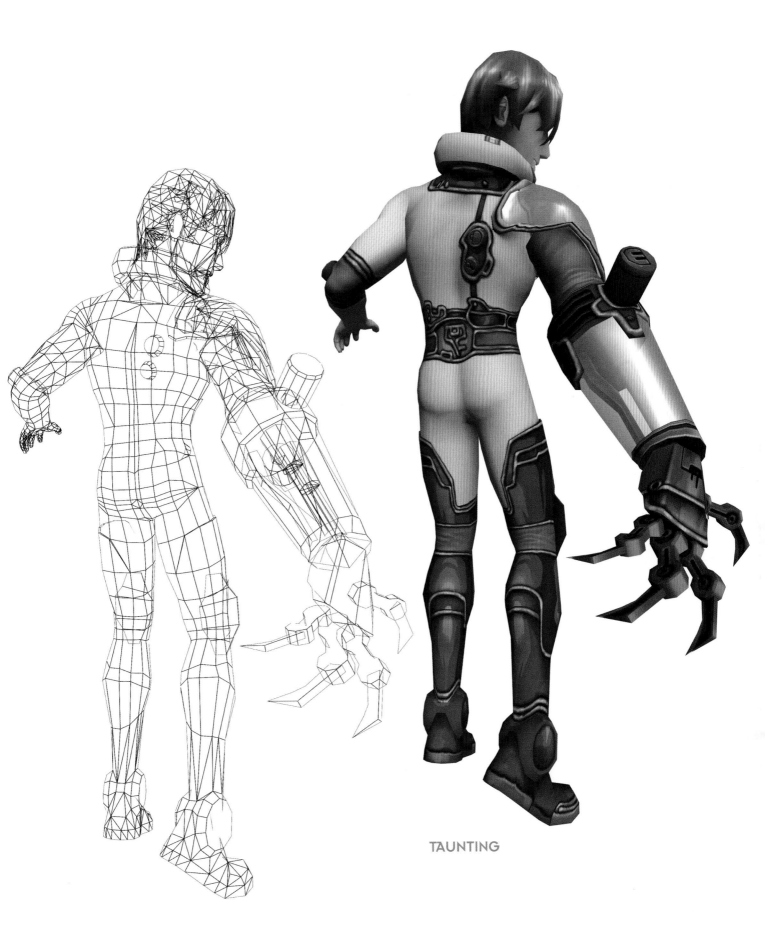

TAUNTING

FACIAL EXPRESSIONS

Video games appear on the small screen. Unlike animated characters in movies, the characters in video games are usually shown in full shots, not close-ups. Therefore, the computer programmer doesn't have to create a highly detailed, realistic expression. Only a basic expression is necessary.

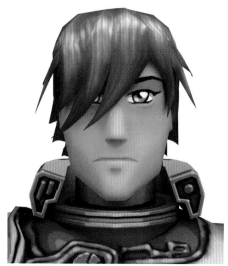

NEUTRAL
(WAITING FOR A COMMAND)

HAPPY

ANGRY

SMUG

SERIOUS

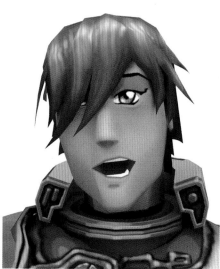

PLAYFUL

INTERVIEW WITH DAVE WHITE
SENIOR ARTIST AT CYBERLORE STUDIOS

Here's a multiple-choice question for you: What's the coolest job in the world? Is it: (a) hubcap salesman, (b) podiatrist, (c) pickle tester, (d) video game artist? Take your time. Don't rush your answer. Okay, time's up. For all of you who chose (d), you may very well have a bright future as an artist! For all those who chose (a), (b), or (c), be prepared to sit the prom out.

Many people want to become video game artists, but they don't know where to start, what the job requires, what the available positions are, or how to apply for a job in the field. This section explains all of that to you, plus it provides you with a behind-the-scenes look at what everyday life is like at a real, top-notch video game design studio.

Cyberlore Studios, Inc., is a cutting-edge video game design studio that develops the coolest games. The people at Cyberlore have utilized their computer design talents for some of the most prominent video game companies, including Microsoft and Hasbro. Cyberlore released *Majesty: The Fantasy Kingdom Sim* (from Hasbro Interactive) and *MechWarrior4: Black Knight* (from Microsoft Game Studios), an expansion for the highly successful *MechWarrior4: Vengeance*, as well as many other titles. Cyberlore has recently released a PlayStation2 (PS2) version of the classic board game Risk, and is currently developing a PS2 game called *Playboy: The Mansion* for PC and console systems.

Dave White is a senior artist and veteran computer and console game developer at Cyberlore Studios, Inc. He is very connected to the industry, and is eager to share his experience and insights with aspiring professionals.

Chris Hart: Dave, please tell readers something about your background.
Dave White: I was one of those

kids that took apart every toy he had and used the remains to build all kinds of crazy contraptions. My mom was never too happy about that, as you might imagine. I also loved to draw and do other "creative" things like play video games all day long.

Through practice and hard work I was able to get into the Columbus College of Art and Design, which is in Columbus, Ohio. I studied illustration, traditional Disney-style animation, and computer graphics. I made a lot of good contacts while I was in school, so I managed to get a job working in the computer games field before I even graduated. My fist job was nothing glamorous. I was an animator for children's educational games, which became boring very quickly. I decided that I needed a job where I could animate explosions and giant robots instead of puppy dogs and clowns, so I began a job search for something a bit more serious. My lucky break came from an address I got out of a gaming magazine called *Next Gen*. The magazine had featured an article called "How to Get a Job in the Gaming Industry," and my friend and I applied to something like seventy different

companies. We got two positive responses; he took a job with one place, and I took a job with the other. That's how I ended up with Cyberlore Studios way out here in western Massachusetts. I've been with the company just over seven years now!

CH: What is your title at Cyberlore Studios, and what does that entail?
DW: I am considered a senior artist, which is the highest of our three levels. You have to meet a lot of qualifications to reach that level, including several years of industry experience, strong 2-D and 3-D and communication skills, and you need to have shipped at least one full product. I have shipped fifteen.

CH: Some readers who may be interested in getting into the video game industry might not be aware of all the positions available. Could you tell us what some of the job titles are?
DW: We have several key positions within the art department. *Concept artists* sketch and create the initial look of characters and the game world. *Modelers* build the characters and environments in 3-D. *Animators* make the models move

and act. And finally, *texture artists* add realistic details and color to the characters and environments. It is just as common for one artist to do several of these tasks as it is for an artist to specialize in only one area.

A video game company can't survive on artists alone! We also need *designers* to come up with fun ideas and develop the games, *programmers* to create the code that makes up the game itself, *sound engineers* to create the music and sound effects, and finally, we need *management* people to keep the whole show running smoothly.

CH: How did Cyberlore get started?
DW: It all started way back in 1992 when Lester Humphreys and Herb Perez got together and formed a small company called MicroMagic West. Their first game was an Advanced Dungeons and Dragons Gold Box game called *The Dark Queen of Krynn.* Not long after the first game, the company name was changed to Cyberlore Studios, and the company was incorporated. We have since released some great titles such as *The Genie's Curse, Majesty: The Fantasy Kingdom Sim,* and *MechWarrior4: Mercenaries.* Eleven years and many computer games later, Cyberlore is still going strong. This Christmas will mark the release of our first full console title, the PS2 rendition of the classic board game Risk. While neither Lester nor Herb are still with the company, [their] tradition of fair and equal employment (and making fun games, of course) is carried on through [the company's] many creative employees and our CEO, Joe Minton. We have a lot of great things in store for our fans in the near future, but I'm not going to let the cat out of the bag just yet!

CH: You're in the unique position of being equally skilled as a freehand artist and a computer artist. How necessary are freehand artists in the gaming industry?
DW: Freehand artists are, in my

opinion, a pivotal part of game creation. At least one artist who is good at traditional skills—such as drawing, painting, color theory, and 2-D design—is an instrumental part of every development team right from the beginning. These are the artists who are the best at portraying ideas for fantastic worlds and characters. It is so much easier and quicker to create a color sketch or painting than it is to create a 3-D model, that it just isn't practical to do initial concept artwork in 3-D.

CH: I've visited Cyberlore, and it seems that everyone is enjoying himself or herself. Is this one of the coolest jobs in the world?
DW: You bet! I haven't done everything there is to do in the world, but I do like my job. It has its ups and downs, but that is true of anything in life. I find my job the most fulfilling when I get to work on my own ideas and really push my creativity to its limits. A lot of people think I get paid to play games all day and that just isn't true at all. I work hard, but it is very rewarding to create a character and then get to control and play as the character in a game.

CH: If one of my readers is interested in getting into the business, what do they need to include in a portfolio?
DW: The material you should show varies greatly depending on the position you are applying for. If you are applying as a concept artist, I would expect to see a lot of figure drawings and some color illustrations to show that you understand how to use color well. I would also expect to see some original character and environment designs to show that you have a good imagination. Never show a piece of art that is derivative or based on another artist's work.

If you were applying as a 3-D modeler, I would expect to see a lot of 3-D models that show you understand anatomy and the basic forms of people, animals, and

machines. I would also want to see that you understand the principles of low-polygon modeling and high-polygon modeling, both of which are used in game development. I can definitely say that an artist who is capable of both 2-D and 3-D skills will definitely stand out from the crowd. We also like to see that an artist understands the tools he or she would use in the workplace—tools such as Adobe Photoshop, Kinetix 3D Studio MAX, and even video editing software like Adobe Premiere and Adobe After Effects.

I also think everyone should know the importance of having an on-line portfolio in Web-page form. We get a lot of submissions when we post a job listing, and it is so much easier to look at and keep track of an on-line portfolio. We don't have to worry about losing the résumé or storing all kinds of prints. When I say a lot, I mean well over one hundred, so you can imagine how much clutter and confusion would be caused if everyone gave us a bulky paper portfolio. Besides, we work in a digital world, so a Web-based portfolio shows us that you are in touch with that world.

CH: How would someone go about networking in order to make contacts in this business?
DW: A lot of video game magazines have contact information for game companies. You can also look up your favorite companies on the Internet. Once you have their contact info, you can write to the art director to initiate a dialogue or ask questions. Be careful though; art directors are always busy, so be careful not to bother them too much. Most game-company Web pages have information on how to apply for a job with the company. There are even businesses that specialize in helping people get jobs in the gaming industry. These people are often referred to as headhunters. Many people consider headhunters the last resort, but they can be a great asset since they already have

a lot of contacts in the industry.

CH: What type of art education would you recommend to give someone a solid foundation and an edge over the competition?

DW: I can personally vouch that having a good traditional art education will give you an edge on the competition. Every artist should master these areas: figure drawing, composition, and color theory. It is also helpful to take sculpture, drafting, and basic industrial design courses. Painting is a big plus if you want to be a concept artist. Sculpture may seem a bit odd, but it is very useful in helping you understand anatomy and shapes in 3-D, which directly translates to 3-D modeling in the computer. I would even go so far as to recommend studying some fashion, which is useful for costume and character creation.

There are a lot of regular colleges that offer art courses, but I recommend that you go to an accredited art institute or [art] college. The difference in the intensity and quality of your education will be remarkably better. Even if you can only afford to take the first year of courses,

referred to as *foundation classes*, you will still gain a lot of valuable experience.

CH: Is it possible to get into the business without a lot of formal art training?

DW: Yes, it is possible, but you will probably have to start out at a small company making very little money and working on obscure games. Don't be discouraged; just think of it as an apprenticeship, like the old masters used to do. It is important not to let your ego get in the way of doing what is necessary to get a job. I used to think I was really great back in '95, when I first got into the field; but now that I look back on the quality of work I was doing, I can't believe anyone was willing to hire me. Everyone has to start somewhere, and as long as you work hard and try to better yourself, you will always be able to find work.

CH: Please share with us some of the challenges of working in a video game environment.

DW: Time constraints are usually the hardest part of the job. It just seems like you never have enough time to do things the way you want

to do. We also deal a lot with external publishers, and we don't always see eye to eye on everything, so you have to make a lot of compromises.

CH: What are some of the projects you're most proud of?

DW: Hmmm . . . I am really proud of the work I just completed for the upcoming PS2 and X-Box game *Baulders Gate: Dark Alliance 2*, which is being developed by Black Isle Studios. We often get hired just to do artwork for other companies' games. On a similar note, I also created a bunch of monsters for *Neverwinter Nights: The Shadows of Undrentide* from Bioware. Monsters are always fun! I am especially proud of Cyberlore's latest full release, *MechWarrior4: Mercenaries*. I was the sublead in charge of the Mechs. We created the game for Microsoft Games, which was fun because I got to work with many of their talented artists. I created all of the concept artwork and redesigned all of the Mechs as well as creating the textures for all of the Mech game models.

INDEX